MEN IN BLACK FILMS ™

MEN IN BLACK FILMS
THE OFFICIAL VISUAL COMPANION TO THE FILMS

ISBN: 9781789090765

Published by Titan Books
A division of Titan Publishing Group Ltd.
144 Southwark St.
London
SE1 0UP

First edition: June 2019
10 9 8 7 6 5 4 3 2 1

Did you enjoy this book? We love to hear from our readers.
Please e-mail us at: readerfeedback@titanemail.com or write to Reader
Feedback at the above address.

To receive advance information, news, competitions, and exclusive offers online,
please sign up for the Titan newsletter on our website: www.titanbooks.com

A CIP catalogue record for this title is available from the British Library.

Printed and bound in China.

MEN IN BLACK FILMS

THE OFFICIAL VISUAL
COMPANION TO THE FILMS

LISA FITZPATRICK AND SHARON GOSLING

TITAN BOOKS

CONTENTS

FOREWORD 06

INTRODUCTION 08

01 MIB 14

INTRODUCTION, IT HOLDS UP	16	JEEBS AND JEEBS' PAWN SHOP	40
FIRST CONTACT, MEN IN BLACK CODE	18	BUG SHIP CRASH	42
MIKEY	20	EDGARBUG	43
MEN IN BLACK HEADQUARTERS	22	NEW YORK CITY MORGUE	44
AGENT J	26	DR. LAUREL WEAVER	45
HERE COME THE MEN IN BLACK	27	GENTLE ROSENBURG	46
AGENT K	28	ORION'S BELT	47
AGENT Z	30	ALIEN AUTOPSY	48
SUPERNOVA SETS	32	EDGARBUG'S REVEAL	50
THE LAST SUIT YOU'LL EVER WEAR	34	CRASHING THE WORLD'S FAIR	51
NEURALYZER	35	EDGARBUG'S FINAL SCENES	52
WEAPONS	36	INVOKING THE ENCYCLICAL	53
K'S 86 FORD LTD	38	TWO BECOMES ONE	55

02 MIB II 56

INTRODUCTION, DÉJÀ VU	58	CHARLIE AND SCRAD	77
JEFF THE WORM	62	JARRA	77
BEN	64	SERLEENA	78
LOCKERTOWN	65	HEADQUARTERS EXPANSION	80
LAURA VASQUEZ	66	TECH UNIT	82
KEVIN BROWN	67	CHANGES IN THE MIB	84
POST OFFICE	68	FRANK THE PUG	85
POST OFFICE ALIENS	69	J'S 2003 E-500 MERCEDES	85
DENEURALYZATION	70	THE WORMS	86
JEEBS' BASEMENT AND DENEURALYZER	71	WORMS' BACHELOR PAD	87
SCUM OF THE UNIVERSE	72	THE TRUE LIGHT OF ZARTHA	88
COSMIC COMEDY	74		

03 MIB3 90

INTRODUCTION, SPACE AND TIME	92
BORIS THE ANIMAL	96
LUNARMAX PRISON	100
AGENT O	102
WALL OF HEROES	103
WU'S DIAMOND GARDEN RESTAURANT	104
AGENTS' APARTMENTS	109
BOGLODITE INVASION	110
TIME JUMP DEVICE	112
JEFFREY PRICE	113
MEN IN BLACK IN THE 60S	116
AGENT O 1969	117
ALIEN ADVENTURES	118
MEN IN BLACK HEADQUARTERS THROUGH TIME	120
AGENT K 1969	122
WEAPONS	124
NEURALYZER ROOM	126
GRIFFIN	128
SHEA STADIUM	130
MONOBIKE	132
JET PACKS	134
CAPE CANAVERAL	136
COLONEL JAMES EDWARDS SR.	137
ARC NET SHIELD	138
K'S LEGACY	140

04 MIB INTERNATIONAL 140

INTRODUCTION, BEYOND THE STARS	142
SPARKING CURIOSITY	146
DISCOVERING MIB HEADQUARTERS	148
AGENT M	150
MIB HYPERLOOP	152
BACK IN BLACK	154
MIB LONDON HEADQUARTERS	157
ALIEN CONCEPTS	160
AGENT H	162
HIGH T	166
UNDERGROUND CLUB	168
VUNGUS	173
PAWNY'S DAGGER	173
THE TWINS	174
AGENT H'S CAR AND WEAPONS	178
AGENT C	180
MOROCCO	182
NASR AND BASSAM	183
ANTIQUE SHOP AND CHESSBOARD	184
PAWNY	186
ALIEN MOTORBIKE CHASE	188
WEAPONS, PUZZLE BOX AND WEAPONIZED BLACK HOLE	192
RIZA & RIZA'S ISLAND	195
RIZA'S ALEN PETS	196
EIFFEL TOWER	198
THE MANY ITERATIONS OF THE HIVE	200
BATTLE IN PARIS WITH THE HIVE	202
MOVIE POSTERS	204

ACKNOWLEDGEMENTS	208

FOREWORD

While science fiction usually has its sights set on the future, as a movie genre it tends to be a reflection of its own time. Whether it's the fear of a communist conspiracy turning us into unthinking automatons which underlies *Invasion of the Body Snatchers*... or the anxiety about out-of-control machines taking over in films like *Space Odyssey* and *Terminator*... or the more nuanced relationship between human and artificial intelligence in *Her* or *Ex Machina*, sci-fi often uses the tropes of its audience's own world as a means to speculate on what might come next.

So what do we make of the late 90s, when the first *Men in Black* was released? It was a time of optimism and exuberance, before recession and 9/11 and imminent climate change reminded us that there are forces that we don't see at work that make this world a more treacherous place than it seems. The zeitgeist was maybe best summed up by one piece of technology: the iMac, those bulbous colorful computers that seemed to say "have fun with me and don't worry what's going on under the surface." And while he wrote it fifteen years earlier, Prince had it right when he urged us to party like it was 1999.

It was into this world that Agents J and K appeared and promised to protect the Earth from the scum of the universe. It was the most unlikely of amalgams – a science fiction comedy grounded by the conventions of the buddy-cop procedural.

While it arrived as a July 4th 'tentpole' release, there was something charmingly 'tossed-off' about it: the movie never broke a sweat in assuring us that "Hey, there might be an alien armada racing towards us that will end life on Earth, but we've got it covered."

So here we are, twenty-one years and four movies later, and the world is a very different place. In some ways our new film reflects this – no longer is New York the center of the MIB universe – we discover that the agency has a storied history and headquarters across the Earth. But what remains, and is perhaps even more in keeping with a world that at times may seem unmoored, is a sense of assurance – the basic idea of a group of cops who secretly go about their business in protecting the Earth's inhabitants, no matter their planet of origin, from threats both extraterrestrial and residing right here in our own backyard.

What also remains is the work of the countless artists and crafts-people who, like the MIB agents they help bring to life, work tirelessly behind the scenes, and are the real reason why producers like us are asked to write introductions like this. Nothing takes more effort than to seem 'effortless,' so it is to those extraordinary talents that this book is dedicated.

Walter Parkes and Laurie MacDonald

INTRODUCTION
THE BEGINNINGS OF THE UNIVERSE

The Earth as depicted in *Men in Black* is a complex and surprising place. A small blue planet, orbiting an insignificant medium-sized star, home to the thousands of aliens who have relocated there, as well as to the secret agency that protects them, along with the planet's human inhabitants, from "the scum of the universe." But according to Walter Parkes and Laurie MacDonald, the creative producers behind this global franchise, all that came later.

"The 'what if?' premise was certainly appealing – what if aliens really did live among us? What if there was a secret police force that existed under the radar? What if by joining it you could know everything about the universe – but would have to give up the most intimate aspects of your life to know it?" says Parkes. "But to be honest, what grabbed us first were the external elements: the guns, the sunglasses… and those black suits."

Somehow that was enough for the producing team to glimpse the possibility of a movie – or as it turns out, a series of movies which would become a beloved global franchise, and now a reboot with a new cast and group of filmmakers – from six issues of a little known graphic novel series that had been out of print for years.

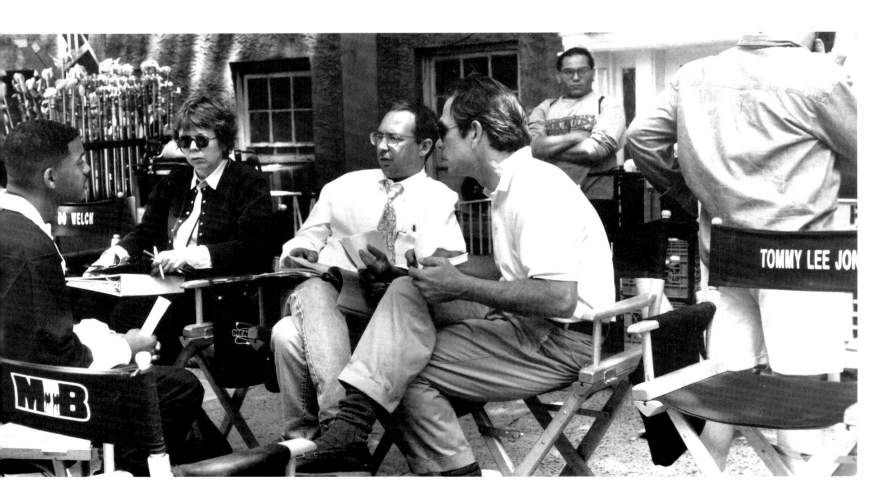

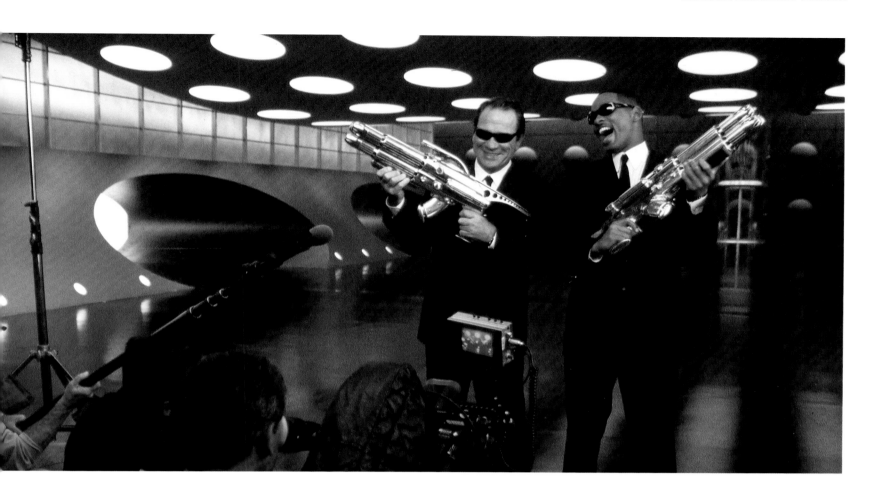

WE COULD GET THREE ISSUES OUT OF THIS

Principal photography continued through July of 1996, but the acquisition of the *Men in Black* story began over five years earlier. Lowell Cunningham, a loyal fan of Will Eisner and upon whose comics *Men in Black* is based, had been considering a few story ideas. Then one random Kentucky afternoon, he was hanging out with his friend (and urban folklore enthusiast), Dennis Matheson, when a nondescript black car cruised by. "That's what the men in black would drive," remarked Dennis. "Tell me more," urged Lowell. He was not a conspiracy theorist, but was fascinated by those who were, and the rich source material they could provide. Lowell soon learned about the underground legend of this secret society — and its early ties to ufology. And so he started to spin a few stories around them.

A friend getting contract work at Malibu Comics — a modest, indie comic book publisher/distributor run by four passion-driven, comic lovin' dudes — suggested he add them to his pitch list. Lowell sent off a sample and within a week he got a

call from Tom Mason (one of the founding four), who remained his editor for the duration. "The thing that caught my eye? It had a great title," shares Tom. Malibu's founding backer and resident dealmaker Scott Mitchell Rosenberg concurred. "I was surprised no one had used [it] before." What piqued Tom's interest? "We were getting superheroes, monsters, and barbarians. Nobody had pitched anything like that to us, ever. I loved the idea that there are secret aliens around everywhere, and government agents that investigate this. It all seemed interesting and unique."

Tom's pitch to his partners was, "'Hey, I think we can get three issues out of this.' And that was as far as my gigantic prescience went." Malibu was cranking out over twenty-five comic book series a week, most in short series of three to six comics. For these readers, superhero was by far the top genre. And yet, Tom felt it was worth *not* passing over. Scott agreed. Tom continued, "I thought Lowell had something. I didn't realize what it would actually become."

ABOVE: Tommy Lee Jones and Will Smith, *Men in Black II* hanger, between takes.

PREVIOUS PAGE: Will Smith, script supervisor Mary Bailey, director Barry Sonnenfeld and Tommy Lee Jones discussing the script. Bailey continued with Sonnenfeld for all three *Men in Black* films.

INDEPENDENT COMIC TO GLOBAL FRANCHISE

The early 90s was not a hot era for comic book acquisition, and at Malibu there was no such thing as film rights clauses. Most writers retained full ownership over their work – that's how this start-up distinguished itself from the work-for-hire, mainstream mold of DC and Marvel – and attracted a host of first-time comic book authors, including Lowell Cunningham.

When the comic book wave took a downturn, Scott began shopping for options. This included opening Malibu's doors to a string of film producers and development executives reaching into the comic book fringe for fresh material. It was now a post Tim Burton's *Batman* world, and it was in this environment that Cunningham's relatively obscure, short-lived comic book series, *Men in Black*, was plucked from the stacks and reborn as a major Hollywood movie.

Long before the final sale of Malibu Comics to Marvel, Scott secured representation for Malibu by ICM, and Irene Webb was the book person there at the time. "Scott Rosenberg came to the ICM team," shares Irene, "and [asked], 'Would you like to represent my company?' and they said, 'Better get Irene.'"

Scott sent over the same bag of comics he'd been leaving with each new curious producer. One cover made Irene think of *The Blues Brothers* (a favorite of hers at the time), then of her three-year-old son. "'Oh, Nick would love these guys!' What did I know about comic books? Nothing. I left it to the two-year-old boy." Her child's enthusiasm propelled Irene to include *Men in Black* in the bundle of selected comics circulated to her usual client list, which included Parkes-MacDonald Productions (then Aerial Pictures) who had a deal with Columbia at the time. Tom remembers the callback well. "Scott told me, 'Walter's interested in *Men in Black*.'"

Ultimately, Irene repped the *Men in Black* film rights to Columbia in her first-ever comic book deal. "It was funny [because] I had never represented a comic book! And these people had probably never bought [one]! So, we were breaking new ground." Upon meeting young Nick at the premiere five years later, Laurie and Walter exclaimed about him to Irene, "Oh! Without you none of this would have ever happened."

BELOW: Agent K thinking in the pizza shop (left). Agent J doin' the flashy thingie (right).

NEXT PAGE: Producers Laurie MacDonald and Walter Parkes, circa 1996 (top). Ed Solomon (middle). Tommy and Will between takes, *Men in Black II*, video store bedroom scene (bottom).

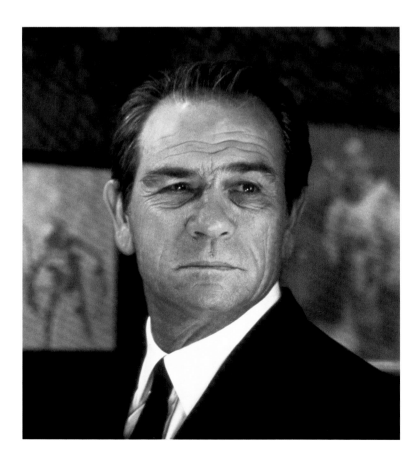

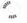

THIS IS GONNA BE EASY

In the years that followed, as studio heads and creative producers, Walter and Laurie would prove their bankability in choosing quality projects with exceptional commercial potential. But back in the early 90s, that was ahead of them.

When Steven Spielberg invited them to co-run Amblin, it was Laurie who had the management experience (as an executive VP at Columbia). To date, Walter had enjoyed great success as a screenwriter, but these were early days for them as working partners, and the first film they produced together. "So it… was like, 'Oh, well this is gonna be easy,'" jokes Walter, looking back.

"I do remember specifically what it was about *Men in Black* that appealed to [us]," reflects Walter. "They were human characters surrounded by aliens, not superheroes themselves. They went out, did what they did, got no thanks and had to go back to work… there was just something funny about that, and sort of touching. And we loved that they were cops."

Also, *Men in Black*'s relative obscurity – as a story, a myth, and a world – was its greatest strength, in their minds. Since Lowell's comics were known to so few, they felt free to go in new directions. Overall, "we were doing something different," remarked Barry Sonnenfeld, the director of the first three *Men in Black* movies. In terms of screenplay development, the challenge before them now was how to adapt this world into a cinematic one, and a tale worthy of the big screen.

DEVELOPING A SOLID SCREENPLAY

In searching for a writer to adapt the comic books, Ed Solomon seemed an obvious choice. "You think about *Bill and Ted* as comedy and science fiction and Ed was a good person to work with on it," shares Walter. And so they asked him to give it a look. "I thought it was really clever and interesting," shares *Men in Black* scriptwriter Ed Solomon, "but the comic books were not comedic at all. I would… play it entirely different in terms of tone and *humanity*."

What followed was months of story sessions between Parkes, MacDonald, and Solomon. "I would go off for a while and then we'd meet, I'd pitch to him, and we'd brainstorm." Solomon turned over his first draft on January 3, 1993, but there were a few stops and starts in putting the full filmmaking team together. Years passed in development before the first version of the script was finalized. Ultimately they continued making significant revisions into 1996, including throughout principal photography. "The story went through a million changes, but what was important to find was the tone," Walter offers. I think Ed's unique imagination was an important first step. Without Ed, there'd be no Noisy Cricket."

During script development many different versions of the story were explored. Whole scripts were drafted and passed over, including trial contributions from several additional, uncredited writers. "*Men in Black* is a deceptively very difficult franchise," shares Walter, "Because it is equal parts procedural drama, comedy, science fiction, an imaginative version of our world, and, at its best… an emotional idea underneath the whole

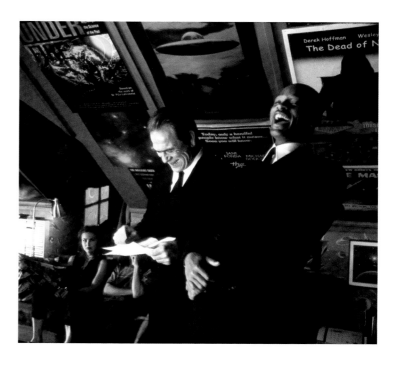

thing." Some of the challenges lay in the invention of new forms. "The idea that you could do science fiction and comedy together was not a big thing at the time," shares Ed. What eventually carried the story along was the humor of these everyday humans navigating a recognizable world gone a bit whacky. Tone was key in stitching these elements together. And that tone had to be comedic.

What they discovered, Walter describes, is that "The best moments in *Men in Black*, are almost re-imagined tropes that you recognize from conventional, or classic cop stories, then put them through this imaginative, absurd universe, and play them straight." The final arrival into these durable insights, however, involved an incredible amount of creative inquisition, debate, and patience. "We ended up with a version that might have been its best version," reflects Ed. "And it was due to all that push and pull, from all the people arguing and advocating for creative positions, and different takes." As they now embark on *Men in Black International*, Walter and the team can be very precise about the tonal requirements that make this franchise work.

IN GOOD COMPANY

Walter and Laurie had begun developing – and had partially cast – *Men in Black* while still producers at Columbia (under Peter Guber and John Peters, then co-heads of Sony) when they received a phonecall that would change not only their careers, but the fate of the franchise. It was from the legendary super-agent and head of CAA telling them that Kathleen Kennedy and Frank Marshall were leaving Steven Spielberg's company Amblin, and asking if they were interested in picking up the reins.

Spielberg had just completed the greatest back-to-back of all movies, *Jurassic Park* and *Schindler's List*. And so, "this was a time in Hollywood when Steven was so successful, that studios would gladly attach him to movies," shares Walter. Even so, "To go run a big, rival movie company is a good way to lose your project," chuckles Walter in hindsight. "We had a feeling about *Men in Black* from the first moment on… and thought it was going to work." So they shared their early draft with Spielberg. "He read the script, and, you know, he's just got a very good nose of these things and said, 'God, I love this.'"

Columbia was thrilled to attach Spielberg as an executive producer, which not only gave Walter and Laurie 'cover,' but also served as a gravitational force in helping to attract talent.

Several months later, Spielberg installed the couple as co-heads of movie production at DreamWorks – the first new motion picture studio in fifty years. From here they continued to serve as producers of the forthcoming *Men in Black*. Spielberg kept a benevolent eye on the project, lending opinions but largely leaving the management to Parkes and MacDonald.

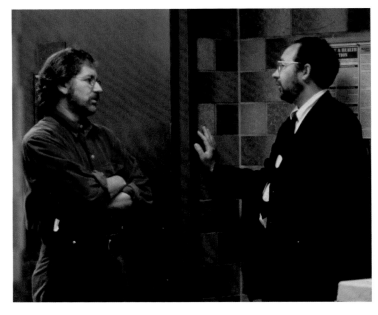

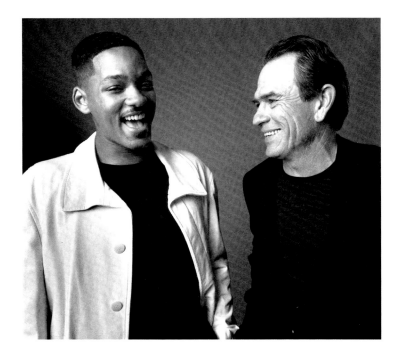

THIS PAGE: *Men in Black International* director F. Gary Gray conferring with producer Laurie MacDonald (top). Steven Spielberg and Barry Sonnenfeld on set for *Men in Black* (middle). A casual moment during a *Men in Black* photo shoot, circa 1996 (bottom).

COLLABORATION AT ITS BEST

Men in Black was breaking new ground; the intention was to blend comedy, science fiction, and action in a uniquely stylish way. "When you look at the challenges, it's no surprise that the road led to Barry Sonnenfeld," says Parkes. MacDonald adds: "As a cinematographer, Barry helped invent a modern way of shooting movies with the Coen brothers. And as a director, he had shown an affinity for big commercial movies in *The Addams Family* – but it was *Get Shorty* that took us over the top." Barry's feel for dead-pan humor and stylish story-telling was exactly what they needed. "What people don't realize is that nothing is harder than to make a complicated production feel like it was 'tossed-off' – Barry brought a unique freshness to every frame he shot," says Parkes. In retrospect, Sonnenfeld's seemingly spontaneous style was a perfect counterpoint to Parkes and MacDonald's penchant toward highly structured scripts.

"I think the difference between Walter and Barry's sensibilities," shares Ed, "led to a great movie."

There is another sensibility reflected throughout the final script – that of David Koepp, who according to Parkes, MacDonald, and Sonnenfeld, played an instrumental role in crafting the draft that would become the basis of the movie. "He gave the movie a sort of muscularity," notes Sonnenfeld. "He made it leaner." "David embraced the cop genre elements of the story without sacrificing imagination," says MacDonald. "His work was transformative."

And for *Men in Black International*, Barry will receive a credit, of course, but the surprise is this isn't the first time that director F. Gary Gray has followed in Sonnenfeld's shoes. "A funny irony," shares Barry, "is that F. Gary Gray directed the sequel to *Get Shorty*, and now he will be doing the sequel to *Men in Black*."

BELOW: Chris Hemsworth, F. Gary Gray, Tessa Thompson, Rafe Spall on set for *Men in Black International.*

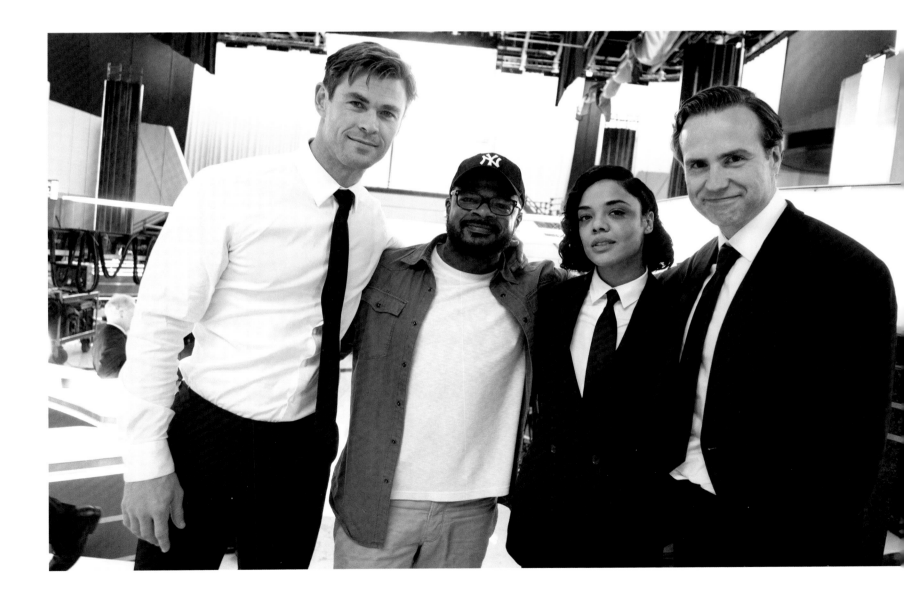

MIB
MEN IN BLACK

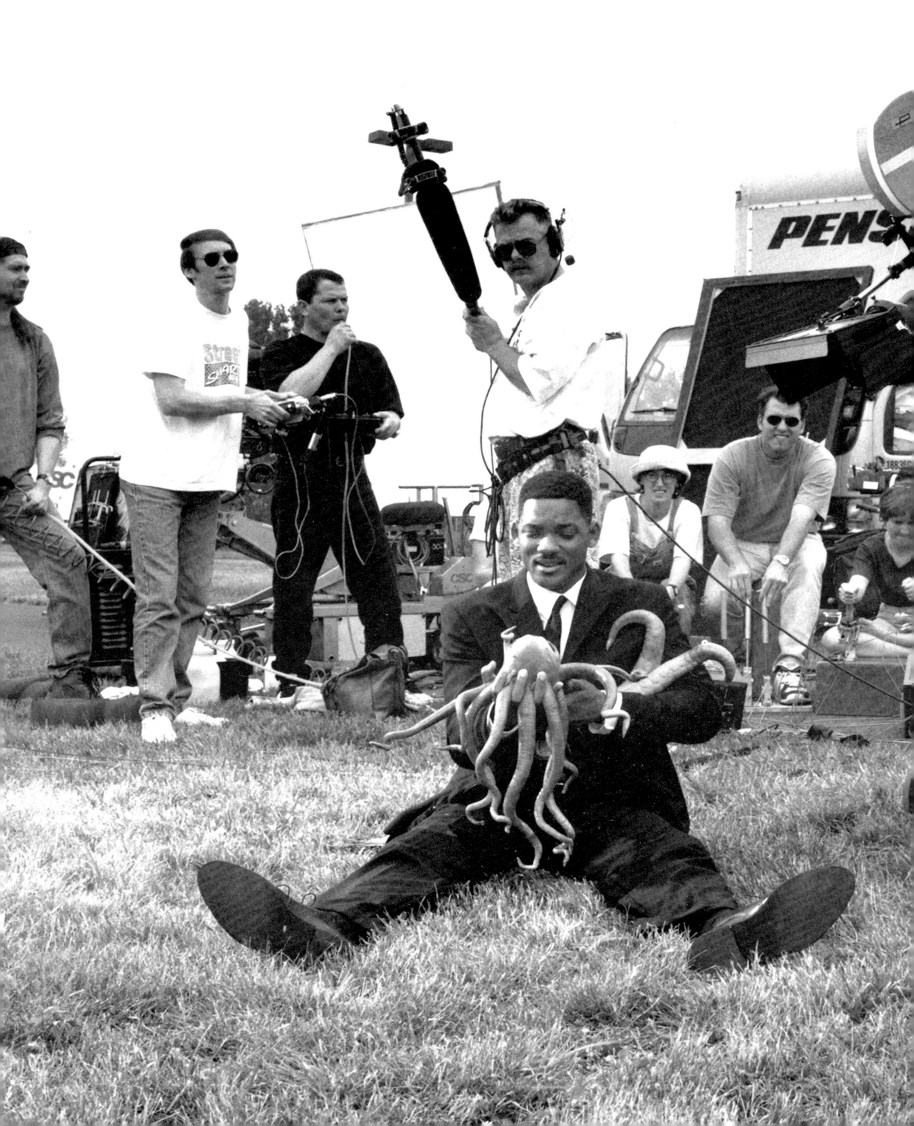

INTRODUCTION

IT HOLDS UP

While in production, did they have a sense that *Men in Black* was going to do well? Producer Walter Parkes had an inkling, but for director Barry Sonnenfeld: "You're always surprised. You never can feel you have a hit on your hands." But from the outset, there was a singular cool about the film. There's a core structure and certain conceits of this universe that audiences are continually interested in revisiting – and for *Men in Black International*, it has, once again, attracted the top, fresh young talents, the rising new guard of today's film world.

"[*Men in Black*] was a breath of fresh air," shares Lorne Peterson, a luminary of the old guard Industrial Light & Magic *Star Wars*/model shop world. "It just had a story that came out of nowhere. It was *new*... an interesting and humorous take on the whole alien 'thing.'"

"To me, regardless of the complications of putting this whole thing together," shares scriptwriter Ed Solomon, "what you had in *Men in Black* that really lives through it is a lot of really talented people. Everybody that came in upgraded the process. *Every single person*: Bo with his amazing sets, art department, production

design, Rick Baker's creatures, Barry Sonnenfeld, Eric Brevig. Visual effects were amazing. Danny Elfman's score. Every element was additive."

In writing the third film, "[*Men in Black*] was very personal for me," reflects scriptwriter Etan Cohen. "It was a movie that I had seen on a date with my wife when she was still my college girlfriend. Now we've been married twenty years and have three kids, and the movie franchise kind of spanned my adulthood, in a way. We always loved the movie. I just thought it was a classic."

"I'm proud of these movies," shares Doug Harlocker (prop master for the first three films), "because I look at them and they're still funny. I think they're just kind of crazy, surreal, [and] original." Nearly every person interviewed has said the same thing – *Men in Black* is one of the most fun movies they have ever worked on. "[It] was one of my favorite films I've ever done," shares set decorator Cheryl Carasik. "So new and fresh, and the concept. People still call or email me and say, 'I just watched *Men in Black* again and, I gotta tell you, that movie just holds up.' And I think it does. It really does."

FIRST CONTACT NEW YORK 1961

"Aw, you brought that tall man some flowers."
AGENT J

The Men in Black exist because the Numen disappeared for parts unknown, and the galaxy descended into chaos. That, in essence, is the origin story for the world of *Men in Black*.

Proof of alien life was discovered at Roswell in 1947 and Alpha, the original chief, established the Men in Black to help protect Earth just in case anybody came back – and wasn't friendly. (Turns out many were already here, but we didn't learn that until later.) Alpha – who later became the first chief, and mentor to K – penned the first draft of the agent code. First contact was made in Flushing Meadows in 1961 and, after we sheltered the Baltians as extraterrestrial refugees, more refugees – like a *whole* lot more – plus their complex technologies, began to descend upon our planet.

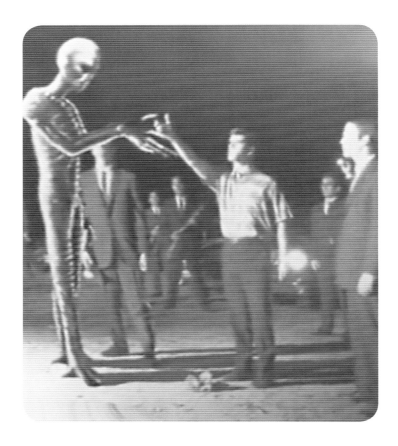

As we came to realize the bigger picture of the galaxy and our place in it – and how irrelevant, ill-prepared, and outgunned we truly are – Earth was established as a neutral zone. The Tycho Treaty (named after the historic astronomer Tycho Brahe) was signed. Its contents were inspired by the words of Nicholas of Flüe, the patron saint of Switzerland: "Don't get involved in other people's affairs," which goes to the heart of the Men in Black ethos. Its spirit of tolerance ensures our survival.

A new era begins. The Men in Black – apocryphal agents, cosmic G-men, techno-gunslingers – are now our best, last, and only line of defense. Earth maintains diplomatic relations with everyone, and avoids unilateral alliances.

We are the Switzerland of space.

THIS PAGE: A prop photo depicting young Kevin's first encounter (1961).

MiB

BLACK CODE

...tee into Men in Black has this credo read ...by his or her current chief. We hear Chief ...ds to J when he joins the ranks and, for the ...nal comic book series, Lowell Cunningham, ...rite parts of the movie." Every agent commits ...d, like the U.S. Pledge of Allegiance, the ...e is a sobering rite of passage designed to ...and again.

...e originally a three-line credo that uncredited ...o picked up from the original comic books. ...that is mine," reports Cunningham. "The ...tem, we're over, above them, we're they,' ...the comics. The preceding part is a well-...o what I had done." For Walter Parkes, ...nents poetically embody so much of what ...the Men in Black are all about. "I recently ...n Black International director] Gary Gray," ...trying to convey to him something about the ...lack." But it was David who had originally ...attention. "[David] went back into Lowell's ...d said, 'Guys! Why aren't you putting this ...ou don't have the best thing in it.' There is ...hat paragraph that goes to the heart of it. ...y, but just magnificently hard-boiled. That's

...ript business card.

You will dress only in attire specially sanctioned by MIB special services.

You'll conform to the identity we give you.

Eat what we tell you, live where we tell you.

From now on, you will have no identifying marks of any kind.

You will not stand out in any way.

Your entire image is crafted to leave no lasting memory with anyone you encounter.

You are rumor, recognizable only as déjà vu and dismissed just as quickly.

You don't exist.

You were never even born.

Anonymity is your name.

Silence your native tongue.

You're no longer part of the system.

You are above the system.

Over it.

Beyond it.

We're "them."

We're "they."

We are the Men in Black.

MIKEY

> **"Do you know how many treaties you just violated?"**
> AGENT D

REPORT: AGENT K

CLOSING REMARKS

DATE: JULY 19, 1997

RE: RESPONSE TO DISTRESS CALL FROM SAMARIUM PRISON – ESCAPED CONVICT

Yikem 'Mikey' Xexaco (Criminal #SAMYX9), convicted on multiple counts of Codes 51 and 272, has been terminated (see page 2 for details). Request Samarium diplomatic team visit headquarters to collect remains and exchange intel on Mikey's known associates and intergalactic trade routes. Have southwest Men in Black division identify which regional peddler sold Yikem his human bodysuit. Recommend the apparel department produce and distribute a set of badges for all active agents in Arizona, New Mexico, and Texas that read "Border Patrol, Division 6."

Agent D has gone into retirement. Have begun search for new partner.

SIGNED, AGENT K, MIB NEW YORK
cc: Diplomatic Division, Planet Samarium

Many aliens come to Earth to seek refuge from violent circumstances. Not Mikey. He *was* the violent circumstance, and he'd been trying to hide on Earth for years. He was a rage-prone, interstellar criminal with a long list of crimes in multiple empires, and was supposed to be in jail. With distinguishing eyestalks, retractable antennae, fanged jaws, and small flippers, this froggy alien was a bad dude – and well known to the Men in Black. His full name was Yikem Xexaco; he was a Samarium and a professional smuggler.

"Put up your arms [pause] AND all your flippers!!!" barks Tommy Lee Jones, again. "Cut!" shouts Barry Sonnenfeld. The issue wasn't that this was the first day filming *Men in Black* or that this was, in fact, the first day Barry and Tommy had ever worked together. (Will Smith didn't join the production for another two weeks.) Nor was it that Tommy, fresh off *The Fugitive* (and an Oscar win for Best Actor), rightfully presumed he should play K as funny. This is a comedy, right? Truth is, it wasn't until Tommy saw the premiere that he fully grasped what Barry had been aiming for all that time. Why he'd been telling him to flatten out his performance, to 'play it straight,' to never appear surprised or amused or impressed. So Barry continued, "You know, Tommy, it's going to be funnier if you don't acknowledge that 'flippers' is funny. You do this every

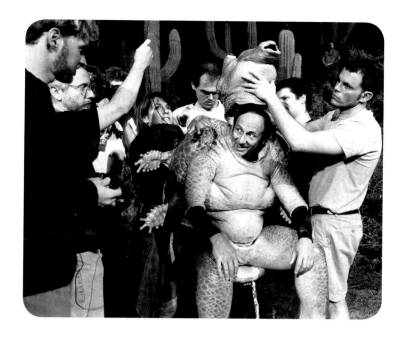

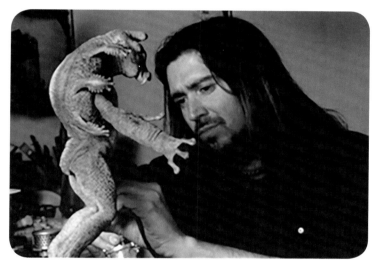

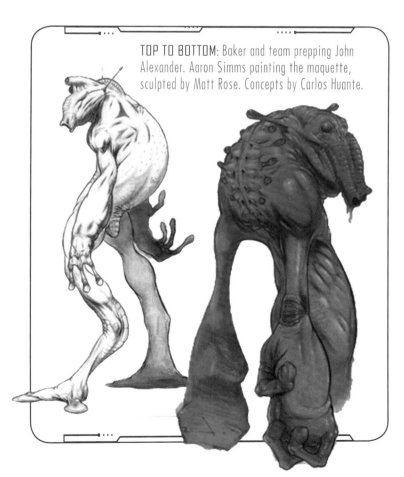

TOP TO BOTTOM: Baker and team prepping John Alexander. Aaron Simms painting the maquette, sculpted by Matt Rose. Concepts by Carlos Huante.

day. It's a normal thing." So this was the day Barry began the long march of helping everyone see what he saw as the tone of this film, and how to achieve that – with this core, now very *Men in Black* idea. Put an average person in a fantastical situation and then 'play it straight.' That's the winning formula.

Over the next 18–20 weeks, he would often say, "Tommy, don't be funny. You're just 'government issued.' GI. You're FBI. You don't think anything." At some point, Barry got a call from a William Morris agent by the name of Michael Black, and they had a bit of a chat. And Barry said, "Just wait. Tommy will be funnier than Will. This is the way it has to be. Tommy has to trust me."

What neither Barry, nor Tommy, nor the creators of Mikey could have known during those first few weeks filming this new, fresh, and untried story concept was that they were crafting an imaginary world that would become beloved by millions and endure for decades. Nor was it apparent that the high arts of puppeteering, mask and bodysuit making, model shop building, and other labor-intensive physical effects would make way in the coming years for a new era dominated by CG. But on this day, on this film, Mikey was, and remains, the first of many Rick Baker *Men in Black* marvels.

The script offered a scant description: "Giant space Mexican." Rick Baker (alien make up effects artist for the first three films) tasked his lead creature designer, Carlos Huante (*Blade Runner 2049*, *Prometheus*, *Arrival*), to come up with an idea, and he came back with a rather ferocious, 'monstery' creature. Rick requested some modifications. "Make him sleeker, more like a frog instead of really 'buggity,'" shares Carlos – and so Mikey was born. Sculpts were done by Cinovation's Matt Rose and Chad Waters. Baker and mechanics designer Jurgen Heimann devised the mechanical elements of the suit.

John Alexander, an actor and body-suit performer who had worked with Rick Baker on *Gorillas in the Mist* and *Greystroke*, was Rick's one and only choice for donning the bulky latex Mikey suit and bringing this creature to life.

His 'roar' was where Mikey transitions into ILM-driven CG but, "for eighty percent of that scene," recounts Barry, "it's Tommy, on stage, talking to a real actor in an alien suit." Barry continues, "The only time we used CG Mickey is once he started to move and run." And when an actor can perform to something other than a green ball? "It was definitely a lot of fun to watch puppeteers perform with actors live on set," shares Eric Brevig (visual effects supervisor, second unit director, *Men in Black*). "Whenever you can film them for real, even if they're just manipulated puppets, there's just the magic of performance that is much more cumbersome to recreate in post-production using all the tools."

For the CG portion, Eric and his ILM team built on Huante's concepts, adding fanged jaws, dripping saliva, and a flippery threat display. There was something sympathetic about Mikey, but once he bared those fangs the audience didn't have too many worries seeing him splattered all over the desert. The digital FX guys were responsible for setting up the blue goo explosion when K blows Mikey – and all his flippers – into sticky bits. "By the time the goo flew," shares Jurgen, "we were taking John out of the suit in the back room."

MEN IN BLACK HEADQUARTERS

NEW YORK CITY HEADQUARTERS

Since the establishment of the Tycho Treaty in 1961, the New York City headquarters – a subterranean, alien-friendly terminal – has served as global operations hub for the Men in Black.

It is fully operational, thirty-seven hours a day. What began with nine founding members mushroomed into a league of hundreds of agents, many of whom come and go each day through the non-descript Battery Park Tunnel entrance into the main hall. It's a vast underground labyrinth that continues to grow every year.

Hiding in plain sight is a way of life not only for the Men in Black but also for all the aliens allowed to pass through its visa control center. The island of Manhattan is a place where the unusual can live among us in peace – but even in New York City, the Men in Black have rules. Code 213, for example, 'Unscheduled spacecraft landing,' is a deportable offense. If it's a serious violation, the offending alien can get banned from the planet – and the only neutral zone for light years around – for, like, forever.

Access is extremely limited, by design. There are only two entry points – agents use street level entrance, and visiting aliens pass through customs from the landing docks. This beating heart of the Men in Black houses three key functions: command center, customs, and the lab. The main event each day is assigning agents their missions. To aid this purpose, a collection of alien tech has been

BELOW: Men in Black headquarters, including Z's office and immigration – designed by Bo Welch.

OPPOSITE: Some staff liked to sport anti-gravity shoes.

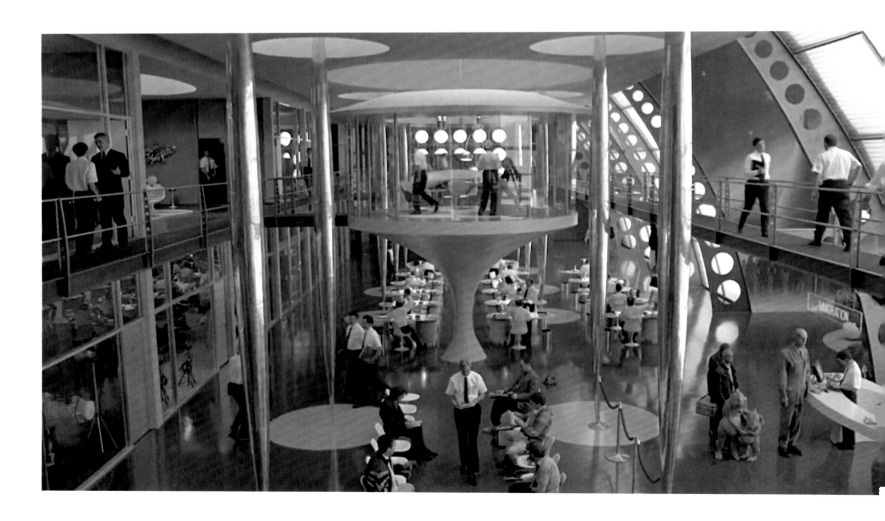

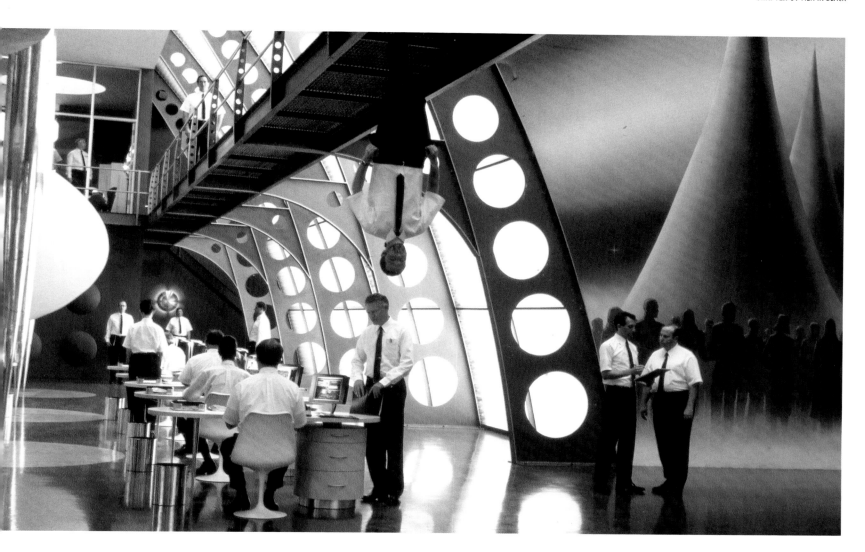

deployed here for data analysis, tracking, and off-planet communications.

The data hub is run by two Centaurians – the twins Bob and Blblup. They are Men in Black's hard-working computer mainframe programming wizards – and keepers of both the Bionet and ACS (the Alien Control System). It's their job to crunch data and process communications. Their non-linear minds and multiple appendages are well equipped to handle the complex layers of information ripping through the center every second, including over sixty million alien DNA sequence files. From here, the twins and Men in Black can keep tabs on every registered alien. Their work is the heart blood of headquarters' daily flow of critical information, including tracking movements on and off planet. If an alien was even thinking about coming to Earth, they'd know about it. It was the twins who implemented Centaurian time.

Customs is the arrival area for visiting and permanent resident aliens – not all are granted access to Earth's neutral grounds. Visas last three weeks, three months, or three years. The coveted citizenship visas (like a green card) are issued once a year. In addition to the main hall, there's a vast array of spaces on levels below, including hangar, testing room,

RIGHT: Various headquarters design details. Every element of nearly all *Men in Black* sets were fully stylized.

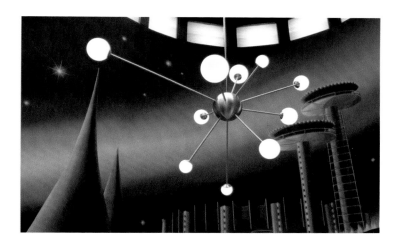

morgue, locker room, deneuralyzation office, flushing tubes, firing range, vault, and armory.

Gifted and/or impounded alien technology is stored in the restricted-access R&D lab. What was once just a science center now also includes weapons and defense. Its developments, whether freely offered or hacked into, are the lifeblood of Men in Black's resources, independence, and future. Their acquisition of alien tech began with the Baltians in 1961 (liposuction, the 8-track). Many gifts have followed (microwaves, Botox, hot pockets).

"My job is to create an environment that will frame, flatter, and amuse us," expounds *Men in Black*'s celebrated production designer, Bo Welch. His work spans decades, including collaborations with many of today's most sought-after directors. "Bo is one of the most genius and probably least recognized production designers of our time," shares art director Chris Shriver. "I think if you look back at his body of work [you'll] see that every single picture has a visual point of view

that's unmistakable." His work often has an air of whimsy or irony to it. "I think that's where his passions lie," continues Chris, "which made *Men in Black* the perfect vehicle for him."

Headquarters was initially a series of connected townhouses on West 23rd St. Files, typewriters, old-school detective stuff. "I looked at that and in my head had already decided, 'Well that doesn't make any sense. There's no *anchor* to this group,'" says Bo. "I knew right away... that I was going to sell [Barry] on the idea of an Ellis Island/airline terminal for aliens." Was that a challenge? "I drew a picture," shared Bo, "showed Barry and it was like *instant*. Oh yeah. It was not a tough sell."

Bo understood that this is an organization that monitors and controls the flow of aliens to and from space. "You have to show that, you can't just describe it," he says. The true spirit of *Men in Black* was born of that nexus between the space age and the threat of nuclear annihilation: the early 60s. Our world had grown smaller

BELOW: Welch's concept for the testing room, chock full of those ever-so-comfortable egg chairs.

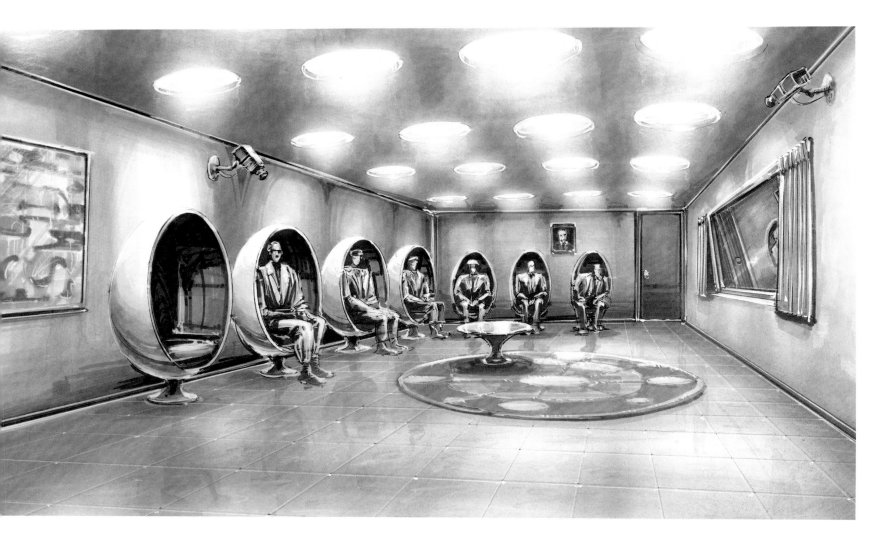

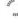
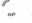

and we were looking to the stars. The Kennedy-era vision of the future. Shea Stadium breaks ground. The Cuban Missile Crisis. World's Fair.

Headquarters was established in 1961, so Bo drew from the times. His iconic Men in Black headquarters synthesized specific aesthetics, including now-famed modernists Eames, Eero Saarinen (TWA terminal), Santiago Calatrava, and Oscar Niermeyer. Flying saucers, hard-boiled sci-fi cinema, curved shapes, ovals, ellipses, circles. Polished chrome and silver. Circles, circles, and more saucery circles everywhere. Clean builds, almost geometric, monumental and unadorned. No earth tones, no red, no blue. No windows – set in hyper contrast to the gritty, grimy, messy, real New York street scenes. An underground bubble in touch with space.

And oh, so monochromatic! Flat black, bright white. Silver. "That's just, basically, *Men and Black*, literally," explains Bo. "You want to strip out all extraneous color so that the aliens stick out [and] read against that environment. So that's why it's monochromatic, black, white and grays and silvers. The stuff that's cool are the aliens – you want to create an appropriate frame for them."

Like most honest trendsetters, Bo was slightly ahead of the mid-twentieth century modern design wave – a real-world trend that has endured to this day. "That 60s, retro, space-age, Kennedy era aesthetic? I smelled that in the ether, to be honest. So the timing was really good. Because we did… hit that hard. Saarinen and Eames and all those great designers of that era. And then, that's when it really hit the world, too. Lucky coincidence."

From this theme, the suits, cars, props, and weapons all took their cue. Doug Harlocker worked closely with Bo to realize all the guns for the series. "Bo is just an incredible collaborator because he is… really one of the most creative people I know. When you think that you have come up with something really funny and great, and then he gets five minutes with it? You realize, 'Oh, Jesus. Bo is brilliant.'" Bo lets his staff run with things as well. "He allowed us a lot of freedoms," Doug continues. "But you want his input at some point, because we also can second-guess ourselves and wonder, 'Is this as good as it can get?'"

RIGHT: Entry to the subterranean headquarters via the Brookyn-Battery Tunnel.

> " THE TWINS KEEP US ON CENTURIAN TIME. IT'S A 37-HOUR DAY. GIVE IT A FEW MONTHS. YOU'LL GET USED TO IT – OR HAVE A PSYCHOTIC EPISODE."
>
> CHIEF Z

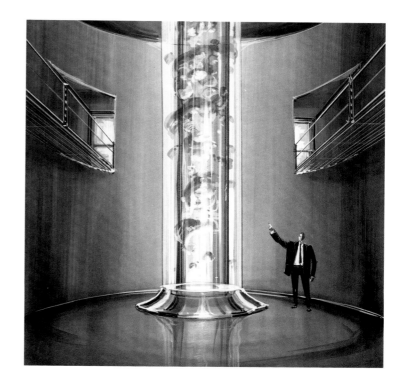

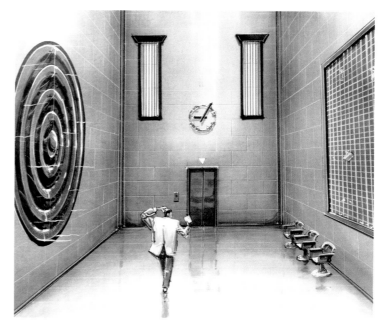

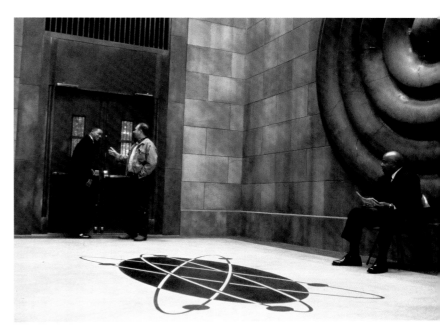

AGENT J

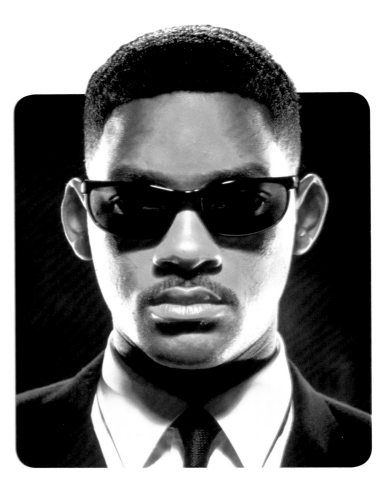

Agent J, like his father before him, was a natural born hero. Drawn to help, protect, and quietly serve. Raised without a mom or dad, young James' instincts led him to the NYPD, where he thrived. Through K, he learned there was an even bigger game afoot – and how vulnerable our marginal species truly is. Men in Black: The ultimate police force. And so he traded in his Smith and Wesson 3913NL for a neuralyzer and a Noisy Cricket. The Men in Black gave him a place where he could be himself. It was more than a job; it seemed like everything was starting to make sense for him. The true hero was home.

Agent J was born James Darrell Edwards III, in 1964, in Florida. He was thirty-three years old when he met K, and policing was his life. Quick reflexes, physical prowess, and keen intelligence are all quite useful for Men in Black agents but, like many things, an agent's most powerful weapon is how he thinks. The more that was thrown at him, the more competent he got. J was proving to be every bit as capable as K had

promised he would be. He eventually became, alongside K, one of the most effective and accomplished agents in Men in Black history. In time, he became a mentor and educator to younger agents, and the organization began to recruit a new generation in his mold.

Already well known for his television and music career, Will Smith's first big blockbuster, *Independence Day*, hit while they were shooting *Men in Black* in New York. Costume designer Mary Vogt recalls it well. "I remember it came out on a Wednesday," (and did extremely well.) "And I thought, 'Oh great. This really nice guy is... suddenly such a huge, huge star. He's going to be different. But he was completely unfazed by that. He was exactly the same." Like his character, J, Will always tried to keep the mood light and the crew amused.

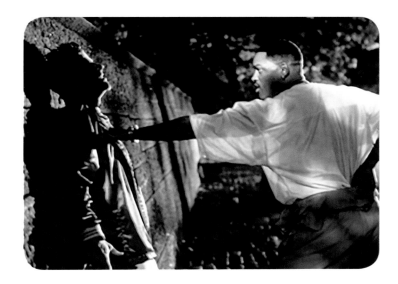

HERE COME THE MEN IN BLACK

The song 'Men in Black' was not planned for. But in retrospect, when we think of the iconic original *Men in Black,* its theme song springs to mind just as easily, pleasantly looping in the background. Will rapping, Coco, the R&B singer, belting out her soulful chorus.

As a rapper, Will Smith was already well known for his music before *Men in Black* began. So it wasn't completely out of the blue for Barry to suggest he take a crack at something, but none of the producers, or the studio, knew anything about it. Yet. "I said to Will," recalls Barry, "'Write a song for the end credits for us to sell the movie.' And he said, 'I'll think about it.' And then he went off. He never talked about what he intended to do," continues Barry. Some time later, one evening after they were done shooting, Walter, Laurie, and Barry were heading for their cars. "I'll never forget, we were walking in the Columbia parking lot," reflects Walter. "There's a limo, the window rolls down and Will goes, 'Hey, come here, I want you to hear something.'" And so the four of them settle into the cabin seating, lean back, get quiet and perk their ears. "And he plays his remix of 'Forget Me Not,'" shares Walter, "which he had just done in his garage." The reaction was instantaneous. "It was that great," shares Barry. "And it was totally his thing, on his own. None of us had anything to do with it and it was fantastic."

The song was Will Smith's first solo single and, true to Barry's initial idea about what might be possible, it did get added to the closing credits. If it had been released as a commercial single in the U.S., it may have hit the billboard hot 100 charts, as it had done in many other countries when it was released. But it did top the airplay chart, and Will won a Grammy Award in 1998 for Best Rap Solo Performance. The accompanying video was nominated by MTV for its Video Music Award for Best Male Video.

Will was originally suggested to Barry Sonnenfeld for the part by his wife. "I went to meet with Lisa Hensen (then head of the studio), Walter, Laurie, and Ed Solomon and said, 'I think it should be Will Smith and Tommy Lee Jones.'" Through some successful maneuvering Barry secured an in-person meeting between Will and Steven Spielberg, who was favoring Chris O'Donnell at the time. "Will was in Philly at a wedding (I had never met Will, by the way), and I helped arrange for him to helicopter up to the Hamptons. Will met Spielberg and, of course, you're instantly charmed by Will." Walter Parkes was present for this meeting as well. In looking back, he reflects, "The Will Smith of *Men in Black 1*? There is no more charming, funny, talented, beautiful, courageous human being that has been on screen. He's just unbelievable. The guy has so much talent."

Twenty plus years later, it may be time to yield the *Men in Black* floor to some amazing new talents. "When I directed *Men in Black 3,*" reveals Barry, "it was pretty obvious to Tommy, Will, and myself that this was the last show we wanted to do." The executive producers remain in place (Spielberg, MacDonald, Parkes, and Sonnenfeld), but the proverbial neuralyzer has been passed to the next generation of actors.

THIS SPREAD (CLOCKWISE): Officer Edwards confronting perp. Will Smith and Barry Sonnenfeld having a chat on set. Agent J embracing an alien close counter.

AGENT K

"NO, MA'AM. WE AT THE FBI DO NOT HAVE A SENSE OF HUMOR WE'RE AWARE OF."

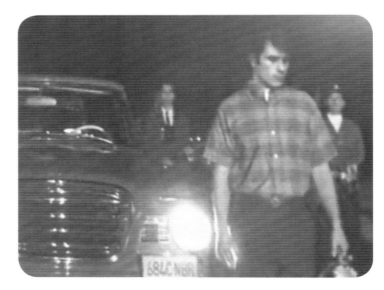

The Men in Black were established not long after Roswell, where the crash site remains provided incontrovertible evidence of extraterrestrial life. But it wasn't until March 2, 1961, when the Men in Black made first contact, that Kevin Brown's life was irretrievably altered. This love-struck teenager, on his way to see his date Elizabeth, took a wrong turn down the wrong road. "There were nine of us that first night. Seven agents, one astronomer, and one dumb kid." It was the Baltians who received his flowers that evening and, although he watched over her from afar – and later the young James Edwards III as well – he wouldn't actually see Elizabeth Ann Reston again until 1998, thirty-seven years later.

BELOW: Agent K (Tommy Lee Jones) donning the signature suit and sunglasses.

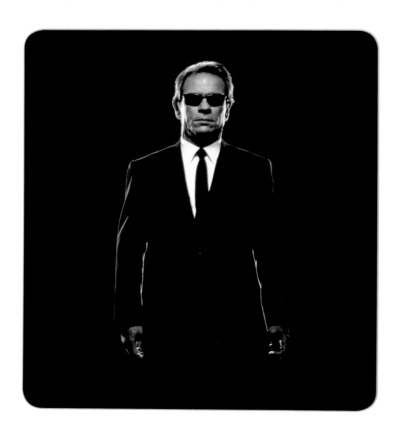

REPORT: AGENT A

DATE: MARCH 3, 1961

An unlucky, wayward lover stumbled upon our secret meeting. Talk about wrong place, wrong time. He seems changed by this experience and keen to join up. Bit high strung though (and humorless for such a young person), and shows very little promise. Given how strapped we are, we should probably take on the stunned Romeo. His 'ground zero' knowledge may prove useful. Let's give him a few weeks. If there is no progress, consider erasure.

SIGNED, AGENT A, MIB NEW YORK

Where J preferred improvization, Agent K was always 'by-the-book.' This rigidity was a reflection of his well-structured, emotionally compartmentalized life. He loved his work, but his sour, humorless veneer was how he coped with the sacrifices his life choices had required of him – as they do all agents in the Men in Black. Over the decades, his shell began to harden, but he channeled that pragmatism and grim exterior into rough and extreme alien encounters few other agents would touch. Within Men in Black, his firm hand would help ensure J's ascension in the agency. "In our minds," describes *Men in Black 3* scriptwriter Etan Cohen, "he was a father figure. Keeping tabs on [James] the whole time he was growing up. And when he was ready, he came to get him. [Since then], he has been trying to steer [J's] relationship with his father to a good place."

For Walter Parkes, Tommy Lee Jones embodies all the nuances of Agent K's character to perfection. "I love how Tommy does this, and it's built into the equipment of his eyes." With little dialogue, we're able to understand what K is thinking. "That is the story," continues Walter, "about a man who is mourning a decision he made, to do all this as opposed to accept love in his life. When I look at Tommy in that role, you sense this hurt underneath it all. And that's really cool, right? We never refer to it. We never play it, but there is this longing, and this sense of loss."

Up until *Men in Black*, Tommy Lee Jones had acted in a wide range of genres, but not comedy. He credits Jerry Seinfeld with giving him the inspiration to branch out. Again, Walter felt he was a natural. "His comic timing is unbelievable. The way he anticipates or slows down? He is able to play the absurdity of situations as if they're not absurd."

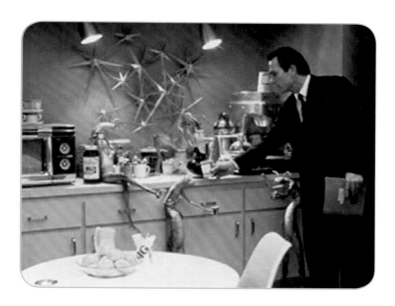

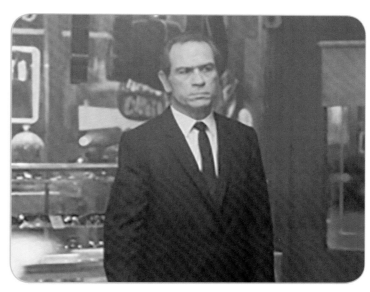

THIS PAGE: Agent K: Getting coffee, in Jeebs' shop, and recruiting Agent J.

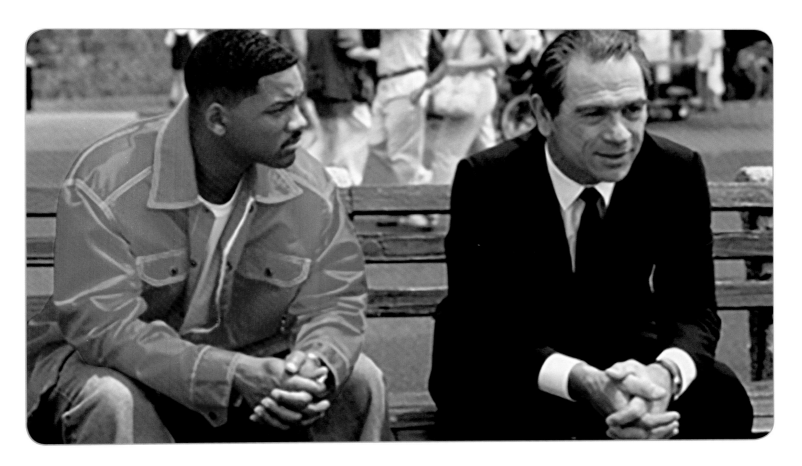

AGENT Z

"May I ask why you felt little tiffany deserved to die?"

Chief Z was never a field guy. Nor was he a member of the original Men in Black. But for all he has contributed to the organization, he might as well have been. Zachary Taylor Scott was recruited out of the NASA security force as a reverse-engineering expert in the 60s, while the Men in Black was still a fledging group of self-appointed ambassadors to visiting aliens. He quickly took to the core mission of Men in Black and set about embodying it in a way that has continued throughout the global organization long after his passing. The mission appealed to his civic-minded libertarian streak – he was committed to the safety of the human race but felt unsure about any government's ability to protect and serve.

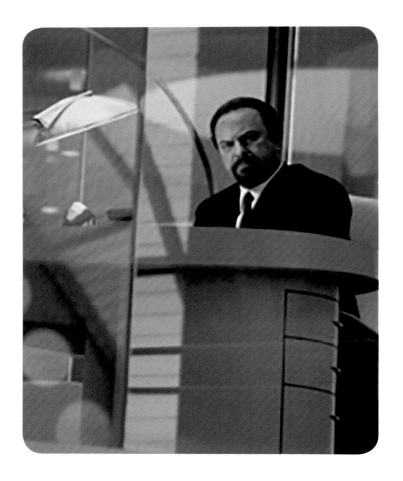

Unlike some of his predecessors, he was a natural-born leader, and well liked, if a little feared. His mental agility and memory were razor sharp, but make no mistake, Agent Z could brawl with the best of them. His martial arts training was a powerful tool in a scuffle or when needing to outwit the latest foe. He took down some fearsome planetary enemies in his day and was also a natural born trainer and mentor. Agents rewarded this faith in them with their loyalty and respect. He had a preternatural confidence that was infectious.

THIS PAGE: Chief Z (played by Rip Torn) at his desk.

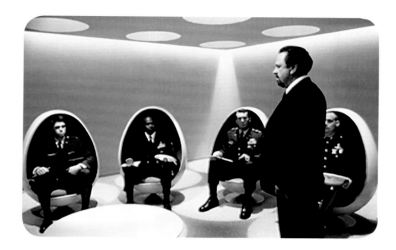

THIS PAGE: Chief Z testing potential new recruits (top). Art department sketch of the recruitment scene (above).

He also had a soft spot for lost extraterrestrials, such as Jeff the Worm, Frank the pug, whom he 'deputized' as his executive assistant, and the worm guys (they charmed him with a some pretty awesome coffee). Every inch the company man, he excelled as an administrator and 'empire builder' in the sense that Men in Black remains today a financially independent, global institution. Chief Z led with a spirit of openness and cunning, compassion, tough love, and humorous pragmatism. From his glass perch, he maintained a 360° view on all of Men in Black's activities. Few could surpass the mountain of village knowledge he possessed, but O, whom he set up as his successor, was probably the closest.

His passing was a shock to the system. He and the Men in Black were so synonymous it was hard for many to imagine the place without the old crank. Z's legacy as chief of the Men in Black, although expunged, will not be forgotten.

Rip Torn was playing Artie on *The Larry Sanders Show* (1992-1998) when cast as Chief Z. He also did an uncredited cameo at his own character's funeral in *Men in Black 3*. When *Men in Black II* came around, Rip was in his seventies but, for his tussle with Serleena, "[He] was so game," *Men in Black II* associate producer Stephanie Kemp recalled. "We had been hanging upside down and doing karate kicks and he never complained."

"During Z's office scenes," Kemp remembered, "they would let him off the ground on a wire, and he'd do this karate kick at Serleena. Before we could even put him back down on the ground, he'd either still be in character and ready to continue, or maybe he'd be trying not to laugh — and asking Barry to do it one more time."

MIB HEADQUARTERS: AGENT FILES

THE BIRD'S NEST

Like with all of production designer Bo Welch's creations, his first considerations are always how best to support the story and the camera (and the director's shooting style). Z's office, affectionately referred to by those in production as the "bird's nest," is a prime example of this thinking. The office itself is designed on an oversized, Saarinen-style base, aka "a golf tee," chuckles Bo. "The idea," he continues, "was the head of the Men in Black organization would want a spot where he could see everything… like a control spot where you can see the aliens coming in and out, that giant egg screen, [and] the various agents at their desks."

RIGHT: Bo Welch's design concept for the headquarters, including Z's office.

> "WE'RE NOT HOSTING AN INTERGALACTIC KEGGER DOWN HERE."

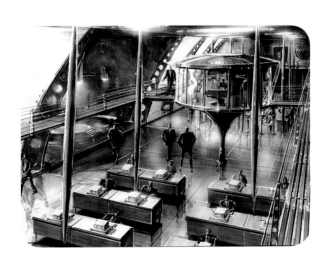

SUPERNOVA SETS
BO WELCH'S PRODUCTION DESIGN

" I've done more work with [Barry] than *anybody*," remarks Bo Welch. Back in 1995, however, Barry Sonnenfeld wasn't sure *Men in Black* would be much of a gig for the well-regarded production designer. Bo had already built a strong reputation and quite a résumé, including three films with Tim Burton (*Beetlejuice, Edward Scissorhands, Batman Returns*), Mike Nichols' *Birdcage*, and Alfonso Cuarón's *A Little Princess*. "He called me on the phone and, in typical Barry fashion said, 'Hi Bo, it's Barry. So, it's *Men in Black*. There's not a lot to do. You're probably not going to want to do it. It's really, it's you

know, it's probably location. And I don't know, you are probably busy and don't want it,' and he's, like, *un*-selling it to me."

Bo read the script and was intrigued, but it was Barry's shooting style that convinced him. "He has a very specific film language that he's developed over the years. So, when you build a set and he shoots it, you are going to see it," explains Bo. Recall the zinger scene from *Men in Black* with Agent J smashing up the tech unit? "That kind of action (which [Barry] made up), for a production designer is like, 'Oh my God, what a gift.' Because he used a prop to show every square inch of that set."

BELOW: Bo Welch and Barry Sonnenfeld reviewing *Men in Black II* set props, including a tubular, copper-colored weapon.

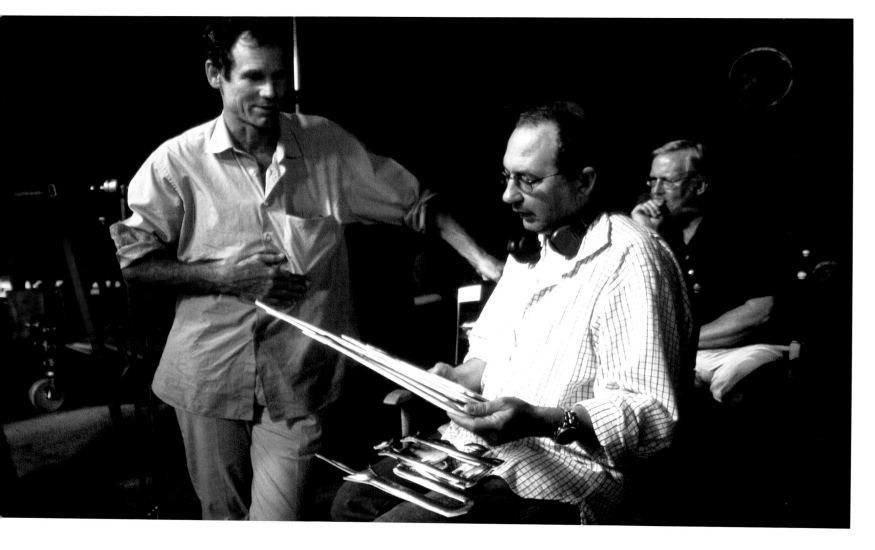

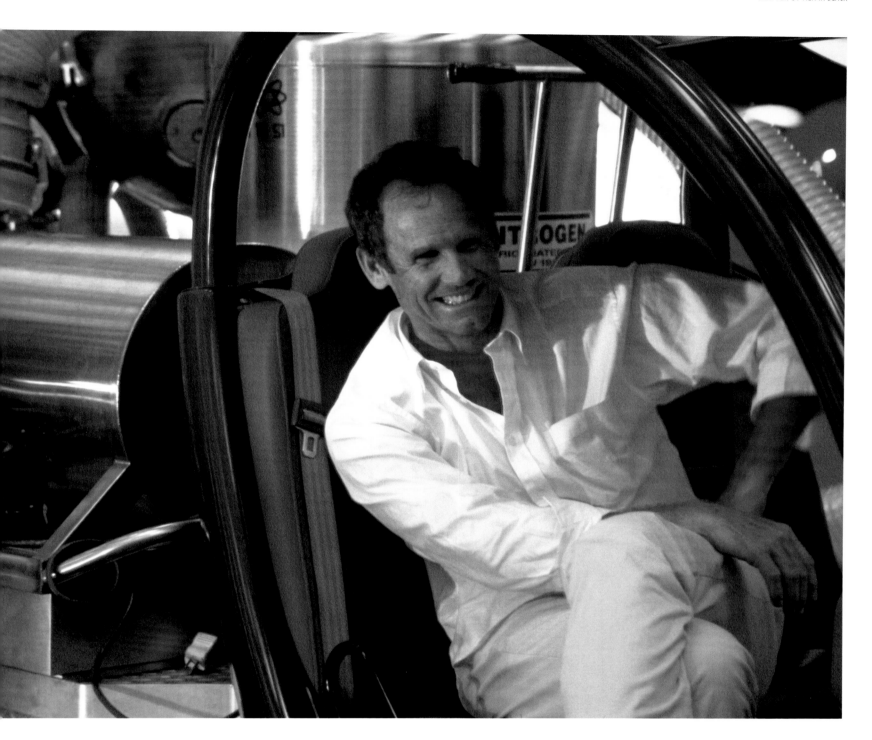

It's a reciprocal relationship. "Bo created sets to be photographed and directed," shares Barry. "The thing that both Rick *and* Bo have in common," shares Barry, "is they think like filmmakers. It's always about moving the story forward or creating a set that you can shoot in."

Bo Welch's vision informs every scene in the film, from set design to the ironic contrast, and the hi-lo aesthetics that are now a key signature of the *Men in Black* world. "Bo is one of the few production designers that actually has sort of an auteur signature. Because his stuff is always sort of witty," shares Walter. "You

never try to do funny sets," reveals Bo, "but whimsy and wit is a different thing. What I try to do is create as grounded and as real environments as I can."

The original script possessed no design cues, conceptually, which gave Bo a blank canvas upon which to create. "For me, the exciting part is in *Men in Black*, when Tommy takes Will on that first elevator trip and they open the door," shares Bo. "It's the first reveal. It was really thrilling, because *that's* what I was aiming for, design-wise. And it helped anchor. It gives you a place to be and it sets the *tone*."

ABOVE: Bo Welch taking a moment in one of the electric Men in Black cleanup vehicles.

THE LAST SUIT
YOU'LL EVER WEAR

The Men – and Women – in Black across the globe must adhere to a preset wardrobe. There's a budget for it – $5,000 per year. Men wear agency-issued suits and lace-up dress shoes. And they must shave daily. Women may choose pants or knee-length skirts, low heels or plain flats. Ties must be tucked and clipped at all times. And active agents must always keep two pairs of sunglasses on hand.

Their look was in style when the Men in Black began (50s, 60s) and, as times and fashions changed, they paid little mind. It goes to the heart of the films' philosophy, shares Barry Sonnenfeld: "Once you see aliens, once you know aliens exist and how unimportant everything is, 'Don't tell me about fashion. Really? I'm going to worry that white ties are in this year?'"

Costume designer Mary Vogt took her cues from Barry and began the task of suiting up the agents based on the pre-Bo Welch version of Men in Black headquarters – the brownstones.

NEURALYZER

The most successful battles of the Men in Black are not the ones fought, but those not remembered. The powers of neuralyzation enable the agency to maneuver through the world undetected. Its contribution cannot be overstated. "The neuralyzer is from my comics," shares Lowell Cunningham. "It can erase memories and program people."

The cement truck-sized prototype was rolled out in 1962 and its effects were, shall we say, a bit imprecise. The technicians continued to dissect its memory-wiping powers until they discovered the heart of what makes the neuralyzer effective. It involves a unique cocktail of visible and invisible electromagnetic light and a variable burst of this light causes the optic nerve to overload. And blam! The brain temporarily shuts down to protect itself. In addition to wiping memory, those flashed are receptive to suggestion. The three-tiered time dials provide control over the amplitude of the burst – and the amount of memory to be erased.

Where *Star Wars* had its lightsaber, the Men in Black have their 'sword,' the neuralyzer. Portability revolutionized Men in Black operations, further ensuring the organization's anonymity and its future. "We built [it] from scratch," describes Doug Harlocker, "and had to put a lot of technology in very small packages. Back then, [pre-CG], you were trying to get everything to work practically. For something to pop open, have lights, be able to press a button and make it flash? We were taking apart Polaroid camera light flashbulb bars and harvesting the slow-burning flashbulb… to put inside the neuralyzer to get a big and slow enough flash."

When Agent K was ready to retire, he passed the torch on to his hand-picked protégé, Agent J. "This was the one thing that never changed," reflects Walter Parkes, when talking about the many iterations of the screenplay during development. In referring to that final scene, "I gotta give it to Will, the brilliance. How cold he is. It's like he'd become a Man in Black, when Tommy says, 'See you around sport.' 'No, you won't.'"

She was thinking salty, 1960s FBI, thrift store style. "Then one day I wandered over to the art department… and I see this absolutely gorgeous model that illustrator Rick Heinrichs (now a celebrated production designer), was making of the headquarters. Very high tech, very modern." And she thought, "They can't walk around in this high-tech palace in dirty suits." So she quickly pivoted to the suit Cary Grant wore in *North by Northwest*. "It's a great suit, gorgeous," exclaims Mary, "and [Grant] actually designed it." Already a big star, he maintained his own tailor and favored the strong-shouldered look of the 30s and 40s when he had established himself. So he had a suit fashioned. One with a skinnier body and a really strong shoulder, and "that's why it looks so great… so you could say Cary Grant designed the Men in Black suits!" laughs Mary.

THIS SPREAD (CLOCKWISE): Spectral analyzer (by James Carson). Fingerprint erasure concept. Neuralyzer prop. J erases his prints. Clean-up crew concept.

WEAPONS

In the eyes of many of his *Men in Black* colleagues, Doug Harlocker embodies the best of what a prop master can be.

But when it comes to industry recognition, their contributions can be overlooked. "Somewhat unsung and less spoken about is Doug Harlocker," offers Walter Parkes. Cheryl Carasik echoes this sentiment. "He's a genius [and] his eye for detail is just meticulous. He's one of the top five prop masters in the business to this day."

"I never formally trained under anyone," shares Doug. "I just sort of, serendipitously, fell into it." When he first got the call, "I was incredibly nervous to work with those guys, because it was Amblin. Because it was Spielberg. Barry making everything up… designing everything from scratch."

Doug fabricated the handful of Welch-designed 'hero' guns – but was also given free rein to create. "[Bo] was very happy with the direction that we were going, just organically. We see so many plastics in movies and I wanted all [this] to be hardware," says Doug. So everything is shiny, glittery, and made out of aluminum. Much was milled.

In the spirit of realism Barry Sonnenfeld was after, Doug strove to do as much physically as possible. With the mini-cricket, for example, "we had to make it fire, so we were using non-gun blanks, and things that were new on the market back then to try to get a muzzle flash," he shares. "These days, you can just put that in in post [and] it looks great. Totally convincing. Back then, you were trying to get everything to work *practically*."

BELOW: Collection of "kludged" weapons by Doug Harlocker on display, including a Reverberating Carbonizer (center) in Jeeb's shop, from *Men in Black*.

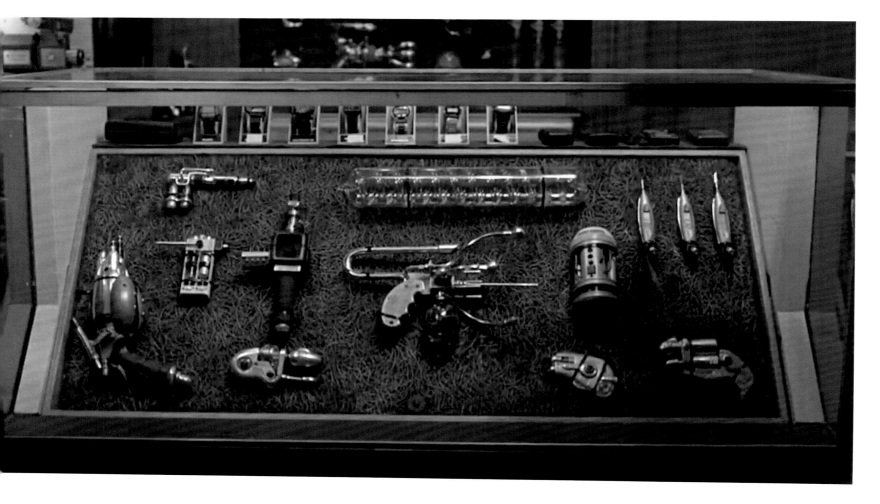

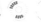

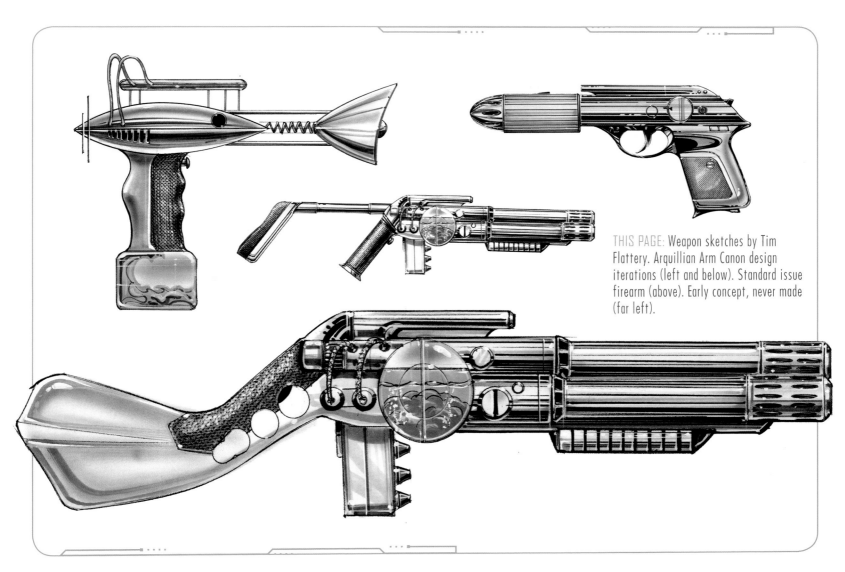

THIS PAGE: Weapon sketches by Tim Flattery. Arquillian Arm Canon design iterations (left and below). Standard issue firearm (above). Early concept, never made (far left).

Today, Doug has a shop of thirty but, in the 90s, he and a small crew would hunt around in search of unique parts. "I would go to aerospace salvage yards in LA and buy any interesting object that I could possibly find," he says. "We would lay out hundreds of feet of parts on the floor, look around, and start to ask, 'What makes a gun? What makes an alien weapon?' We would begin to put pieces together, and group [them], saying, 'if we welded this to that, added a little light to this, and did something else to this...' we would basically come up with something."

A lot of research would be done before bringing designers on board. "It was my job to get what I needed from the illustrators," says Doug. "It becomes a collaboration... back then, it was a lot of conversations like... is there a brain in the gun? Wouldn't it be cool if there was a glass ball that had a brain in it... hanging below the gun?"

"When people come up to me and say, 'You worked on [Men in Black]? The Noisy Cricket!' Everybody knows that thing," shares Doug. "It is the most iconic prop other than the neuralyzer. I would say that the Noisy Cricket is more iconic than anything else in the movie."

RIGHT: J with a Tri-barrel Plasma Gun. K with a Pulsar Blaster.

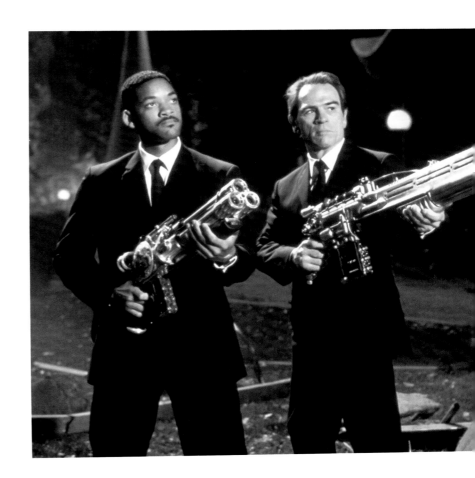

K'S '86 FORD LTD

J whined a bit about the company-issued Ford POS but, that was before he discovered how tricked out it truly was. All Men in Black vehicles hid numerous upgrades, but like the vans of Cunningham lore, nothing should set them apart. Black, nondescript, and packed to the fenders with futuristic capabilities and weapons.

This Ford LTD Crown Victoria was designed by Bo Welch. Doug Harlocker worked with illustrator James Carson to manufacture various elements. For the chase scene (overseen by Eric Brevig), the ILM crew built a ninety-six-foot replica of the Queens Midtown Tunnel. At 1/8th of actual size, the cars were about a foot long. It was authentic, down to the graffiti, and took four months to build.

"It was a delight to work with such skilled physical craftsmen," shared Eric. "I miss that, where nowadays everybody [chooses to] do it all on a computer. There's a lot of missed opportunities for photography, that had a lot of verisimilitude."

In the wake of the digital successes on *Jurassic Park* and other action films during the mid-90s, CG was beginning to take hold in all aspects of feature film production. The first *Men in Black* was at that nexus between the old and the new. "It was a wonderful combination. We had the CG car riding in a tunnel, then it was a miniature over taxis that were miniatures," says Eric. "It was the best of both worlds because the audiences can't really catch on … if you change techniques within the shot. I think the visual effects work [was] very tight and bulletproof. [And] a lot of fun because it was all part of the action."

ABOVE: Ford LTD cockpit concept sketches by Tim Flattery.

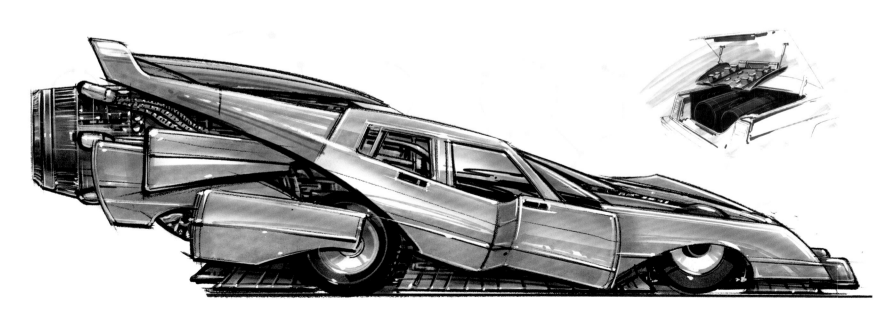

ABOVE: Ford side panel in early stage of expansion. Sketches by Tim Flattery.

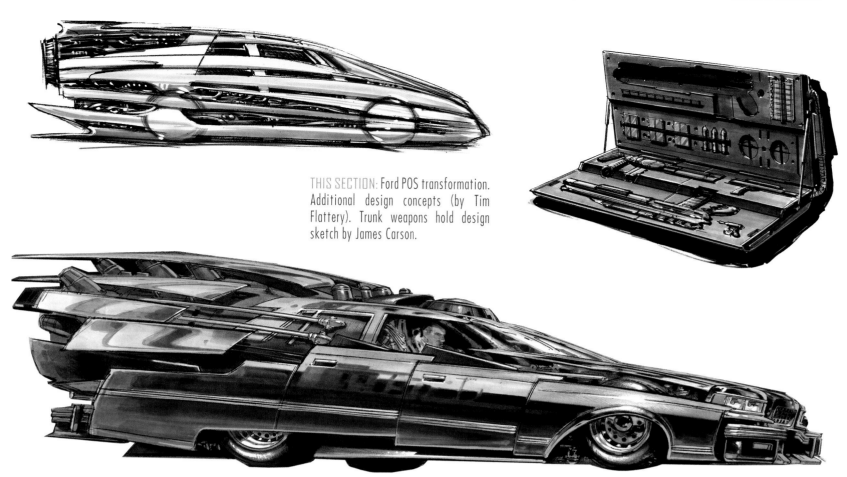

THIS SECTION: Ford POS transformation. Additional design concepts (by Tim Flattery). Trunk weapons hold design sketch by James Carson.

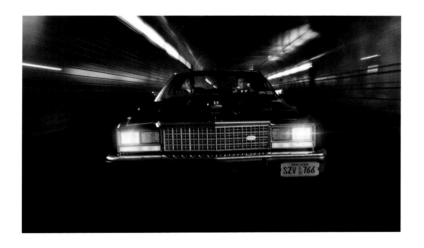

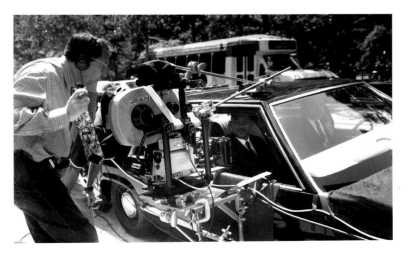

ABOVE: Smith and Jones on set at ILM (top) and with Sonnenfeld in NYC (bottom).

ABOVE: ILM/CG-enhanced car chase (top). Shooting street scenes in NYC (bottom).

JEEBS AND JEEBS' PAWN SHOP

You could say Jack Jeebs is a long time resident of Manhattan. He's also a Skook from Sirius IV. In the years since his arrival (he set up shop in 1988), he's put his skills as a pawnbroker to good use with two sets of customers, one human, one alien. One legal, the other not. The Men in Black tolerates his steady stream of low-level crimes because he's useful, and he sort of grows on you – literally.

"Every time his head grew back," shares Barry Sonnenfeld, "when we looped him, we had him suck helium, which wears off very quickly." So they started him with a high-pitched helium voice, and within seconds he was speaking normally once again. Tony Hudson at ILM supervised the Jeebs getting-his-head-blown-off sequences. With his attire, "There was always a slightly retro feeling to these movies," Mary Vogt. "And Jeebs had almost a 50s thing [going on]."

THIS SPREAD: Will Smith's often looking for how to make the scene funnier, which Barry loves about the actor. "When they're in Jeebs' place for the first time, Will was really smart about how to block [it]. The truth is they're both really smart, but Tommy was always about economy and Will was often about, 'Is there a better joke?'"

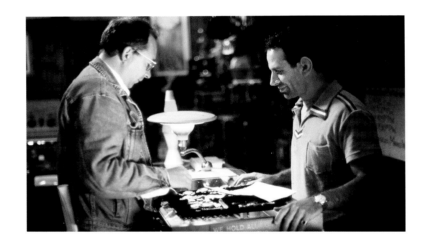 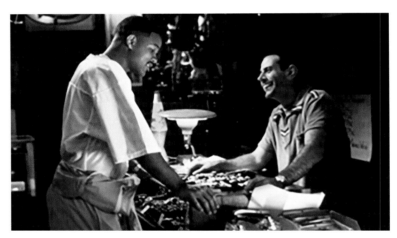

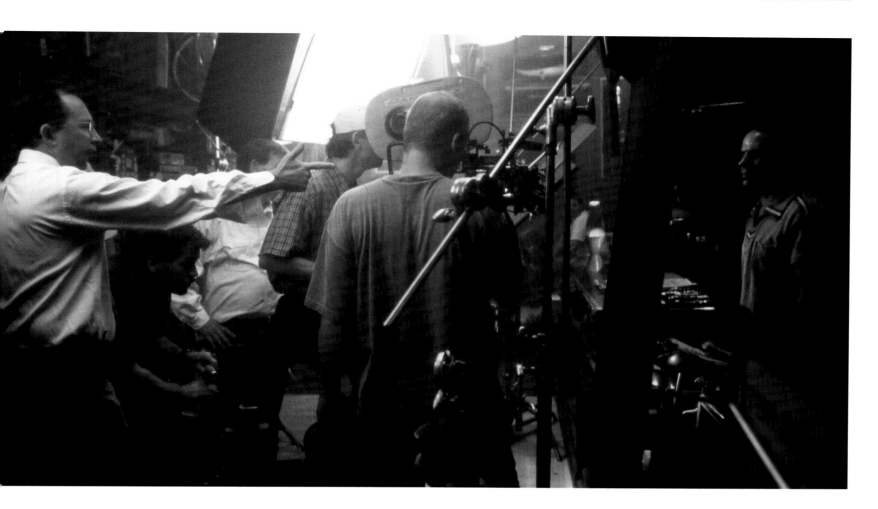

Jeebs is played by the actor Tony Shalhoub – Barry worked with him on *Addams Family Values*. "I love his character, because [Jeebs] is incredibly obnoxious, incredibly New Yorker-like. And I loved working with Tony Shalhoub, who is one of the *bravest* actors in the world. He has no concerns about looking ugly, or stupid, or being obnoxious." This was of course meant for laughs. "We didn't want him to look just like an absolutely normal person," described Rick Baker, "so we made Jeebs a little tweaked in the first movie… He took the ball and ran with it… he's one of those actors that has a lot of fun with the make up." A three-time Emmy winner for *Monk*, Shalhoub was also nominated for a 2018 Emmy Award for his role in *The Marvelous Mrs. Maisel*.

The interior of Jeebs' Universal Pawnbroker shop is on stage in Los Angeles, and is very much Jeebs' domain. "I was trying to create a certain immediate quality there," shares Bo Welch, "a juxtaposition of the 'weird goings-on' and having the characters be blasé about things that would drive normal people out of their minds." Doug Harlocker handled all the hidden weapons and their cases. "Everything that opened when the tables were turned, and revealed all the weapons… some of those were fully designed." And others, described Doug, were "kludged," as was often the case for the props department in that period, especially when it came to the guns. The goal was always to "make interesting shapes." And boy, did his team generate a lot of them.

ABOVE: Sonnenfeld portraying K's action for the scene (shootings Jeebs).

ABOVE: Snapshot of the Bug's crash landing on Earth.

BELOW: Storyboards show how the scene was planned out.

BELOW: Art department colored illustration reveals more detail.

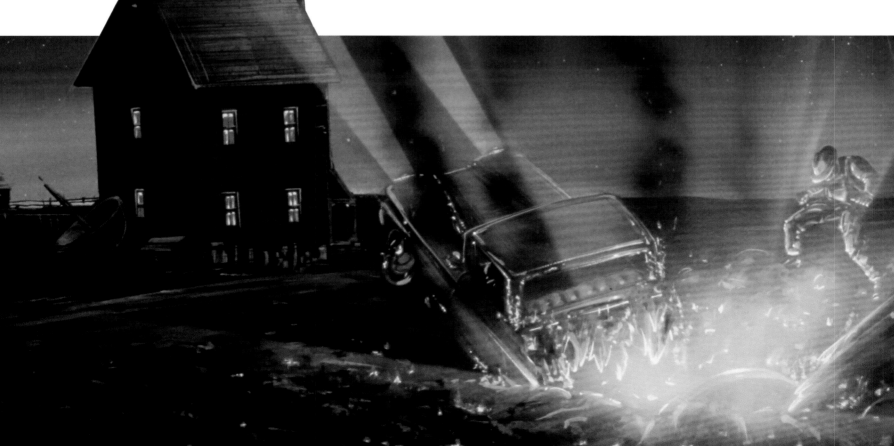

EDGARBUG

The alien that eagerly kills farmer Edgar Frump is from the Bugus Gigantus species. The Bug, now informally referred to as Edgarbug, hates being on Earth, but he's got a galaxy to steal and the latest intergalactic war to trigger. And he almost succeeds. But his need for vengeance runs deep in his five hearts. Agent J exploits this blind spot — and so, in the end he, Agent K, and Dr. Weaver take Edgarbug down.

Vincent D'Onofrio's performance was a challenge he embraced to the fullest. "If you want to talk about brilliant, impossible contributions to making the franchise work, is Vincent D'Onofrio as the Edgarbug," shares Walter Parkes. "What a performance that was. That's an actor's actor. Actors look at that performance and they just can't believe it. Because he is playing this physicality of this other thing inside of him, so fantastic. And he is so big, imposing, and sort of scary in a way... not violent, but there's this unsentimental quality about *Men in Black* at its best."

The script called for a giant, menacing alien, but what kind? Rick Baker gave Carlos Huante the weekend to come up with some initial ideas. He drew from real life for inspiration. "I was looking at a praying mantis and a vinegaroon (a giant scorpion)." An LA native, he'd visit relatives in Mexico and Texas as a kid. On one trip back into the U.S., "I was visiting cousins in El Paso. My one cousin and I were walking, and I saw this big thing sticking out of a crack. It was this giant bug's backside, which is essentially what Edgar is. I was so overwhelmed, and he goes, 'That's a vinegaroon, watch out!' and I'm like, 'What do you mean?' 'They stick vinegar at your eye. You've gotta watch out.' It was the coolest, most screwed up thing I'd ever seen." After presenting his initial sketches to Rick, they worked on some modifications. Once satisfied, Rick presented a finalized version to the filmmakers.

BELOW: Snapshot of one of Vincent D'Onofrio's many 6+ hour daily sessions with *Men in Black's* celebrated make-up artist, Rick Baker (left). Cinovation sculpts (right).

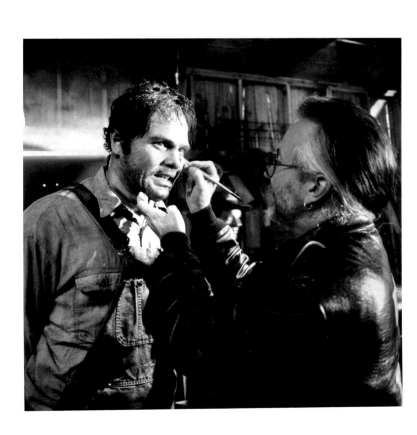

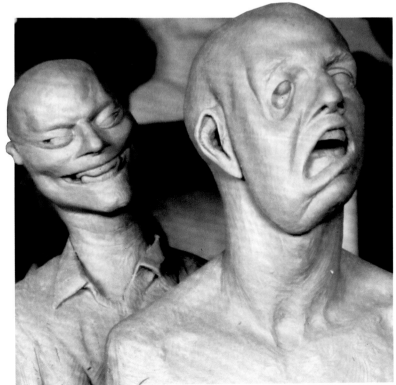

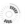

NEW YORK CITY MORGUE

Agent K's made more than a few visits to the New York County Morgue.

Designed by Bo Welch, it was built on stage at Sony. "It's a beautiful set," shares Cheryl Carasik. "And was fun as hell." Bo looked for ways to introduce subtle, alien-esque accents. "The one thing that I wanted to do, conceptually, is the tile work. In that morgue [is] a very carefully painted, graduated green. Like subway tiles. And... when applied, the wall has a slightly three-dimensional basket weave feel. I always looked at it as alien skin. So everything has a reason. That green, alien, scaly skin in combination with a lot of stainless steel — I just thought it would look beautiful."

Cheryl worked out the details. "The paint department is amazing. They made those shaded green tiles, which is actually Masonite. A lot of [what] we do is really enhanced by [them]... in feature films of this caliber, they are truly artists with what

they can do." And the walls oozed. She continues, "Tom Duffield [is a] great art director. He made sure that all the walls had slimy parts. [Some] parts were very pristine, but others had vats of liquid — maybe embalming fluid? The walls were all slimy [and] dripping." Set decorating built out every detail of multi-bodied, mortuary refrigerators that were fashioned after real-life. "Inside the main area, we designed real stainless steel fronts [with] trays inside to hold the bodies."

Both Bo and Barry gravitate toward green — and away from blue. "Neither of us are fans," shares Bo. "So a lotta blue is stripped out of these street scenes." A few shades are acceptable, but mostly, blue is out. Barry reasons, "If you put [it] in any frame your eye goes right to it. There's something about blue. It's the most sensitive layer on film stock." Place it in the background and "your eye would be there and not [on] Tommy and Will."

BELOW: Director Barry Sonnenfeld, Tommy Lee Jones, and Will Smith discussing the scene.

OPPOSITE: Actress Linda Fiorentino plays a medical examiner caught up in the lives — and deaths — of aliens.

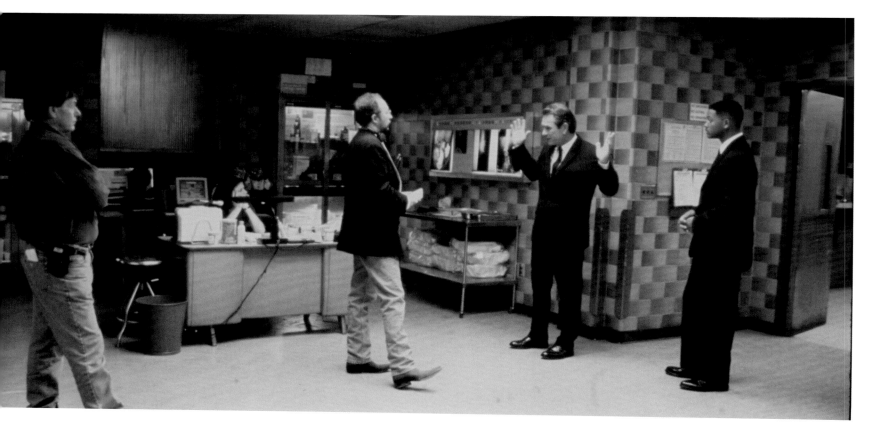

DR. LAUREL WEAVER

As deputy medical examiner for the New York County Morgue, Dr. Laurel Weaver saw her share of bodies, even many alien ones over the years. Not that she'd remember it. She had also crossed paths with Agent K frequently before meeting J, but each time was always her first encounter. Perhaps it's an innate curiosity and open-mindedness, or maybe she's just been zapped too many times by K, but she's not fazed by the seemingly new discovery of alien life. But then again, she does have this déjà vu kind of feeling, like she's seen this all before.

Her skills with a Men in Black gun prove her worth in K's eyes. And J's. J recruits her as his new partner, but she only lasts a few years. Turns out, she prefers the company of the dead.

"Her slightly off-beat quality was important" shares Walter Parkes. Invited to work on *Men in Black* shortly after winning the New York Film Critics' Circle Award for Best Actress (*The Last Seduction*), Linda Fiorentino brings depth and energy to this character. And she did all her Edgarbug stunts herself!

BELOW: Even with a gun to her head, Dr. Weaver keeps her cool.

REPORT: AGENT K

DATE: JULY 25, 1997

RE: LOCAL MORGUE, ALIEN BODY TRANSFER

Visit #9 to New York County Morgue since January. Surprising number of alien residents wind up at this location. As a quiet transfer location for the newly dead, this particular morgue works well. It's got two separate entrances, including a relatively inactive alley (easy access for truck back up) and only two full-time staff. The front office admin spends most of his time in the back room with headphones on and misses most of the action. The doctor is not the panicky type – clean up and removal continues to go smoothly, without incident.

SIGNED, AGENT K, MIB NEW YORK

cc: Chief Z, Men in Black Headquarters Mortuary

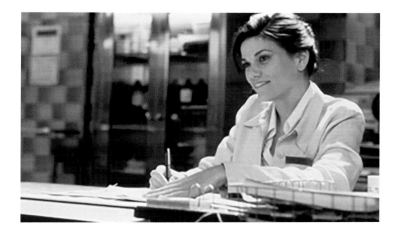

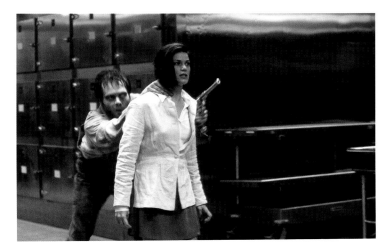

GENTLE ROSENBURG

"To prevent war, the galaxy is on Orion's belt."

The Arquillian Prince, aka 'Mr. Gentle' or 'Rosenburg' (so-named after scriptwriter Ed Solomon's cousin), was a genteel and innocuous cat-loving gem merchant living far from his troubled home. Sent to Earth decades ago to safeguard his species' most precious resource, the Third Galaxy, Mr. Gentle had done his job well and kept a low, Brooklyn-based profile.

Sadly for Arquillians, Edgarbug tracked his movement and, while the Prince dined on pierogi (a favored Leshko's dish of Sonnenfeld's while an NYU film student), the Bug killed both Mr. Gentle's host body and that of his agent. The Prince expired hours later.

True to the spirit of *Men in Black*, this little green man was not a Martian come to destroy us, but a loyal subject of the Arquillian Empire who had taken refuge on our planet. In the year surrounding first contact, the rising threat of nuclear war fueled nightmares of diminutive aliens with oversized brains and outsized technologies who have come to eat, abduct, kill, or transform us.

More Yoda-like than *Mars Attacks!*, Mr. Gentle offered up a benevolent reinterpretation of the horrors depicted in 1960s sci-fi. This animated puppet and its robot head was beloved by cast, crew, and fans. Today, a limited edition life-size reproduction of Rosenburg sells for thousands of dollars. As of this writing, the New York stage actor Michael Nussbaum, at age 94, continues to do live theatre in Chicago, including a recent portrayal of Albert Einstein.

ORION'S BELT

"When are you going to learn that size doesn't matter?" scolds Frank to Agent K. Size indeed – the marblesque Third Galaxy is *literally* a galaxy, as well as "the best source for subatomic energy in the universe," according to the pug.

"Orion's Belt was a crazy piece of luck," shares prop master Doug Harlocker. "I was in Marin [County] looking at a particular jeweler's work. [Heidi Nahser Fink] was making these spheres inside spheres and I thought, 'Wow, that's really interesting.' In the end, I took [the piece] back and pitched it to Barry and Bo. She made the original Orion's Belt charm, as well as the oversized version shot in post. Heidi is a fabulous jeweler." A trained goldsmith, Nahser Fink went on to craft story centerpieces for *Men in Black II* and *Men in Black 3*, and continues to develop commissions for Harlocker as well as other filmmakers (*Wonder Woman, Ocean's 12*).

RIGHT: Commissioned by Harlocker, this charm contains a marble-sized galaxy.

ALIEN AUTOPSY

It lasts less than ninety seconds, but is one of the most pivotal and emotional scenes of *Men in Black.* "It's one of those cases where an incredible amount of work goes into a few seconds of screen time," notes Rick Baker. "Hopefully a really good few seconds." The making of Mr. Gentle (known affectionately as "Chuckie" to cast and crew) and the shooting of the scene involved teams of people and months of preparation and collaborative creative development. "This scene was ambitious," describes Mark Setrakian, then Cinovation's lead mechanical designer, "and pulling it off required a lot of planning… and a team effort between Cinovation and the ILM model shop."

Rick Baker and his team at Cinovation invented and physically crafted both sizes of the Mr. Gentle puppet, as well as a life-size silicone reproduction of actor Mike Nussbaum's head and upper body. Cinovation also spearheaded the concept for the robot interior; ILM executed the final designs for both sets of interior gearing required, one three inches tall, the other twelve feet (for close ups). It was shot twice – first at the morgue and later at ILM. Eric Brevig and his team assisted in melding together the final shot. Even today, nearly two decades later, Mr. Gentle remains a marvel. *"Men in Black* was the creative convergence of artists and filmmakers at the peak of their powers," offers Mark Setrakian, who led the team when they went up to ILM. "[Mark] did all the mechanics on the puppet," shared ILM model maker Howie Weed, "and he was also the voice."

ABOVE: Inspired by a Model A Ford with brake and gear changing handles.

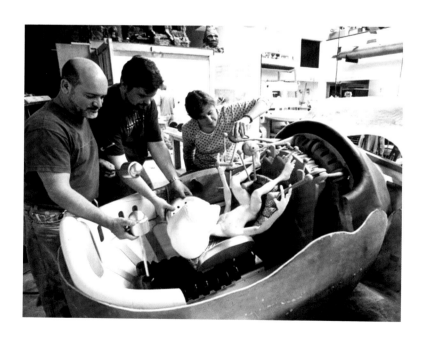

ABOVE: ILM's Mark Siegel, Howie Weed, and Carol Bauman.

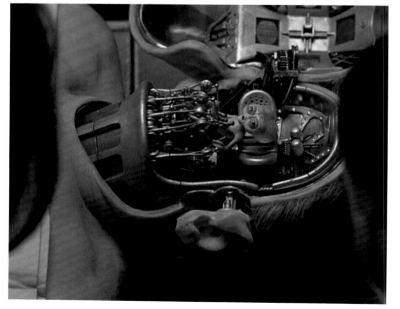

ABOVE: The head required molds, sculpting, airbrushing, and hair implantation.

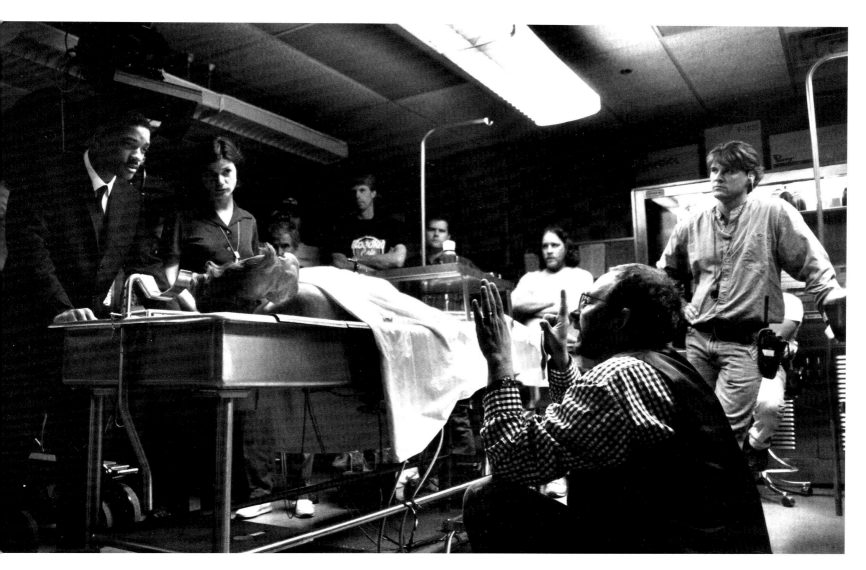

ABOVE: Director Barry Sonnenfeld framing the shot while Will Smith, Linda Fiorentino, Howie Weed, Mark Setrakian (lead puppeteer, voice), John Lundberg, and others look on.

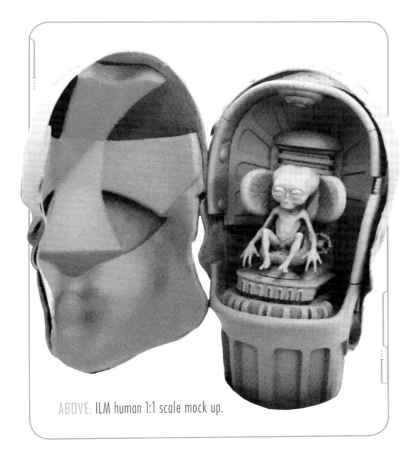

ABOVE: ILM human 1:1 scale mock up.

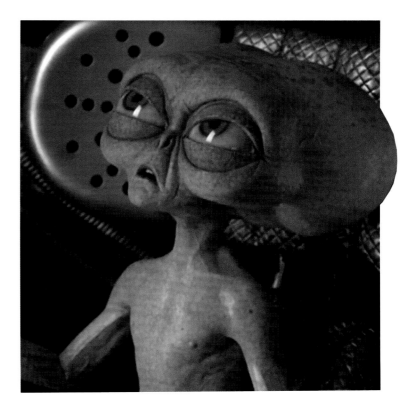

ABOVE: Cinovation puppet and seat inside the ILM head.

EDGARBUG'S REVEAL
THE AGGRESSIVE, SPACE-FARING INSECTOID

At the end of the film, the Bug pulls Edgar's skin wrap away, finally revealing his true self, an imposing, four-legged, fifteen-foot tall alien. "It starts as a real shot," explains Barry Sonnenfeld, "and then, as his face peels off and we see what's behind, it becomes CG." Edgarbug was ready to ditch that skin sack anyway – it was nearly rotted away at that point, thanks to the amazing make up effects work of Rick Baker, who had been slowly accelerating the decay of Edgar's skin over the course of the film. The sequence combined Cinovation's make up and ILM's digital effects, explained Eric Brevig, ILM's visual effect supervisor.

Eric Brevig and his team tackled how to translate the script requirements into something believable for the audience. Carlos Huante developed this Bug reveal out of farmer Edgar's skin. Like many creature illustrators, he looked to nature for inspiration, and brought his buddy Jim Oxford to Cinovation to assist in the sketch work. "We were looking at mosquitoes giving birth," explains Carlos. "The way that they actually transition from larvae… [and] push their way out into becoming a mosquito is so *screwed* up, because they come from this weird little thing and it turns into a *big* thing. So we said, 'Well, there it is. Let's just do *that*.'" When in doubt, follow nature. "There's nothing we can do that's more crazy than that. *Nothing*." Eric chose to shoot this in Sonnenfeldian tight close ups and reaction shots to enhance the implication that Edgar was unfolding – like an insect emerging from its egg sac.

THIS PAGE: Pencil sketches of Edgarbug by Benton Jew.

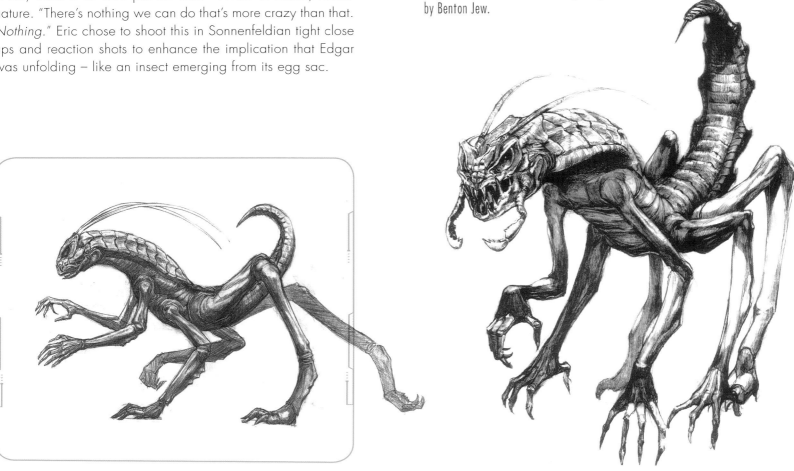

ABOVE: Eric Brevig shot the crash using high-speed miniature photography.

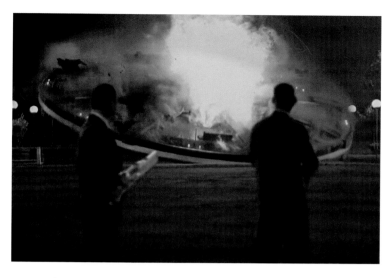

ABOVE: Shot on stage at ILM and built in miniature, including the dug-up lawn.

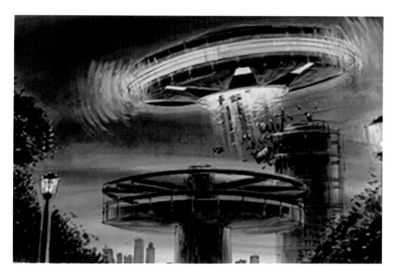

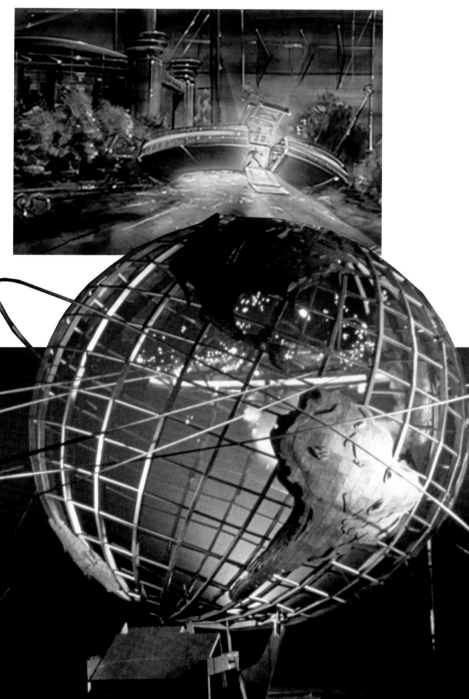

BELOW: The spaceship was mounted on a four-inch aluminum post and operated by a cart driver. Rigged to explode, the nine-foot-long saucer was guided into the unisphere via cables.

EDGARBUG'S FINAL SCENES

Edgarbug was always going to die. But *how* he died was up for grabs in the final weeks of production.

From the first drafts and in the years that followed, the ending had been an ongoing conversation. "I wanted a more philosophical, clever, science fiction ending," says Ed Solomon." Whereas Walter Parkes' instincts were more action-oriented. Ed recalls Walter saying: "'No, I think the ending really wants to be Agents J and K, with a gun, blasting the shit out of an alien.' And so that dialectic is what led to the ending as we had it."

Barry Sonnenfeld had always wanted a little more adventure in their sci-fi action adventure film. "Until the very end, the movie was Will Smith talking to Edgarbug about the nature of humanity and the universe. There was no action," says Barry. It was a humorous, existential dialogue. "I kept feeling... you don't want the ending to your movie being a debate between a bug and Will Smith." In looking back, Walter admits that, although overall he thought the film was going well, "The dailies were good, the story was sharp... I was worried about the ending, which we sort of did on the fly."

About a week before they were going to shoot the Flushing Meadows Edgarbug finale up at ILM, everybody began to huddle. "[It was] the weekend and we were supposed to shoot the next week," shares Walter. "Barry, me, Laurie, and TV writer Keith Sutton were walking around the set, the Sunday before the Tuesday we're supposed to shoot, saying, 'Well, what are we gonna do?!'"

Suggestions were being kicked around, and Walter pulled in Spielberg to help figure this out. "Listen. Even now, Steven's the best 'What do you think?' call," he professes. Two ideas came out of those hurried brainstorm sessions, both involving a lot of action, both including J taunting

THIS PAGE: Sonnenfeld and D'Onofrio (as Edgarbug). Saucer crash scene on stage at ILM.

OPPOSITE: Rick Baker positioning the original Edgarbug animatronic on set at ILM.

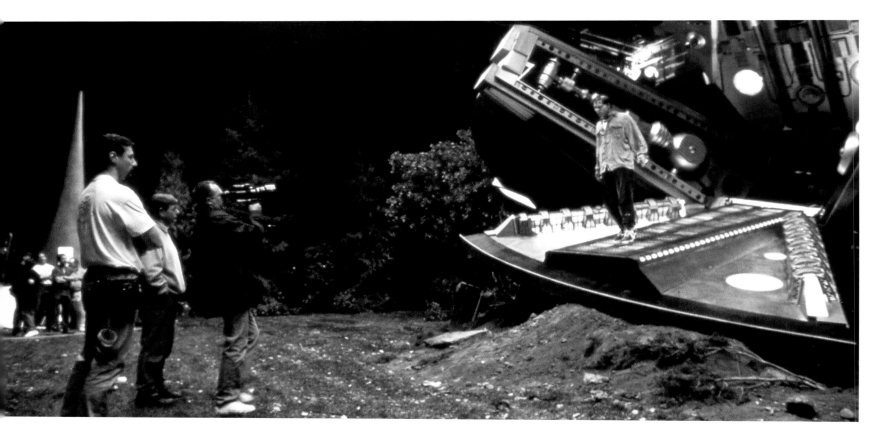

or tempting Edgarbug in some way. The first was J bursting a Coke machine – out spews Coke syrup, aka sugar water, which we know the Bug craves. The second Spielberg was enthusiastic about. "If I remember correctly," recollects Walter, "Steven pitched the idea of Will crushing a cockroach to get Edgarbug's attention. It's amazing how that works, but it's quite true." So Spielberg, Walter, Laurie, and Barry settled on the version the world now knows, which is J squashing Edgar's kin. Next, the question was how to shoot it.

Many months prior, Rick Baker had begun creating what the script required – an elaborate creature that would stand and speak. But now Edgarbug would not be delivering an expository wrap-up. He's going to try to kick some ass. The plan had always been to blend animatronics with ILM-created digital effects for this scene – as had been done with Mikey (when he ran), the worms (when they walked), and Frank the pug (when he talked). But now the scene was going to be all action.

"Well, the truth is Rick had created this extraordinarily fantastic, brilliantly designed, fifteen-foot-tall Edgarbug, based on the script at that time," says Barry. "Once the script changed (a week before we finished the end of the movie), his Bug couldn't do what the script needed it to do." Rick Baker and his team labored for many months to create two versions capable of all kinds of wonderful movement. But the new demands required even more physicality. Now Edgarbug needed to climb the tower, deliver a school-yard roundhouse punch, hiss with a horrifying, pincery, toothy, beady-eyed threat display, appear large enough to swallow Tommy Lee Jones whole, and be possessed of a huge belly which would later explode.

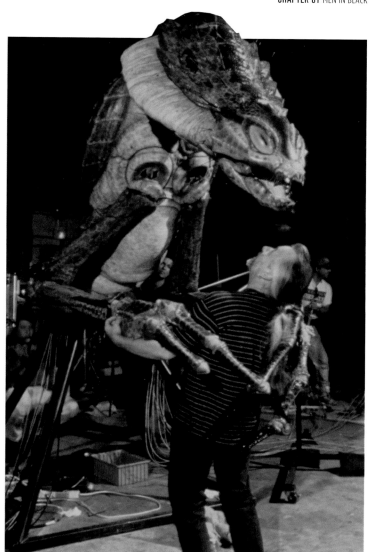

INVOKING THE ENCYCLICAL

Everyone knows Will likes to do his own stunts – and he does elect to step up for the big Edgarbug roundhouse kick into the metal garbage bin, but it's a bit of a tricky stunt and he could get hurt. So he makes a deal with his new pal, Barry, the director. Will and his assistant, Ernest 'Tron' Anderson, wander over to Barry's camper on a break, and say, "We're going to have to invoke the 'Michael Bay encyclical.' I'll do this stunt, but Tron is going to stand next to you. And however badly I get hurt, that's how badly you're going to get hurt." Barry agrees, and during the shot Tron's standing nearby, casually holding a baseball bat. So Will gets yanked across the stage, "And as soon I yell, 'Cut!' and then yell, 'Will! How am I?' and Will yells, "You're fine." And I said, "Tron. I'm fine," and Tron walks away and I don't get beaten up."

RIGHT: Director Barry Sonnenfeld capturing Will Smith in close up.

"YOU'RE MESSING WITH THE WRONG SPECIES, BUG!"

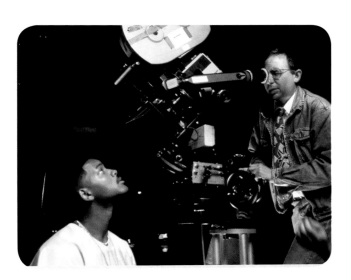

The new actions were incompatible with the creature's mechanical capabilities but, also, the change in tone didn't quite match Rick's Bug. "In fact," shares Barry, "the story changed enough that we actually changed the look of the Edgarbug creature… in the end, it was all a computer graphics character." Walter recalls Barry's explanation from a DP point of view: "The physical Edgarbug was on a hinge, so given the new movements required… it would be really scary [close up] but if it reared back, it had this weird little pinhead. It didn't work. It was sort of a tipping point in the movie business," continues Walter, "[and] the end of big animatronics." Rick and his team were naturally surprised, but ultimately expressed an understanding that the filmmaker made the correct decision for the film.

Eric Brevig reflects, "Rick's most elaborate and complicated prosthetic animatronic, Edgarbug, was, sadly, for reasons that are not Rick's fault, deemed not suitable. After a brief premiere on set it was retired. But the main work is designing and all of that still comes through. And everything else that he created worked spectacularly. I just consider it an unfortunate series

of events that conspired to make one physical character not right for that scene, but it doesn't diminish his contribution in any way."

Rick's final insectoid creature featured a cobra-like hood. Given Edgarbug's newly enhanced sympathies for cockroaches, they needed him to look even more, well, cockroachy. ILM began their work in earnest – visual effects art director David Nakabayashi and digital model supervisor Geoff Campbell supervised the process, working with Spielberg and Barry to create the necessary modifications for the fully CG character seen in the final film. For Edgarbug's new look, Spielberg suggested turning to an episode from *The Outer Limits* for inspiration. ILM illustrator Benton Jew (credited with the body redesign) shares this anecdote. "'We need it to look weirder,' said Spielberg. 'You know, weird like the Zanti Misfits,' [which] is a very famous episode from *The Outer Limits*. It had these cockroach-looking bugs that had these weird, smiling faces on their back." Several million dollars and forty-five CG shots later, Sony had a raucous ending to their movie. "We're so lucky we did it, because it came together," reflects Barry.

THIS PAGE: "Still encased in flesh, his giant pincers RIP free of the rotting skin." – Script excerpt

NEXT PAGE: Agent J and actual cockroaches (yes, they were real), who all came (and went) with their bug wrangler from the ILM set that day.

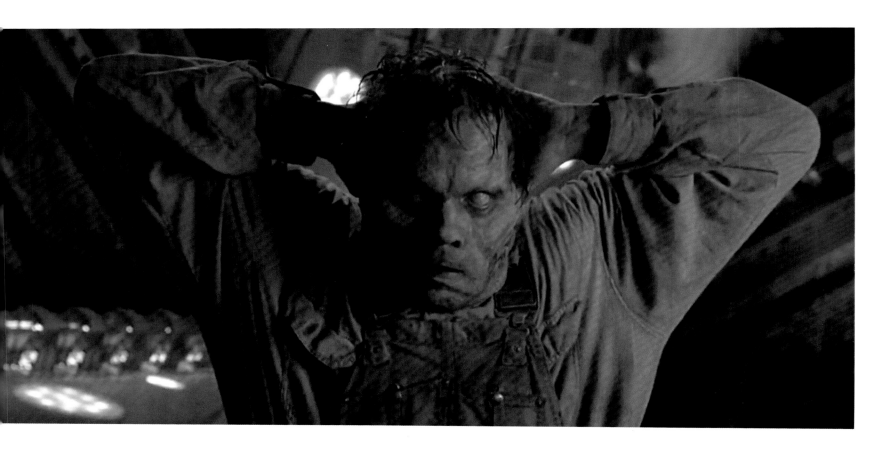

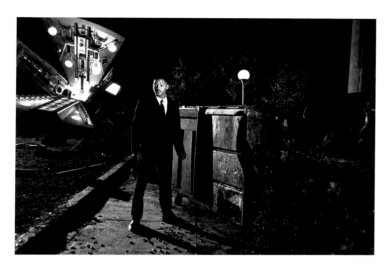

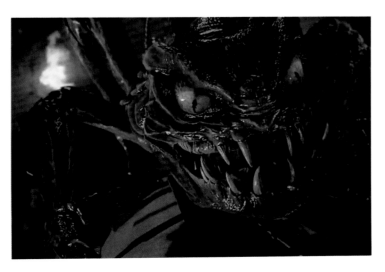

TWO BECOMES ONE

Test audiences showed that the subplot was a bit tricky to follow as well. "There was a much bigger story in the original script," explains Walter. "The weapon was something the two different groups wanted." And the Bug's original purpose on Earth was to keep the Baltians and Arquillians at war – allowing its kind to continue feeding on its carnage. The Bug's new scheme became: steal the galaxy, consume the Arquillian empire. "In the original movie, both the warring factions send their spaceships to shoot at each other with Earth in the middle." "It was a very *Men in Black* idea," shares Walter. "[But] it was too complicated and unnecessary. The stories just have to be clear, and give you great scenes." John Calley, the newly installed chairman of Sony Pictures felt similarly. It fell to Barry to execute and, while at that first screening, he assured Calley, "A piece of cake. We can do it." He knew what others assumed might be impossible, that simplifying the subplot on this film was within reach. Change a few words on screen (easy), revise a subtitle (easy), one of Rip Torn's lines (simple), a new voice over with Frank the pug, and Bob's your uncle. Audience responses went up, and it was all done in post. "So my suggestion," jokes Barry, "is always have a talking pug dog somewhere in your movie in case you need to change the plot in post."

BELOW: Agent K shaking down his informant, literally.

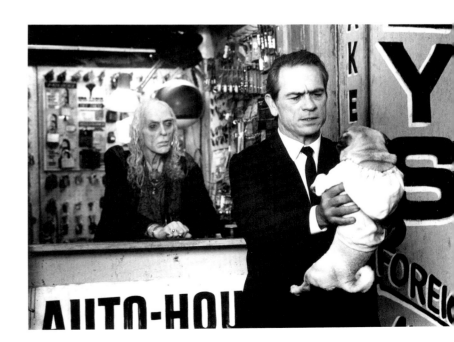

MIB"

MEN IN BLACK II

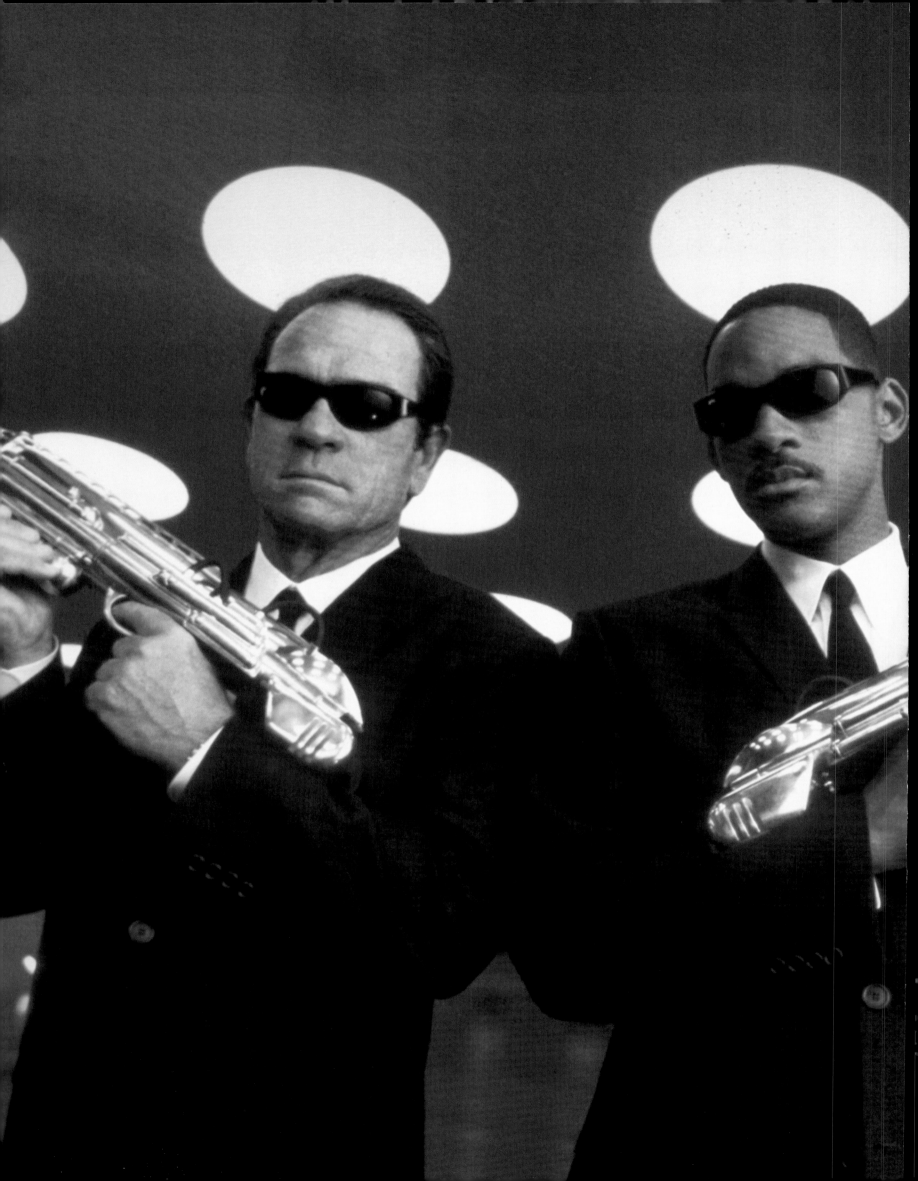

INTRODUCTION

DÉJÀ VU

Men in Black was a phenomenal success for producers Walter Parkes and Laurie MacDonald, Steven Spielberg, Sony Pictures, and all the key creatives central to the first film. Will Smith continued to evolve as one of the most beloved film stars of our time. Nearly everyone was enthusiastic about returning for a second (and all later did) – the question in those intervening years was: what's the story? "For me, it all comes down to, is there an idea… a good idea?" states Walter.

While the inspiration was there, many of the film's creators were also pretty busy developing new projects – and, for Walter and Laurie, that included running DreamWorks SKG as co-heads of production. During and in between the first two Men in Black movies, they produced a string of commercially explosive feature films, many critically acclaimed, including The Peacemaker, Deep Impact, The Mask of Zorro, Gladiator, Catch me if You Can, Minority Report, and A.I. Artificial Intelligence. Meanwhile, Barry Sonnenfeld had struck a three-year deal with Disney in partnership with Barry Josephson (who had been president of production at Columbia Pictures for Men in Black as well as In the Line of Fire, Bad Boys, and The Fifth Element), and together they developed Wild Wild West for Warner Bros. featuring Will Smith. Will, separately, also starred in Enemy of the State and the biopic Ali.

Josephson, Sonnenfeld, and Smith expressed interest in taking first crack at developing the Men in Black II story, and the studio obliged. Some time passed. Walter and Laurie later initiated a conversation with Amy Pascal, then chair of Columbia Pictures, suggesting they had an idea for where to take Men in Black next. The inspiration began with a preexisting script of Walter's, with a premise they thought might translate well to the world of Men in Black. "The second one was based on a whole other script I had written once… about a woman who wants to find out who her parents are," shares Walter. "And [discovers] that she's actually an alien who was left to be protected. Just like Men in Black II. It was a serious science fiction thing that Larry Lassiter and I wrote, and we had Sony buy it. We retooled it to be Men in Black II." The central twist to this concept was making this alien J's star-crossed love interest.

The job of a producer, if successful, is to quietly create a vehicle through which other talents can shine. Like a driveshaft, the film industry functions atop this dynamic. But Walter and Laurie are not 'simply' studio executives and producers, they're also storytellers and are deeply involved in this aspect of the films they're engaged with. "Our thing," shares Parkes, "is, 'OK, looking at the next one, what's the movie? What's it about?' Figure it out." Like many Parkes and MacDonald projects – and as is their preference generally – they developed the storylines for all four *Men in Black* films independently, prior to the studios, directors, or actors getting involved. And so, as they had done with *Men in Black*, so they did with *Men in Black II*. They suggested to Amy, "Let us just hire [someone]." Bob Gordon had enjoyed success on *Galaxy Quest* with Walter, and was his top choice. "I had just worked with Bob," reflects Walter, "and so Laurie, Bob, and I went off, and wrote the script." Like most seasoned film developers understand, the story must come first – before financing, before studio commitment, signing on talent, etc. Because without it, "it's very difficult to get things moving," shares Laurie.

It's exciting to speak about projects in the abstract, especially a sequel to a film as madly successful as *Men in Black* had been. The frenzy of future success can get agents spinning, and projections can quickly escalate. But until there's a hard-earned, 120-page script on the table, one that makes everyone sit up straight and get excited, it can all be a bit of funny money – and outsized numbers can kill a project before it ever gets off the ground. "On these sequels, everyone wants so much money," bemoans Walter. "But when there's a script everyone wants to make, people get really reasonable."

What came baked in from the end of *Men in Black*, setting up the possibility of *Men in Black II*, was K's comeback. "[It's] a ready-made story. The teacher becomes the student," shares Walter. Two key additional plot points were sorted out early on. One was the final secret of the Light of Zartha, and the other was the cold, hard fact Agent J was facing – as meaningful as his work may be, he didn't foresee the never-ending feelings of isolation this job can bring, and his resolve is beginning to crack.

"One of the things I really like about the movie," Barry Sonnenfeld noted, "is that

BELOW: Rooftop finale, shot on stage at Sony.

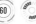

not only are these guys heroes, not only do they save the world, but no one can ever thank them for it. They can't. They don't exist. And that's lonely." These costs to being a Man in Black are what this film explores. Ultimately, Laurie and Walter would spend a year working with Bob on the first draft. "Those meetings were so much fun, trying to figure out where to go," he added. And so this was circulated to Will, Barry, Tommy Lee Jones, and other key members of the creative team. After a few discussions, the 'yeses' began to roll in. The A-team began to reassemble.

Prop master Doug Harlocker expresses the sentiments of many in saying, "that was when the real fun began. We knew what the style of the movie was; we could expand on the styles that we had developed before, and we're in New York, where we wanted to be." The momentous follow up to Men in Black delivered on many of the qualities fans expected from the franchise. Fantastical creatures by Rick Baker, J and K reunited in another challenge to spare the planet from annihilation, but also the signature Sonnenfeld style – the sense of down-home realism amidst the fantastical and a surprising number of special effects. In fact, the budget was close to $100

million, and featured around six hundred – a healthy number of effects for 2002.

But, "this movie is not about visual effects," offers ILM supervisor John Berton. Meaning audiences are not going to see the film for that as they would at that time for, say, a Batman film. "They were going to see something much larger [in] scope, and something much more sophisticated," continued John. The tightly woven blend of drama, sci-fi, and comedy is uniquely Men in Black, and it comes down to tone. All of which is painstakingly crafted by Barry. "Men in Black is quite literally perfectly directed," shares Walter. "I do not think there is one choice that Barry made that was not right. It's stylish, it's unique… you can see the years with the Coen brothers, the whole thing." And in the wake of the first film's success, Barry did not lose an iota of focus on what he knew made it work. "I've always felt that the Men in Black movies were small movies pretending to be big movies. They never succeeded on the action or the scope or scale (which is why I don't compare these to the Marvel movies). I think that the most important part to [them]… is relationships, buddies, emotion, and comedy." And so what makes people go to these movies, really? For Barry, "Will and Tommy."

ABOVE: Agents J and K ready to kick some ass, Men in Black-style.

JEFF THE WORM

> **"WILL SOMEBODY PLEASE CHECK THE EXPIRATION DATE ON THE UNIPOD WORM TRANQUILIZERS?!"**

Jeffrey, a Krydillyon (aka Hyper) Worm, was orphaned while still just a little one-inch wormlet. He emigrated to Earth in 1986. Z and the Men in Black adopted him, in their way, giving him sanctuary among the garbage and rats of the New York City subway system. They had an idea how big he might get — theoretically. Hyper Worms live long lives and, with sufficient food, keep getting bigger, and bigger, and endlessly bigger. He's a bit rebellious, but mostly loyal and accommodating to the only caretakers he's ever really known. (He may be a gruff, wayward Hyper Worm, but he's *their* Hyper Worm.) When J asks, Jeff answers the call, sacrificing himself to help bring down Serleena, who speedily devours him from the inside out.

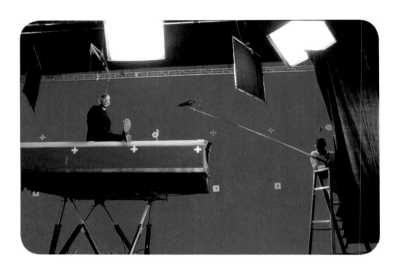

BELOW: Concept sketch by Randy Gaul, ILM (2001).

ABOVE: Will Smith enjoying a moment on set while filming the Jeff scene.

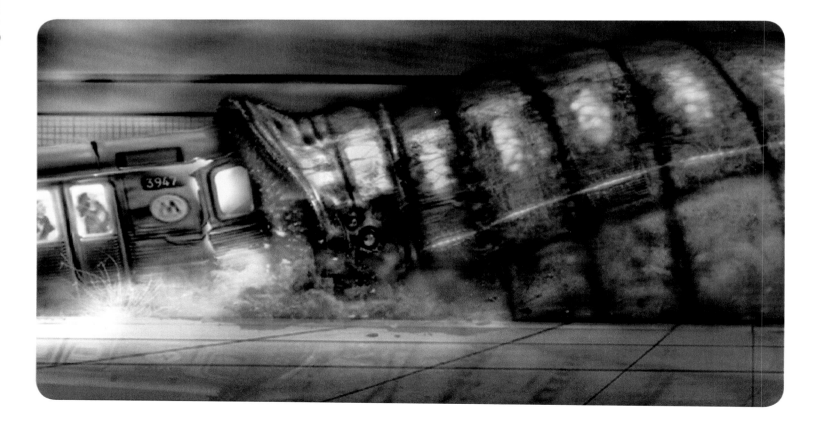

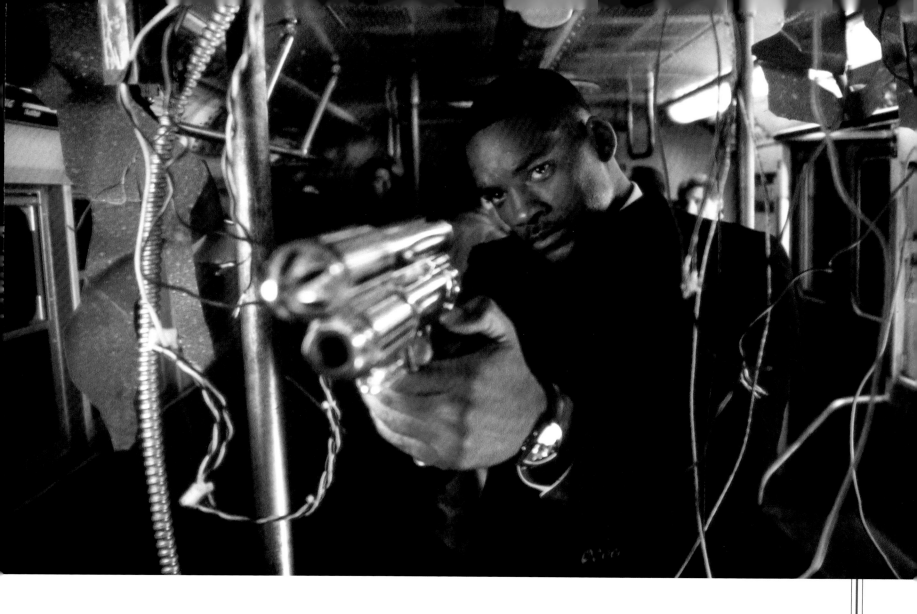

BELOW: Concept sketch of worm tranquilizer. Design by Tim Flattery.

The entire Jeff the Worm sequence is the high-speed, explosive opening of *Men in Black II*. It required a full suite of special effects, but began with creature design. Early Jeff concepts were developed by alien make up artist Rick Baker, with illustrations and maquettes portraying a sea-monster-like character. It was then passed to ILM's creature group. Originally set to return for *Men in Black II*, Eric Brevig had begun pre-production on Michael Bay's *Pearl Harbor*, so visual effects art director David Nakabayashi – "a lovely guy," shares Barry Sonnenfeld – stepped into his shoes. In picking up the design torch, David and his team tackled the opening mouth, the internally lit side angle, dimensional bioluminescence, movement, and the subway crunching chase sequences. Barry's main directive: "Don't make him look like a roll of Necco wafers."

Rick led the kick-off with a very ironic, very *Men in Black* design feature, reminding us that "all is not what it seems." Inspired by real-world anglerfish, his Jeffrey sported a kind of delicate, Venus flytrap topknot. "Jeff has a beautiful flower that grows out of his head. It's like an anglerfish that would attract other fish and then he eats them," says Rick Baker. The design is orchid-like, with a working beak. The team made a puppet version for the opening scene on the streets of New York. It was a brief sequence, but the intention was to set up the sense of ever-present, ferocious threats surrounding our world at all times.

ABOVE: "Don't do it Jeffrey. It's not worth it."

BEN

"FOR TWENTY-FIVE YEARS I'VE TRAVELED THE UNIVERSE LOOKING FOR IT, BUT IT NEVER LEFT EARTH, DID IT BEN?"

Ben had been serving up Sicilian pizzas, calzones, and zeppoles for over two decades, never appearing as anything other than a local pizza shop owner. He even liked the Yankees. His real identity? A Zarthan agent and warrior, chosen to watch over Laura, the Light of Zartha, from the time she first landed on Earth. He was the only family Laura ever knew, although everything she had understood about him — and herself — was a lie.

Working alongside Agent K to arrange Laura's 'hiding in plain sight' life, Ben agreed to help K hide clues to her true purpose inside the pizza shop. Always in his pro-plasma polymer skin sack, he watched over Laura as well as the clues K had planted on the wall. (He never knew when K might come back for them.) The loyal agent died protecting these secrets when he refused to give Serleena the location of the Light of Zartha. After his death scene rain began to fall as tears of mourning ran down Laura's cheeks, giving the viewer an early hint of her true role as the Light of Zartha.

THIS SPREAD: Agent J quickly finding the clue he left behind. (The key to locker C-18, and Sonnenfeld's nod to his previous film, *Get Shorty*.)

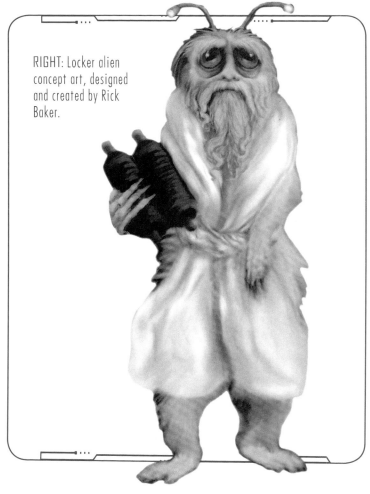

RIGHT: Locker alien concept art, designed and created by Rick Baker.

LOCKERTOWN

The creation of Lockertown "was a group effort," remarks Doug Harlocker. As we've seen throughout the franchise, "I was always looking for ways to play with scale," recounts Barry Sonnenfeld. Aside from the *Power of Ten* scene at the end of *Men in Black* (itself inspired by the 1977 Robert and Eames short film of the same name), this might be the next best example of that conceit in action. "I love these guys," he continues. "They're cute and adorable but they all sound like they are from New Jersey." Their town is made up of scavenged bits collected off the floor in Grand Central Station. They're part packrat, part rodent, but still appealing, with big, meerkat-like eyes, and antennae to accentuate their oddness. "Their whole village is made out of trash," shares Rick Baker, who designed all the creatures. And for the uber-fans out there, watch the Lockertown scene again to see if you can spot the continuity mistake.

RIGHT: Production photo of Lockertown. Sequence by Sony Imageworks.

> **"WHY YOU PUT THEM RATS IN MY LOCKER, MAN?"**
>
> AGENT J

LAURA VASQUEZ

> " IT RAINS BECAUSE YOU'RE SAD, BABY"
>
> AGENT K

Lauranna gave birth to the Light of Zartha (aka Laura Vasquez) in 1976, the year the Zarthan-Kylothian War began. The Zarthans started to worship the baby girl as their savior. Serleena, an endlessly patient Kylothian assassin, would not rest until the Light of Zartha was eliminated. Laura (played by Rosario Dawson) knows none of this – her spectacular destiny is a well-guarded secret, held only by Ben.

Within hours of losing him, the only family she had ever known, she meets Agent J. This sets up the *Casablanca* aspect of our story, although Laura's 'love' interest is an off-Earth destiny she cannot deny. One of the many challenges for the storytellers in *Men in Black II* was how much to play Will Smith in his comedy role (or as the straight man when Tommy Lee Jones is absent), and how much to embrace the tragic romantic connection between Will and Rosario Dawson. *Men in Black* succeeds as a hybrid of drama, action, and comedy.

No small task, even in the hands of filmmakers at the top of their craft, which the *Men in Black* franchise has always enjoyed. With *Men in Black II*, producer Walter Parkes continued to discover that "I can be very, very specific about the tonal requirements of *Men in Black.*" Meaning to succeed, the right balance needs to be found. In fundamental ways, these genres can pull and push against one another with centripetal force. But when they come into alignment? Magic.

Barry Sonnenfeld shot the J and Laura 'getting-to-know-you' diner scene at the real-world Empire Diner on West 23rd St. – with a spaceship (created by production designer Bo Welch) dipped into its roof. This old-style landmark was also used for the opening montage of Woody Allen's *Manhattan*. In an equally tragic non-romance, Rosario paired up with Will again several years later in *Seven Pounds*.

THIS PAGE: Laura playing twister with some very leggy worms.

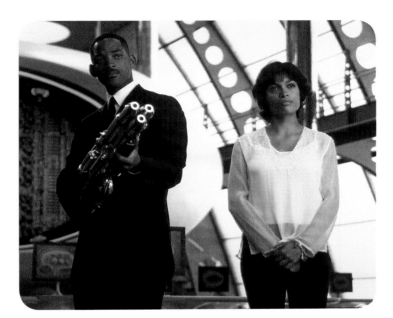

ABOVE: J and Laura, soon to be separated by fate.

REPORT: AGENT K

RE: LAURA VASQUEZ

SPECIES: ZARTHAN

STATUS: RESIDENT ALIEN (UNKNOWN TO SELF)

CIVILIAN PRIVILEGES: RETURNED TO HOME PLANET

SPECIAL NOTES: KEEPER OF THE LIGHT, SAVIOR OF HER PEOPLE

DATE: JULY 4, 2002

CLOSING REMARKS/RECOMMENDATIONS:

Undercover Zarthan Agent Ben was sliced in half by Serleena. Must provide Zarthan Ambassador with his remains. In the wake of our headquarters breach, suggest executive team begin a post mortem analysis of all our security protocols. Weaknesses need to be identified and weeded out.

Request weekly updates on Zarthan-Kylothian War. Arrange a half-day summit with all local, current resident, and temporary-visa'd Kylothian and Zarthan refugees. Chief Z, J, and myself will be in attendance.

Send new agent to Grand Central Station, Locker C-18. Have the Locker people moved to J's locker in headquarters. Be sure to do this quietly, without J being alerted to this activity.

Statue of Liberty Torch needs to be recharged.

SIGNED, AGENT K, MIB NEW YORK

cc: Chief Z; Security Division Chief, NY; Zarthan Ambassador, Kylothian Ambassador

KEVIN BROWN

Agent K hadn't been Kevin Brown since March 2, 1961. It wasn't until J neuralyzed him, over thirty-five years later, that he suddenly found himself, well, being himself again. But only sort of. Fortune was on his side when he returned to Truro to re-woo his lost love, but there were certain core aspirations of this world-weary man that remained intact. A fear of being misled or misinformed, a need to know the truth of things – from the stars to the mundane. The need to run things by-the-book and be on top of his domain, even if that was merely a properly and orderly wrapped postal package.

For his part, K was pretty happy with the idea of losing memories of his scum-chasing past, and gracefully disappearing into retirement. But K was too high value for the Men in Black to cut loose on. (He'd arrested and killed quite a lot of the universe's most notorious criminals. Like, A LOT a lot.) They surrounded him with undercover alien coworkers, to ensure he stayed safe – and to be there should any foiled foes come seeking revenge. In the end, Kevin's well-laid plan backfired. Despite neuralyzation, all those life experiences were seeped into his bones in a way no technology could erase. His sense of disquiet, that the world was off, that the stars held deeper meanings within them, invaded every aspect of Kevin's new life. His wife had left him. And then, one day, an old pal walked through the door.

BELOW: All packages must be properly wrapped.

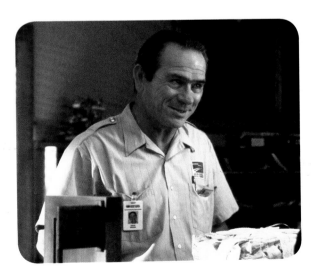

POST OFFICE

Kevin's post office is shot in two locations. The Fire Island Lighthouse serves as a stand-in for the Truro, Massachusetts Post Office. "It was supposed to be in Montauk," shares set decorator Cheryl Carasik, but "there was no post office there. [The lighthouse] was just a building that we used for the exterior; the interior we did all on stage."

The interiors of course included the mailroom, continues Cheryl, "then all the back area where they find aliens sorting all the mail. It was a really fun set to dress. In fact, I don't think there was a set, except maybe one, or two, that I didn't totally enjoy. I mean, some of them are really hard. But you're just in the groove. I think we even labeled the mail 'Montauk,' in case Barry picked something up. I wanted him to feel like he was really there. We would fill out those kinds of details."

The young, Rugrat stamp-loving girl bellied up to the desk is none other than Barry's daughter Chloe Elizabeth Ringo Sonnenfeld, who can make the distinguishing claim of being in all of her dad's *Men in Black* films (and a few others). "Aside from Tommy Lee Jones and Will Smith, she is one of a few actors who has worked on all of the first three movies," proclaims the proud father. (In *Men in Black 3*, she was the Coney Island hippie girl.)

Barry did, however, have a belated moment of terror related to that day's shoot. He suddenly thought, "Oh Jesus, I just put Chloe in a scene acting with Tommy Lee Jones and Will Smith. Am I an idiot?!" So what was his worry? "I forgot that she actually had to act, but she did a great job. Tommy saw how nervous I was, and was so kind and lovely to Chloe, as was Will."

BELOW: Hairless Joey, Split Guy (in two parts), and Eye Guy letting it all hang out.

OPPOSITE (FROM THE TOP): Concept of the post office reveal by Rick Baker. Rick Baker smoothing out Joey's hair. Concept art for Sorting Alien (Sang-Jun Lee, ILM). Sorting Alien (Jeremy Howard) ready for the scene.

> **"BROWN PAPER AND DOUBLE TWIST TWINE ARE THE PREFERRED MEDIA"**

POST OFFICE ALIENS

The Truro Post Office scene was one of the more complicated to set up – because it had to be shot twice: once with actors as humans, the next as their true selves. For Walter Parkes, the post office is one of his favorite sequences in the entire film. Rick Baker's team was in high gear here. Character make up, full masks, prosthetics, animatronics – and later, coordinating with the CG team to blend it all together.

The aliens were the stars and, as Kevin's protectors, the true heroes of the post office.

Rapping Alien was played by real world beat boxer, Biz Markie. Will Smith used to beat box around the set and it caught Barry's attention. "Will's buddy is one of the best at it. We did not treat his voice, nor did we change the sync of Biz Markie's sound," confirms Barry. Markie's pop single, 'Just a Friend,' hit number nine on the Billboard Charts in 1989 and, in 2008, it made VH1's list for the 100 greatest hip hop songs of all time. The second beat J does is from the end of the song 'La Di Da Di' by Slick Rick.

Eye Guy boldly reveals himself before the others. His maquette was sculpted by Matt Rose of Cinovation. It was mechanized by Bud McGrew, but it's the CG-enabled one-eye blink that makes the joke work.

Split Guy is an alien of unknown species played by John Andrew Berton Jr., ILM's visual effects supervisor on *Men in Black II*. The alien controller was a fully animatronic element with radio-controlled arms, lips, eyes, and stalks.

Joey, played by Doug Jones, reveals that below his Morticia-like black wig is a shrunken cranium/puppet head. "That guy looks like either Howard Stern or Joey Ramone, I don't know which," comments Barry.

Sorting Alien is played by Jeremy Howard, who also doubles as the Bird Guy Alien seen in headquarters. "This [make up] is entirely done by Rick Baker, including those eyes. He's actually quite a good-looking guy," says Barry. The arms were created by Tippet Studios in association with ILM.

DENEURALYZATION

I f not Serleena, some other past entanglement would likely have caught up with K eventually. Men in Black probably knew that, or at least it didn't come as a surprise. K did manage, however, to carve out a much-needed hiatus. A decent stretch of blissful ignorance and suspended memory.

The physicality of Tommy Lee Jones' performance as he makes his way back into Men in Black is a tribute to what a dynamic actor he is. Barry Sonnenfeld has this to share about it: "I love the way Tommy plays walking into headquarters. So naïve and nonplussed. He's sort of tentative, and a little bowlegged, a little bit unsure… just sort of checking everything out." And in the elevator, "he does this little lean back and forth and is chewing his mouth a little bit. And that slight lean forward. He's just so not the guy you'd expect in that black suit. I love his performance throughout this whole sequence. Playing it so wonderfully naïve and confused." K is not yet clear about J's intention to deneuralyze him.

"I knew we were going to make both a homemade and a Men in Black deneuralyzer," shares Bo Welch, "so I wanted to design them at the same time. One is real rickety… the other very sleek and surgical looking, but they're two different designs of the same concept." Barry and Bo, in general, go back and forth when considering potential designs. In the case of the Men in Black deneuralyzer, "That was one of those things where… it got more and more elaborate and more and more literal and then, literally, it became a toilet bowl." A chair inside a bowl inside a bigger bowl – all curves and Wonkavision whiteness.

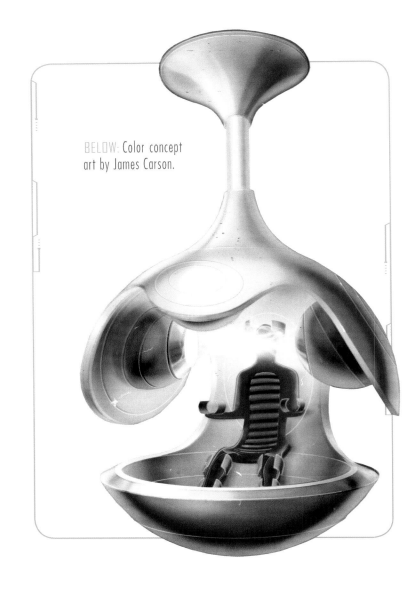

BELOW: Color concept art by James Carson.

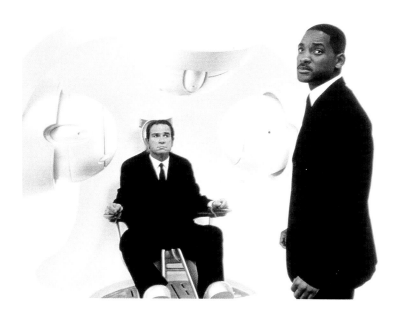

ABOVE: Jones sits in a ball suspended inside another ball.

ABOVE: Code 101 Lockdown breach protocol initiated. Flush!

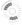

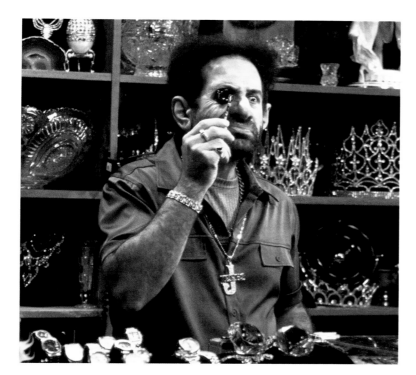

JEEBS' BASEMENT
AND DENEURALYZER

Before proceeding to the basement, there's a terrific face-off between Jeebs and neuralyzed Kevin. "I love that Jeebs' face is sort of off. And I love *why* it's off," proclaims Barry Sonnenfeld. "Which was Rick's idea, that over the years (between the first and the second *Men in Black*), they've probably visited Jeebs many times for information, because he's a snitch." His head doesn't regrow quite right and, each time they shoot him, it gets a little bit worse. So that, "genetically he's not quite what he should be," and each new deformation is permanent, and more exaggerated. "So his ears are wrong – they don't match, his nose is too big, his eyes look even more extremely in the wrong direction. It's a brilliant Rick Baker joke."

The shop itself has received some upgrades from the first film. Exteriors are once again shot on the Lower East Side, interiors on stage in Los Angeles. Take a look next time you watch *Men in Black II* for some specific set dressing changes, such as Cheryl Carasik describes. "Among the many UFO genre items featured is a set of circa 1950s 'Saucer' ceiling lamps, made by the Eames Company from their Atomic Collection." A definitive upgrade from the vintage Atomic table lamp of *Men in Black*.

ABOVE: A new and less improved Jeebs.

RE: JACK JEEBS (INFORMANT) UPDATE

STATUS: MONITORING – CODE LEVEL 4

CIVILIAN PRIVILEGES: MANHATTAN ONLY. WEEKLY CHECK-INS.

Jeebs has moved his primary business to the internet. Suggest ops & security teams consider revising our primary tactics for monitoring known peddlers of black market alien products. Domestic and international.

Between the other Lower East Side agents and myself, database numbers indicate that appendage disphasement has been applied to this Skookian over fifteen times since 1997. It is this agent's opinion he may not recover sufficiently next time to remain useful. He's looking pretty wonky as it is. I mean, way more than he normally does. Recommend researching new pressure points. And make note about this Skookian long term affect in their Alien Species file.

SIGNED, AGENT J, MIB NEW YORK

cc: Chief Z; Bowery, Lower East Side Branch; Security Subdivision, NY, London, Mexico City & Beijing offices

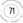

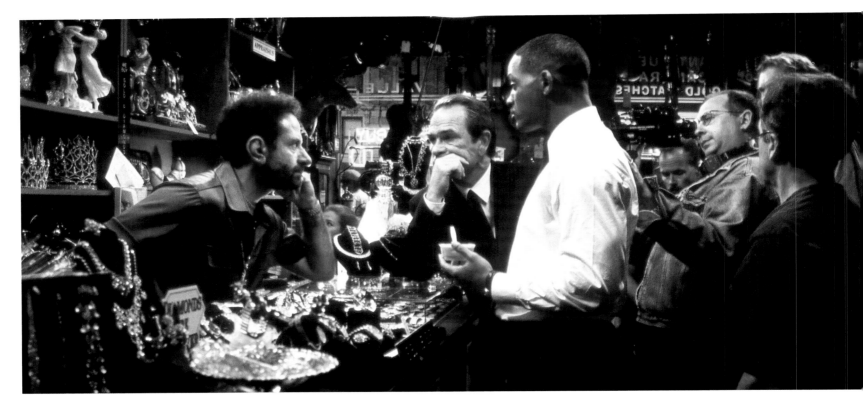

ABOVE: Jeebs/K face-off. This scene is pure Sonnenfeld.

Jeebs had illegally hacked the plans for Men in Black's newly perfected, room-sized deneuralyzer (the Beta version). He's been selling them online ever since, and even worked up his own homespun, jerry-rigged one for the office. More 'junkyard meets Doc Brown' than steampunk, Jeebs' deneuralyzer had a hint of a rusty, scrap metal wire sphere to it, but that is where its similarity to the Men in Black deneuralyzer ended.

"Jeebs' basement in Los Angeles," explains Barry Sonnenfeld, "is Bo's design. Along with Doug Harlocker the prop guy, and Cheryl the set dresser, [they gathered] a wonderful bunch of dumb things." These include: a skateboard, a bite guard, a rusty head rest, a releasable, sky-blue vinyl chair back, a string pulley, a bike wheel, an Evinrude 4 outboard motor, a motherboard, a day-glow green 80s iMac, Mixmaster beaters, a metal fan, and a green bowling ball let loose down a spiral helix of flimsy metal track – all intended to run on outdated software. There was a bit of set up involved and the chair needed to thrash K around. "As high tech as the deneuralyzer was at Men in Black headquarters," Barry continued, "that's how lo-tech this thing was." And so the crank deneuralyzer fired up. Kevin went in, and K came out.

Like Lockertown, this was a group effort. Both are tributes to the high art of mashing together found things. "The actual deneuralyzing gadget was a combination of Bo and props and me and [the] paint [department] and a whole bunch of people finding the right bowling ball," shares Cheryl Carasik. "And making sure the hairdryer was the right period; we just kind of collaborated. But [it was] mostly Bo. He's the one who really brainstormed on that one."

RIGHT: Jeebs' deneuralyzer does the trick. Early concept art by James Carson.

SCUM OF THE UNIVERSE

> **"**YOU LOOK LIKE A CAN OF CREAMED-CORN THREW UP."
> AGENT J

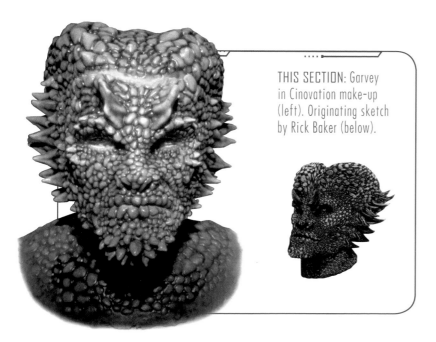

THIS SECTION: Garvey in Cinovation make-up (left). Originating sketch by Rick Baker (below).

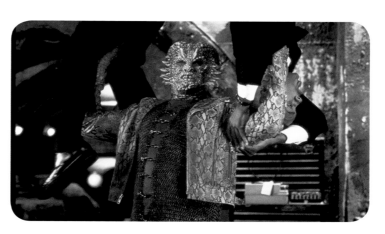

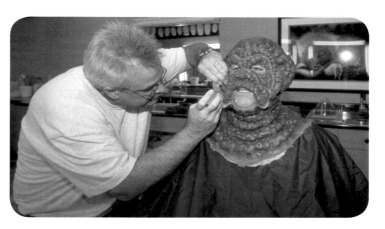

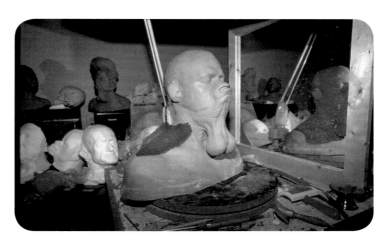

Pineal Eye, Mosh Tendrils, Dog Poop, Corn Face, and the Ballchinian were all designed by Rick Baker. All five were based on visual puns to the delight of young boys and the inner child everywhere. "This was a really fun scene to shoot," shares Barry Sonnenfeld, including the Ballchinian blooper reel on YouTube which he recommends everybody go check out. "There's about eight different names, and I keep yelling, 'Will, do another one!'" Costume designer Mary Vogt reflects on what a good time this task was. "They were really fun to do. And one guy, popcorn head… I did this sort of snakeskin with yellow and black snakes [jacket]. It was funny." And for Dog Poop, "we made them a big sweater because sometimes dogs wear sweaters."

TOP: Cornface is a reptilian creature played here by Michael Garvey.

MIDDLE: Crafting the facemask. "I never would have designed a dog poop alien had it not been for a line in the script," remarks Baker.

BOTTOM: Based on Baker's design, Ballchinian's make-up was devised by Kazuhiro Tsuji.

COSMIC COMEDY
BARRY SONNENFELD'S GUIDE TO DIRECTING

Barry Sonnenfeld is one of most of the most distinctive directors in Hollywood. He brought a sensibility to *Men in Black* that, in the words of many who've worked alongside him, was uniquely his. Here, he shares some of the core techniques that have informed his style of filmmaking – methods and approaches he's honed since his early days as a director of photography.

BELOW: Barry conducting a behind-the-scenes video for *Men in Black*.

OPPOSITE: Barry shooting a *Men in Black* car interior.

TONE

A Sonnenfeld-directed movie is unmistakably unique. There's one reason for that, in Barry's mind: tone. "[With] *Men in Black* one, two, and three," shares production designer Bo Welch, "Barry Sonnenfeld singlehandedly invented this tone of sci-fi-action-comedy, which is not an easy thing to achieve. And it's a very specific tone. It's what made the movie so memorable, and so good."

Again, "Directing is tone," echoes Barry. "And you've just got to trust [that]. I think the single most important job of a director is to figure out tone, and to stay consistent [with it]. And it's through an accumulation of thousands of decisions that you create a tone and style to your

movie." This includes everything from the grand to the minute. From casting, the shape of a one-inch background prop, or what an alien might – or might *not* – do. Barry shares that many of their discussions about his choices went this way: "Rick would say, 'You know you're talking about an alien that doesn't exist?' And I'd go, 'Yeah.'"

One of the challenges lies in the deeply embedded oxymoron that is action-adventure-comedy. Barry explains: "Every time you have comedy, it ruins the tension in the action because you go, 'Really? They're stopping for that joke?'" And vice versa, meaning 'when's it going to be funny again?' It's very hard to pull off.

SMALL BUDDY MOVIES

Second, for Barry, his films succeed because of the relationships between the main characters, despite any grand spectacles they may include. They are small-screen character films with big special effects. Their dynamic is the priority. And it is what the producers were always aiming for as well. "It's easy for the movie to be overshadowed by other details," remarks Walter Parkes. "[It] becomes about the effects… Barry was able to balance all the movie's values successfully. The design, effects, and so on were all in service of the story and the characters and not vice versa. It's a very difficult thing for a director to pull off." Laurie MacDonald adds, "he delivered all we had envisioned. So often you feel, as the film is being made, that it's not what you had in mind. But [*Men in Black*] had the feel of the movie we'd hoped for."

For Barry, "I never felt that we were making big effects movies. If you look at the first *Men in Black*? I've always thought [it] was a very small movie with some smoke and mirrors to make you think you are watching an action science fiction movie, but you were really watching a buddy movie between Will and Tommy – with some aliens – and the rest was just sort of 'pretend' science fiction to get a bigger audience."

"These are very big movies," remarks Emma Thompson. "What's interesting to me is it doesn't *feel* like a big movie, on set it feels like the kind of movie I would make, and I think that's admirable, and remarkable."

REALISM

The sense of verisimilitude is a key aspect of the *Men in Black* universe, and exists by design. The world feels real specifically because it's grounded in real locations and recognizable people (even though some may, ahem, be aliens). Meaning visual and live action shots need to be seamlessly blended together, almost in the spirit of a documentary. Doing this would make it easier to buy into this fictional world, and, somehow, funnier. "[Barry] wanted [*Men in Black II*] to feel more gritty, more realistic," shares visual effects supervisor Ken Ralston, "as if the aliens are really part of the world that *Men in Black* is in, and just integrated into the environment so that you really believe that you were standing in them."

CUTTING IS THE END OF COMEDY

Another very Sonnenfeldian shooting technique: "If comedy is working, it should play out in the two shot. Action and reaction, in the same scene," says Barry. Take the alien birth scene, after the baby vomits on J. They're in the car and K asks, "Anything about that seem unusual to you?" J looks back without a word, but it's all on his face. "No cutaway to a close up. But the audience knows where the joke is. *Everything* about that seems unusual," Barry recalls. "That scene encapsulates what the shows are about."

> **"If comedy is working, it should play out in the two shot."**
>
> BARRY SONNENFELD

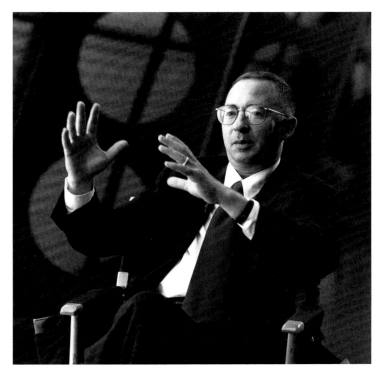

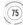

PLAY IT STRAIGHT

Sometimes the way to get the laugh is not to play the joke. Surround your absurd situation with down to earth characters and play it straight, is a signature style of the *Men in Black* playbook, and how Sonnenfeld approaches all of his movies. Sonnenfeld's humor is naturally dry, and this translates into the way he makes his films. It's always about the seeming incongruity of the situation, and all of his characters are dead serious – amidst the extraordinary. They behave like they're not in on the joke, because there is no joke. Which makes it all the more hilarious. Part of his method? He repeatedly tells all his actors to flatten out their performance and talk faster – while he's shooting low and wide. "Don't try to be funny," and "Make it flatter." It's a comedic tone that can't be played by the actor for laughs.

LET THE AUDIENCE FIND THE JOKE

Barry believes in letting the audience feel smarter than the filmmakers. Don't tell them where the funny is – let them decide. "Don't cut too close up for the punch line. Don't cut the insert. Let *them* find the joke. Let the wife elbow the husband and say, '*It's gonna turn out that she's an alien!*'"

MOVIES ARE MADE IN PRE AND POST

"By the time you're done shooting, your movie is as bad as it could ever possibly be. All your dreams, all your loves, all those great moments, they're gone." And so, "I like post-production the best," shares Barry. "It's amazing how you can fix movies in post-production. How elastic they are." The challenge to creating a comedy, in particular, is that live production is filled with details, constant mishaps, and delays, especially with CG. "Production is where every plan you have falls apart. Because you know you needed a sunset, but it's overcast. You needed two days, but you only had one… I find that there are very few *happy* surprises in production. And what's great about pre-production is there's no stress. You're not spending $150-$300,000 thousand a day shooting." With production, there are loads of delays, which are the enemy of comedy. "Comedy likes momentum, and speed." But once you're in the editing room, it can all come together.

BELOW: Barry's early years as a cinematographer inform every aspect of his process.

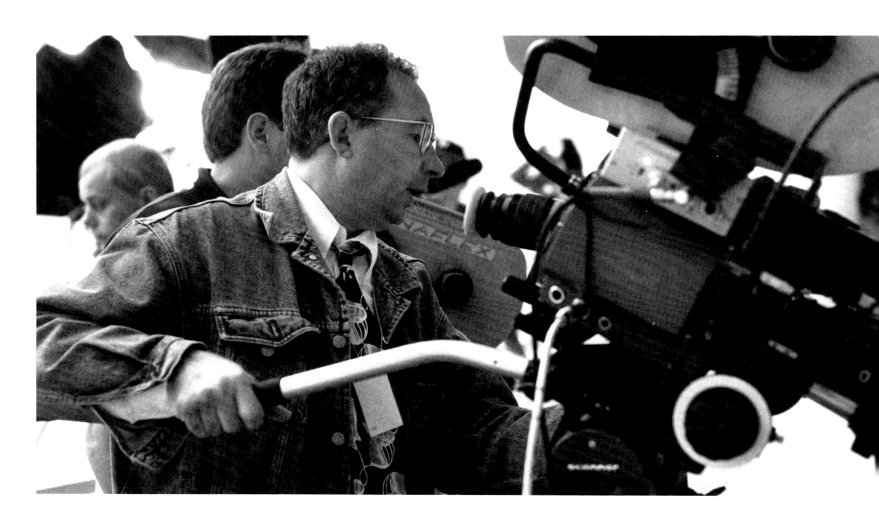

CHARLIE AND SCRAD

"J! HOW ARE YOU, BOO BOO?"

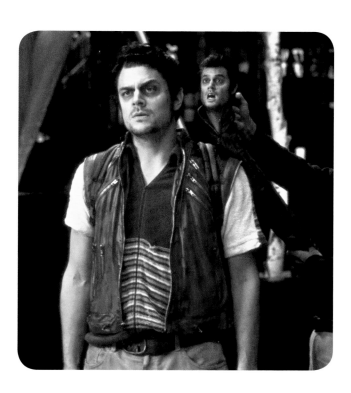

Twin-headed Charlie (and Scrad) may have been coerced into working for Serleena, but they were never really that into it. "Charlie/Scrad is the most indolent alien you've ever come across," shares actor Johnny Knoxville. Barry chose Knoxville for the part because "I had just worked with [him] on *Big Trouble*, and I loved working with him."

Before knowing that the actual Michael Jackson would be in the film, costume designer Mary Vogt chose to put Charlie in a 'Thriller'-inspired red leather vest. "I've always been a big Michael Jackson fan," shared Mary. ('Thriller' was a childhood inspiration for Will Smith as well.) "And so I thought, well, this alien would like Michael Jackson. Then Michael did a cameo and I thought, 'Oh my god, I hope he doesn't get mad!'" She later got to do a fitting for him and all was well. "That was really exciting… he was wonderful."

RIGHT: Rick Baker's team at Cinovation created a Scrad physical puppet head to accompany Charlie (Knoxville) in his scenes. The final look was created digitally in post.

JARRA

"THEY'RE VERY TOUCHY ABOUT THIS GLOBAL WARMING THING."

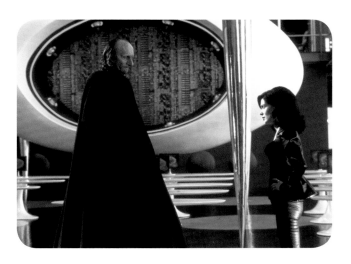

Jarra is played by John Alexander, who also played Mikey, the alien with flippers, in *Men in Black*. The inspiration for this character all began with John's ability to ride a unicycle. Jarra was Agent J's first arrest back in 1997, and the alien's still steaming about it. In keeping with the impound set motif, Jarra's 'Jarrettes' all tooled around in floating mechanical saucers.

RIGHT: Jarra and Serleena reunite.

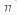

SERLEENA

"I'LL GIVE YOU ONE LAST CHANCE TO SURRENDER, YOU SLIMY, KYLOTHIAN INVERTEBRATE."

"A ramp lowers. A small, neural root creature in the shadows, slithers off the spacecraft. We now see the spacecraft is less than two feet across." With its play on proportions, Bob Gordon's script provides a signature beginning for this *Men in Black* film. Again, Rick Baker casts off the look for this Kylothian secret agent, and ILM takes those initial sketches and carries the torch from then on. "She's made out of roots, basically," explained Rick. "One of the first designs I did was the beginning transformation from this weird root-like thing into this worm and how to try to conceptualize what that was going to be like." Kylothians are shape shifters whose natural state is a vine – it's a gift of nature and a weapon they use against species gullible enough to believe what they see.

"I [was] just trying to find it very reasonable that I [was] a woman on the hunt for the Light of Zartha," shared Lara Flynn Boyle. "Will Smith always used to say to me, 'Your hero is only as heroic as your villain is villainous,'" reflected Barry Sonnenfeld on the challenges of developing this character, and the right tone for *Men in Black II*. Serleena was never a sociopath; she was always acting in the best interest of her species, although her ethics weren't particularly recognizable to us. In death she was lionized by her own.

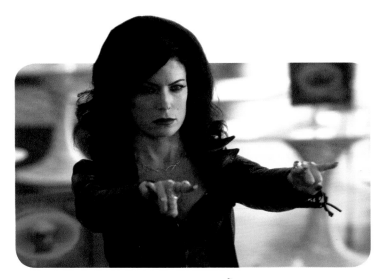

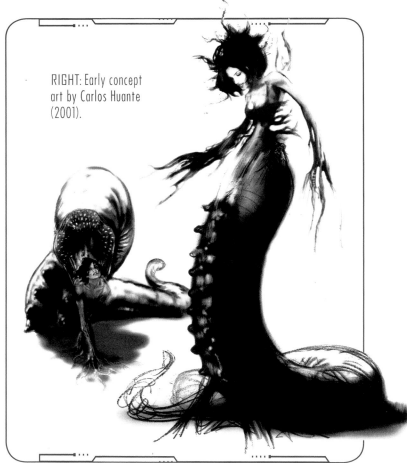

RIGHT: Early concept art by Carlos Huante (2001).

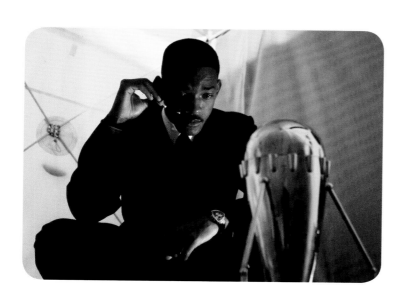

SERLEENA'S SHIP KYLOTHIAN CLASS C

Kylothian Class C spaceships. One of the smallest and most space-worthy crafts ever constructed. They're also the perfect size for Kylothian buds to slumber within for long distance interstellar travel. "Spacecraft" a serviceable script description, and a juicy blank slate for the art department. As with the deneuralyzers, where the insect ship was sleek, Serleena's ride was a tri-footed, teardrop-shaped tribute to early twentieth century science fiction. All polished metal and towering at eighteen inches, this design is decidedly in the steampunk wheelhouse. A near replica was erected years later by the Black Rock Arts Foundation — the Raygun Gothic Rocketship enjoyed a three-year run at Pier 14 in San Francisco (after Burning Man but before NASA and the MakerFaire). *Men in Black* fans might have easily imagined Serleena's slimy, eel-like, snappy-mouthed, electric green root winding its way round inside this monument to yesterday's idea of what tomorrow might be.

ABOVE: "So why is there a Kylothian Class C in my park?" asked J.

RIGHT: "Serleena's vessel. The ship of a warrior. Mean. Lethal. Tiny." — Script excerpt

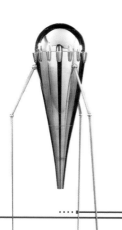

SERLEENA'S GETAWAY SHIP

Jarra took possession of an FTL-capable ship from an underground dealer. Nestled in a corner near the exit ramp, Serleena's jacked alien, single-passenger, battle-ready spacecraft was an art department marvel. Given the script requirements, Bo Welch was considering speed and something uncluttered — with an insect feel. "I look for design and references that have energy and suggest motion," shared Bo, and so "Serleena's ship really was inspired by Santiago Calatrava," an architect and engineer whose sculpts often resemble living organisms. Crafted out of steel and plastic, "that is a beautiful ship. Bo designed it and then we had that made. That was all on stage at Sony," explains Cheryl Carasik.

The floor and walls help fill out the in-camera environment, suggesting a place from which ships come and go, even though the impound area is likely many levels underground. "The up-arrows imply that part of that wall opens up and then she was going to leave in that space ship," continues Cheryl. Another great example of how Bo conceives of a space for filmmakers.

"Bo created sets to be photographed and directed," shares Barry Sonnenfeld. "He thinks about camera shots, he's thinking about character — he's not just designing it to be beautiful, he is designing it to… help tell the story. And he's one of the most unique production designers because of that."

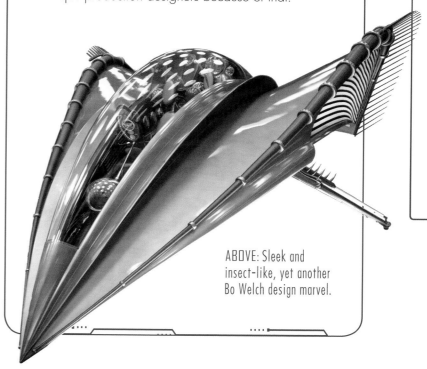

ABOVE: Sleek and insect-like, yet another Bo Welch design marvel.

HEADQUARTERS EXPANSION

Bo Welch's headquarters was only slightly modified. Why mess with success? "When we did *Men in Black II*, we took it just a couple of steps further," shares set decorator Cheryl Carasik. "We redid the desk designs… and upped our ante a little bit with different pieces. But the overall architecture was the same." The key redressing was in the main hall, and the addition of duty-free shopping. The thinking was travel-weary alien appetites wouldn't differ that much from humans. "This is what we have to offer the universe," Bo admits with a shrug. "Burger King, good long-distance service, and duty-free liquor." Beyond these changes, J gets a Mercedes Benz E-500, and Bo expands on the weaponry repertoire with the signature Noisy Cricket Rifle, which the worms proudly pack when they go commando. Worm militia outfits by costume designer Mary Vogt.

Bo Welch envisioned this space as an expansion on the original headquarters, further down into the terra firma of Manhattan. Think ant colony meets airplane terminal – a subterranean labyrinth where thousands of agents and aliens crisply maneuver through the day's activities. "On *Men in Black II*, I thought, well, we'll just go down another floor. I mean, you can have as many floors as you want. In that floor, they had all this stuff… rocket ships and a giant perforated ceiling. It was like a garage or a launch station, where you would physically get in a ship and blast up and exit through the top of the building."

For the impound/hangar, the set dressing was a multi-alcoved tribute to shiny metal parts. The alcoves were like open garages for spaceships of all shapes and sizes. There were six in total, plus dressing strewn all about. Sadly, most of these lovingly collected bits did not enjoy a lot of screen time.

BELOW AND OPPOSITE: Rough concept art for revised newly added hanger. Designs by (then) illustrator Francois Audouy. Uncredited.

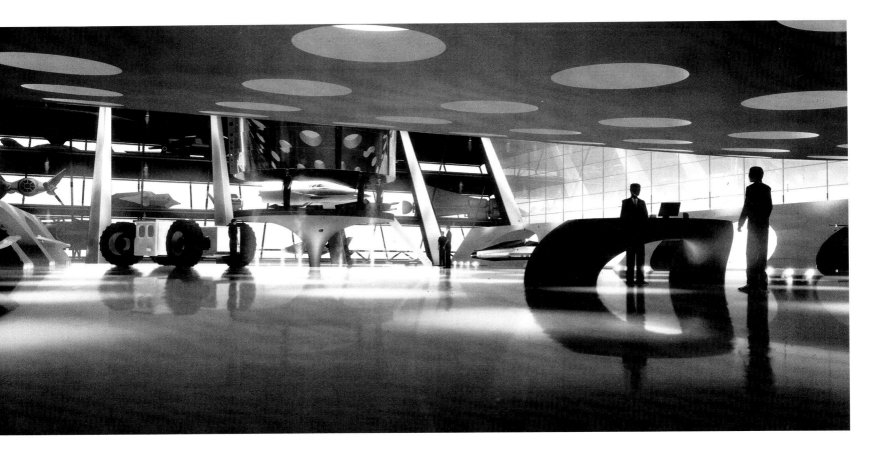

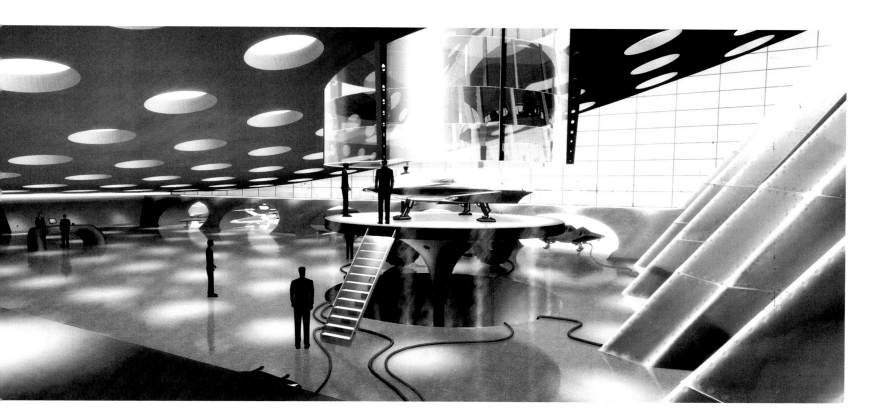

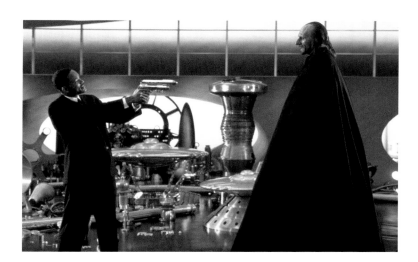

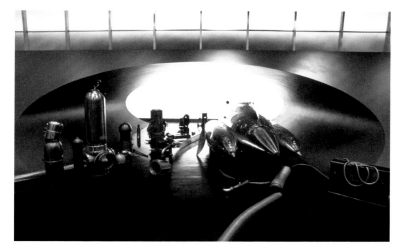

(IMAGE ABOVE LEFT) "OK, [laughs] so this was tough," chuckles Cheryl Carasik. "You see the two little spaceships in there? One a miniature of the other? The larger spaceship in the background is from *My Favorite Martian.*" She dug up pieces to rent from actual collectors – in this case, someone had purchased the original prop from the hit sci-fi/comedy TV series. "We went and got his spaceship and put it in the set." The rest of the pieces were, fittingly, actual rocket parts, from actual rocket warehouses. To give it that slick *Men in Black* look, the art department chromed everything, including that piece in the back, with the mushroom top. That, like many others, is a jet propulsion part.

(IMAGE ABOVE RIGHT) The large piece on the right was made by an LA-based collector. (He also makes really cool robots.) This piece smelled like gasoline because – unlike most of the stuff in there – it was built on a small, motorized car chassis and actually *runs.*

Remember J attempting to look like a badass agent while trying to escape from a huge mound of oversized plastic hosing? "We got all that," recounts Cheryl. "'Set dec' got it from an industrial company that services big rocket places. You know, you just have to get whatever source you can in the time that you have. So we found a lot [and] a lot of this is real stuff."

TECH UNIT

The Men in Black's Research and Development department is its technological crown jewel – the storage center where all of its adopted, gifted, and/or confiscated alien technologies were first perfected and through which the global organization's future independence can be guaranteed. In-house technology, such as new kinds of weaponry and defense materials, is also developed here. This is where, in *Men in Black*, J accidentally toyed with the Zinger (a joke set up by "the Great Attractor") and set off a spitfire of chaos throughout the main hall. Barry Sonnenfeld came up with the idea for this scene at the last minute – it doubly served as a way to showcase all of the intricate detail Bo Welch and his team had invested in the development of the headquarters. The Great Attractor is a reference to a real world gravitational anomaly first detected by astronomers in 1973 – feared by some as potentially possessing the power to destroy the galaxy as we know it.

ABOVE: The beloved Noisy Cricket. Conceived by Ed Solomon, designed by Bo Welch, fabricated by Doug Harlocker.

REPORT: CHIEF Z

LOCATION: TECH UNIT & RESEARCH LAB

DESCRIPTION: STERILE, DANGEROUS FOR CIVILIANS

NOTICE: ALL NY STAFF – STATUS CHANGE

DATE: SEPT 15, 2002

In the wake of several catastrophic mishaps, Chief Z is instituting an increase in the security protocols to the Tech Unit. Only qualified and/or necessary personnel with a clearance level of 4 or above may be granted entry. All access badges will be reconfigured. New punch codes will be issued. Non-agents, agents-in-training, interstellar guests, and recently arrived Earth visitors may not be allowed entry. Any exceptions must be cleared in advance with the head of security, and monitored during in-office tours. And when in doubt, please remember and advise everyone not to touch anything. Anything at all.

SIGNED, CHIEF Z, MIB NEW YORK

cc: Tech Teams, Security Team

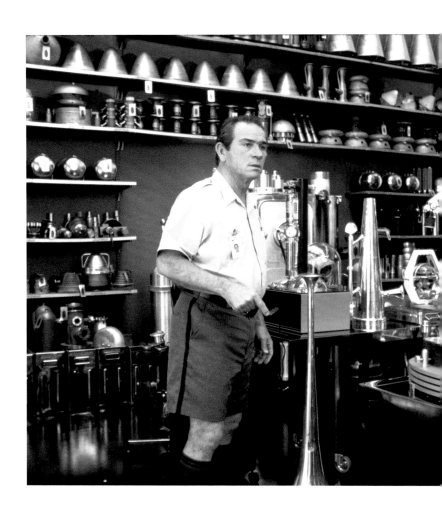

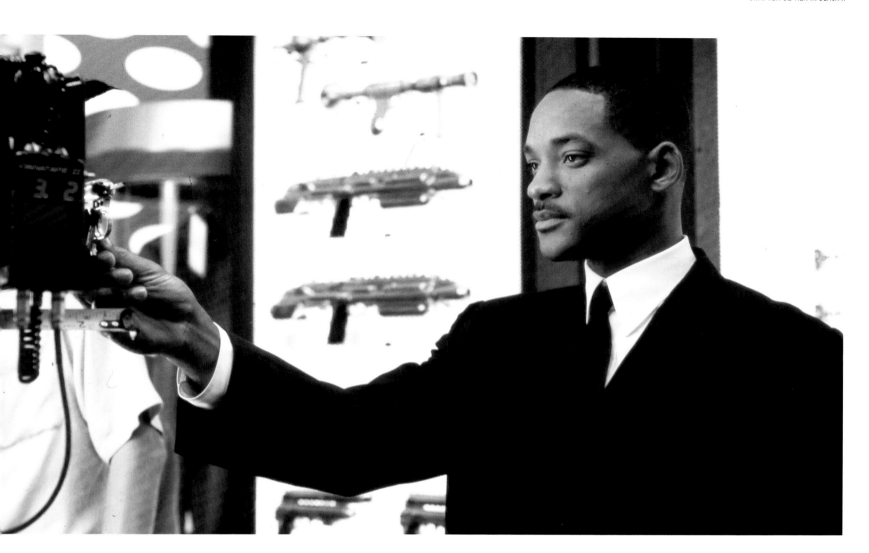

Barry Sonnnenfeld is actually not a fan of ad-libbing. Nor is Walter Parkes. "The good thing about a well-structured script," advises Parkes, "is that you are allowed. It gives you total room." And so, for this last minute addition, "I've got to give Barry credit. [He] had the confidence – because it was a very tight story – to do things like the ricocheting ball [gag]. And I remember there was one time when Barry said, 'I just have a hunch about this,' and I said, 'Let's do it.' And it's fantastic."

In a clever role reversal, it is Agent K who wreaks havoc in this space in *Men in Black II*, by disrupting the very delicate water sphere world of the Jarinthians. "I love that something like a finger going into the sky of the world could create tidal waves," shares Barry, who voices the "All is lost!" screams. "Whenever we can play with scale and the sense of things affecting whole worlds or universes, because of the dumbest, least planned, not expected [things], to me, that's what the whole series is about."

The final version of the Jarinthians was done by Sang-Jun Lee. "It combined the body style of the versions with an eye stalk head," shares illustrator Carlos Huante. The CG globe was added later by ILM.

THIS PAGE: Agent J presenting Agent K with the Noisy Cricket (top). All Is Lost! Concept art of K's finger causing massive destruction to the Jarinthian world (bottom).

CHANGES IN THE MIB

Established shortly after first contact in 1961, the headquarters hasn't changed much since *Men in Black*. It is fully operational, thirty-seven hours a day. After long deliberations about design and story, major upgrades were made for *Men in Black 3*, but for this film? A few desks were redone and not much else was altered. The conceit at that time was "they don't really care too much about redecorating," says Bo Welch. Barry echoes this feeling. "Bo and I didn't really want to update the headquarters. Our feeling was it's been this way forever. Since we first saw aliens in 1961. And once you see aliens and know that there's so much more out there, your concept of fashion – and what's in and what's out – goes away… in the same way that they don't wear cool suits."

Overall, the biggest changes for Men in Black were organizational, and took place in the early days of the institution's history.

Men in Black's presence around the world expanded and solidified, with the New York office established as the central hub for all activity worldwide. Men in Black now has subsidiary jurisdictional bases in Melbourne, Sao Paulo, Beijing, Tokyo, Mexico City, Moscow, Seoul, and Europe (London, Paris, Berlin), with outposts on the poles and open oceans for monitoring water-based alien species. It remains a private institute, independent of any world organizations and governments.

Michael Jackson appeared in the first two *Men in Black* films. "In the first one he's up on the big board and then, in *Men in Black II*, he got upgraded to informant. He's on the screen [and] talks to Z; we put him in Antarctica for that. He was lovely," shared Barry. "He so wanted to be in *Men in Black* [and] wear that suit. But he was lovely and great and very nervous. It was an easy day."

THIS PAGE: Modest revisions to the headquarters include desks, two new elevators and the addition of duty free.

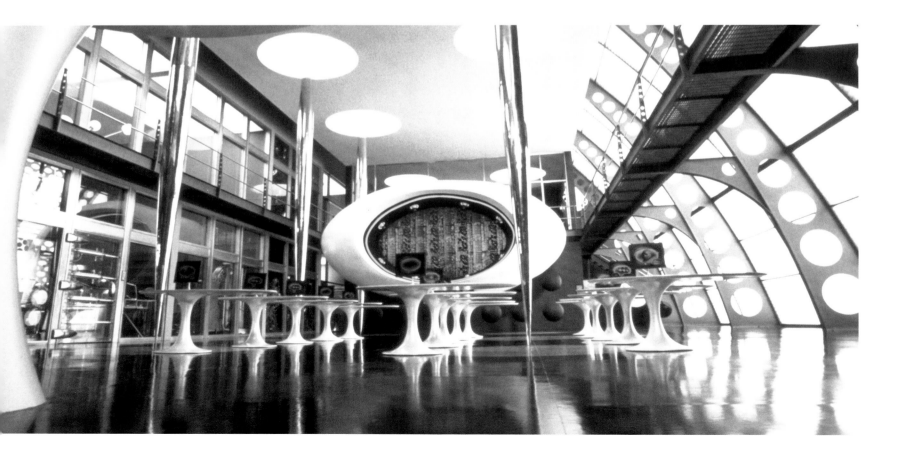

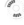

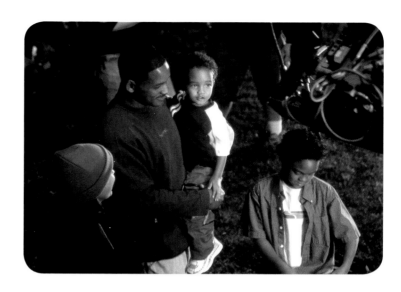

"YOU DON'T LIKE IT, YOU CAN KISS MY FURRY LITTLE BUTT!"

FRANK THE PUG

Trainers typically bring six to eight dogs on to set for a character part. But Moo Shu was such a stand out, "we ended up using him ninety percent of the time," recalls Barry Sonnenfeld. He was the pug for all three *Men in Black*s. "Moo Shu was just an amazing animal, and the animal wranglers were fantastic." At one point he asked Christy, the trainer, "Do you think there's a chance I can get Moo Shu holding a martini glass and smoking a cigar?" Ultimately the effects were inserted digitally by Rhythm & Hues. No animals were forced to don cigars in the making of this movie. And there was no real smoke on set!

BELOW: Frank the pug getting his shot at field work.

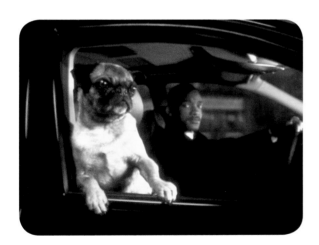

J'S 2003 E-500 MERCEDES

Although much stayed the same between the first two *Men in Black* films, one key concession was made – Will Smith got a cooler ride. The Mercedes-Benz E-500. The 'new hotness.' In fact, at Agent J's request, Men in Black updated their entire fleet. All Mercedes, all the time. It had been specially modified for flight – which could be initiated by pushing the same red button that sped up Agent K's Ford. Carry-over features that older agents will remember and love include the automatic driver and a flight stabilizer. These newer models also had neuralyzers built into the chassis, for wiping memories from any accidental spectators looking up from below. Did you notice the two young boys gazing skyward from the city sidewalk during the final sequence? They were gone in a flash. Check next time. Those are Will Smith's sons, Trey and Jaden, circa 2001.

ABOVE: Will Smith on set with sons Jaden and Trey, circa 2001.

THE WORMS

"K, You're back! Someone said you were dead.... You look good."

Gleeble, Sleeble, Neeble, Mannix, and Gordy. These Annelids hail from the planet Manitoba, but call Earth home. They may be a bit rough around the edges, but they're regular guys and have long enjoyed regular gigs at Men in Black headquarters as attendants. Don't be fooled by the chain-smoking, couldn't-care-less attitude, their technical abilities are top notch. Out on probation for 'liberating' a huge volume of office supplies and duty-free items, Chief Z cleared their records and reinstated these sorry wormholes for their loyal assistance when Serleena overran headquarters. They had fun and dressed the part, wearing camo make up and crisscrossing bandoliers stuffed with knives (costumes by Mary Vogt). The coup de grâce was the Noisy Cricket Rifle designed by Bo Welch. It's a two-hander, and the worms got it all to themselves.

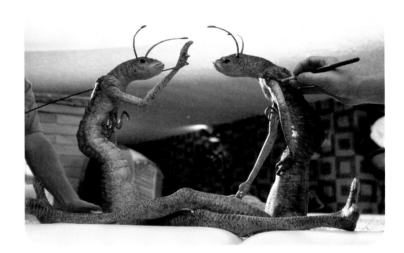

In developing aliens for all three films, Barry Sonnenfeld and Rick Baker had an ongoing conversation. Barry would often lead with "You know, aliens always look so human-centric," and so Rick would go off and develop some non-humanoid concepts. Barry would inevitably reply, "But without eyes, how does the audience know where the alien is looking? And without ears, and a mouth... " Et cetera. There was a learning curve, but one core idea they committed to – not to make every alien look like a man in a suit. Baker recalled, "The worm guys evolved from that notion."

Concurrently, over at Cinovation, Rick had gathered together a murderer's row of hand-picked young talent – many of whom have gone on to enjoy successful careers in the arts, and consider Rick an early mentor. For *Men in Black*, he'd invited his crew to cut loose and come up with loads of rough ideas. Many were not pursued, others evolved. Aaron Sims contributed a piece, as did mechanical designer Jurgen Heimann. The makings of a workable scene were beginning to take shape. "Rick did a great thing early on that was really quite smart," explains Barry. "[He] said to me, 'Now that I've designed these worm guys, don't make them CG. Get puppeteers because then actors can improvize... [and] rod puppets can respond to that improv.' That's Rick thinking like a filmmaker."

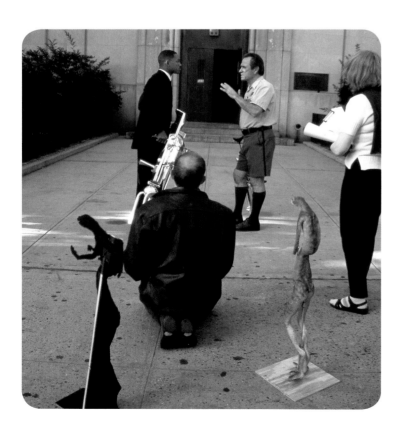

This was an idea with legs! With the green light, Rick recruited puppet master Tony Urbano. "He called me in," shares Tony. "Tim came with me and… [Rick] took us around to see the characters that were being built and give us an idea of the story. We met with the producer and were hired." Urbano began recruiting his team. "The first thing I did was start auditioning." He tried out professional puppeteers as well as Rick's staff. Auditions were held at Rick's studio, using one of his animatronic ape's faces from *Greystroke*. "I was looking for people who could *act*," shares Tony, "and especially people with a sense of humor." Once Barry placed the chosen puppeteers on set and they began improvizing with Tommy Lee, the worm guys truly came to life. "The first film was, for us, a real treat," shares Tony, "because we were allowed to just do stuff… especially the comedy. I think that's what we contributed the most to."

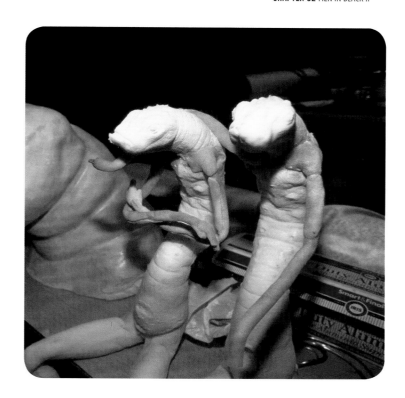

OPPOSITE: Worms being prepped (top). Two *Men in Black II* scenes shot on the same day in front of the Tunnel Ventilation Building on Battery Place, NYC (bottom).

MIB HEADQUARTERS: ALIEN DATA

WORMS' BACHELOR PAD

Make me a cocktail and let's chillax. For *Men in Black II*, the worms got to stretch their legs a bit – they had names, and more distinct personalities. This pad was pure worm, and a clear reflection of their arrested appetites, including an unexpected taste for retro 70s fads that somehow never made a comeback. "The bachelor pad was very funny," shares its creator, production designer Bo Welch. "It had shag carpeting, and very comfortable, albeit miniaturized, furniture." The stools and couch were completely custom made, as was the bar, which was stuffed with airplane mini-bottles of booze. Everything was worm-sized – the hot tub, the workout bench, the fireplace pit, the Saarinen tables. The theme was chartreuse green, including the reupholstered beanbag, which Cheryl picked up somewhere on Third Ave., in downtown LA. "The killer," explained Bo Welch, was the low ceiling. "[It] was about four feet off the ground! So to go in there and shoot, you were basically *crawling*." Then there was the ever-welcoming, snooze-inducing deep shag carpet. It's possible a nap or two was had, by a cast and/or crewmember, during the course of shooting on that set. But we may never know for sure. "The shag carpet… was awesome," recounts Cheryl Carasik, "We hung out there a lot."

RIGHT: A worm-sized pad (top). Concept art by James Carson (bottom).

"**O**NCE YOU GO WORM THAT'S WHAT YOU'LL YEARN."

THE TRUE LIGHT
OF ZARTHA

The *Men in Black II* story presented many challenges for the filmmakers, and there was often much spirited debate about its endings – or how to arrive at them. For Walter, *Men in Black II* "had a strong, central idea. It was *Casablanca*. In other words, very simply, J has accepted the fact of loneliness, and it is killing him. He finds the girl that makes it all make sense, and his job is to get her off the planet. That's the story."

Wrapping up the many story threads all coalesced in one final rooftop sequence, relying heavily on ILM special effects. The scene kicked off with a descending long shot – an actual rooftop in Battery Park. The rest was built on the Sony stage. "The art department built the rooftop structure," shares Doug Harlocker, "and it was based on the charm we made that [Laura] had been wearing throughout the whole movie."

The Interstellar Zeta Beam Ship design went through multiple iterations. ILM handled the pyrotechnics and Will's stunts. John Berton and stunt coordinator Charlie Croughwell set up a black cargo net for Will Smith and "let him go to town." Eric Brevig returned for the last couple of weeks "when we had some crunch time," shares Barry, which included adding Laura's tears.

The Statue of Liberty, or what Barry calls "the ultimate neuralyzer," played a key role in the ending of *Men in Black II*. It was a tricky breadcrumb trail to follow, but "all the clues are there," recounts Barry. J did call it early with the pizza box pointing at something, and the glass 3D tetrahedron-shaped rooftop structure does kind of resemble a pizza slice.

THIS PAGE: Key chain device for the Statue of Liberty neuralyzer (above). Laura reluctantly boards her interstellar Zeta Beam Ship (below).

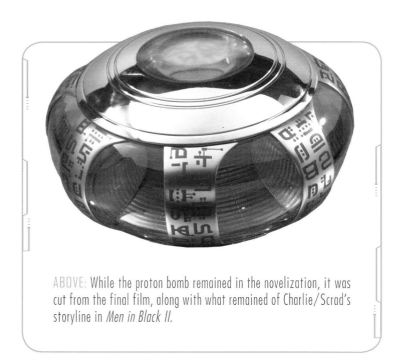

ABOVE: While the proton bomb remained in the novelization, it was cut from the final film, along with what remained of Charlie/Scrad's storyline in *Men in Black II*.

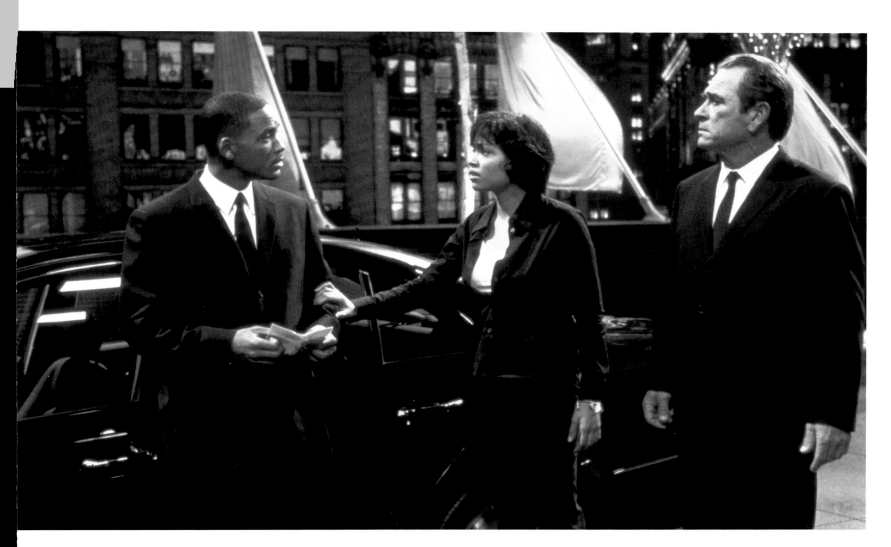

ABOVE: Agent K finally tells them both what's really going on.

The film launched July 4th weekend, 2002 – hence, the fireworks. "It was not meant to seem overly patriotic," reflected Barry. "It was just… about when we are opening." And in case you were wondering, "The Weather Channel remark was written at the last minute by Walter Parkes," shares Barry, "because he knows that's all I do. I watch [it] nine hours a day, just wondering if Vivian Brown is pregnant again."

J's shock and acceptance is played out in a matter of seconds by Will Smith. For all the adventure and dry wit the creative minds of *Men in Black* bring to the writing and design, what binds it all together comes down to emotional moments such as these, brief as they may be. And what endures across these stories is the friendship between J and K. Like many comedic and dramatic duos throughout television and film history, they earned a place in the hearts of their fans. "I just love that the real love story is between Will Smith and Tommy Lee Jones," reflects Barry. And much can be forgiven when filmmakers deliver that kind of emotional impact. "When you can come up with the story and a set of characters that have the right to live on?" reflects Walter Parkes, "Beyond one or two or three movies?" As we've said before, that's a rare achievement in the world of feature film.

RIGHT: Rooftop scene built on stage at Sony.

MIB³

MEN IN BLACK 3

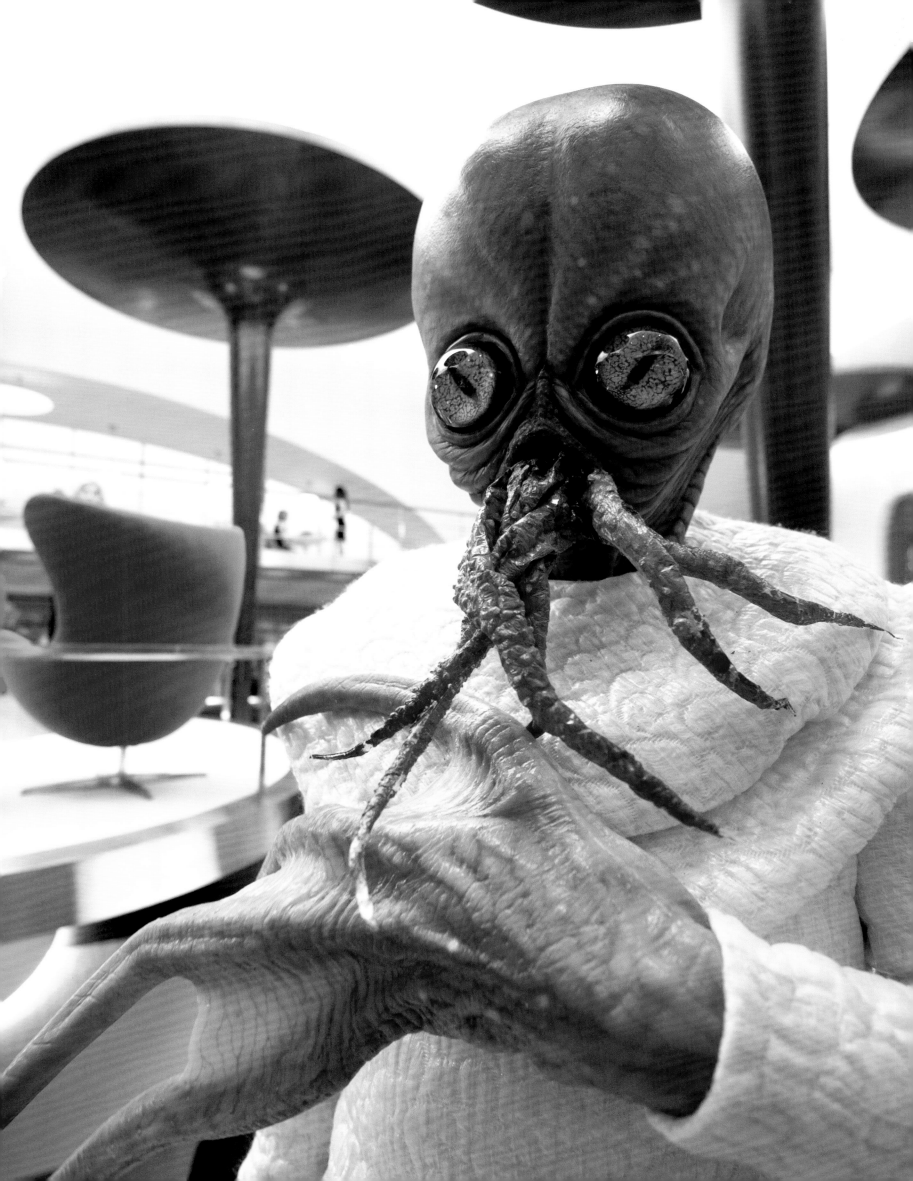

INTRODUCTION
SPACE AND TIME

From H.G. Wells to *Back to the Future*, from *Bill & Ted* to *X-Men: Days of Future Past*, *Outlander* and Dickens' *A Christmas Carol*, storytellers have perennially enjoyed the narrative opportunities time travel can provide. Beware, however, what you wish for. "Such a challenge!" bemoans Walter Parkes, who was also a producer on Spielberg's *Minority Report*. "There's nothing simple about time travel," he continues. "It's almost like our brains can't really figure it out. Because there's always going to be a question you can't answer."

It started out as an early idea of Will Smith's. Director Barry Sonnenfeld remembers the moment well. "We were on set somewhere, and Will came up to me out of the camper and said, 'Hey Baz! [Will's nickname for Barry] I just came up with the idea for *Men in Black 3*.' It wasn't exactly what we shot. But it did involve time travel." Walter also recounts the story: "He had an idea about going back in time." And there was also an 'origin story' around Will and Tommy's connection "that sort of took hold," shares Walter.

Many wondered why *Men in Black 3* hadn't been done earlier. "There was no sense of urgency about it," explains Walter. "Everyone was out doing their stuff, so why bother?" It came down to having a take for the film everyone could get behind. With that now in hand, scriptwriter Etan Cohen was recruited by the studio to work with Walter, and off they went. And on working with Etan? Walter remarked, "It was the most fun development ever. EVER. And his first draft was out of this WORLD. Fabulous!"

"Collaboratively is how I love to work," shares Etan. "I love the energy of pinging things back and forth with people." Etan had cut his teeth early, in a TV writer's room. "[Mike Judge] was a real mentor to me. He gave me *Beavis and Butthead*; that was my college job." Later came features such as *Idiocracy* and the hit *Tropic Thunder*.

Walter originally had his doubts about Etan's background – and whether he could take on sci-fi. And then, "We burned through that story process in maybe six weeks? Which is really little. I think [Etan] may have done the first draft in three of four months." There were some well-heeled methods deployed in getting to that first draft. "We did a lot of outlines, a lot of beat sheets, going back and forth and then an outline. [Once] we felt we had a structure, then I was free to go off and write."

"I really enjoyed the writers' room and got used to that system," shares Etan, "but there's definitely a time and place for locking yourself in a cave somewhere. The first act of *Men in Black 3* basically happened that way. Out camping with family, he was the last one still awake. "I pulled out my laptop and wrote the first act… it just flowed… and it was one of the few things that never changed. It's something Walter and I used to say. You have to drive yourself crazy and then forget it." Like going for a slice of pie.

Not to say Etan wasn't nervous. He confesses there was "both the excitement and the terror" that comes when being asked to work with people you've long admired. "Walter co-wrote *War Games*, which was one of my touchstones as a kid. I saw it at a drive-in." At times he wonders, "How do I know those people in real life?!"

LEFT: Your friendly neighborhood alien, circa 1969.

And so the first draft was ready. "I remember where I was when Will called," reflects Walter. "I was in Brooklyn… and he said, 'I just read the script. Let's do it.'"

Men in Black movies do have a larger than life feel — technically (including over 1200 VFX shots, some all CG) and thematically. But ultimately? They are all about two characters, and what happens between them.

Speaking from the long arm of experience, Walter says, "A movie is as successful as we are in encapsulating its basic idea." *Men in Black* movies are equal parts sci-fi and comedy too, but at their core, they are cop movies. "*Men in Black 3*," shares Walter, "is the story of a long-lost villain going after your partner."

This was also a touchstone for the director. "The general watchword on this was, 'No one treat this as if we're doing a comedy.' That was always Barry's thing," explains Etan. "Don't let anyone know. Just treat everything as if it's just a hardboiled detective story. I think that's a lot of what makes it work so well, is having Will Smith bounce off of a serious world."

There were some much publicized stories at the time about the pre-planned suspension in production and script

rewrites, but all decisions were always in service of keeping the budget in line and propelling a better story — and a better film — forward. Production was largely in New York, so Sony moved Etan into Trump SoHo for the duration — including an adjoining room for when the group writing was at full tilt. In a callback to his sitcom days, "I think I had asked that we get some reinforcements," shares Etan. Again, uncredited veteran writer David Koepp (and long-time Spielberg collaborator) was brought on board to assist with some of the complex script issues involving time travel. There were many cooks, but "they were all Michelin-star cooks. I had become, at a certain point, the 'Bob Woodward' of this process because it was such a complicated story." He started recording everything. "They used to joke and call me Griffin," chuckles Etan. "Because I was the only one, as the writer, who was, 'living in all planes of existence' at the same time. Because it was not only a buddy comedy, but also a procedural but also a time travel movie. And so, you pull one thread and the whole thing just fell apart. It would just make your head explode."

For Barry, as director, not having a full

BELOW: Rick Baker aliens enjoying a rest in *Men in Black 3* headquarters, 1969.

OPPOSITE: Green meanie? Naaah (top). Yep, that's Rick Baker (with extruding brain) having a chat with squid-eyed aliens in raincoats (center). Rick Baker fixing fishie's neckline (bottom).

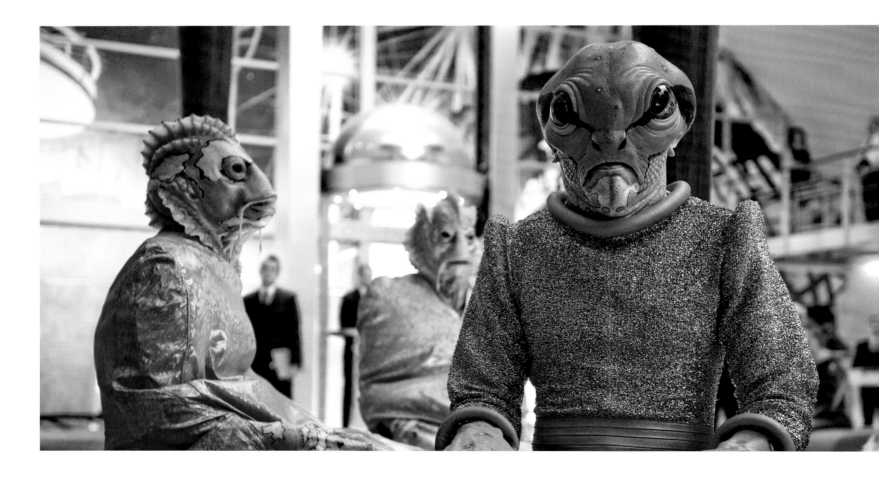

script introduced some interesting challenges. You can plant comedy runners and visual callbacks once the story's set – but not before. And the time-travel conceit kept any ad-libbing to a minimum. "In this movie, you had to be very contained about improv," shares Etan. "You couldn't really be too plastic with the whole scene because it was so interconnected."

And then there's the question of fate. Do you agree that "a miracle is what seems impossible but happens anyway"? There's a 12th century philosopher – and rationalist – by the name of Maimonides, who believed that a miracle is basically timing. It's about when something happens. "To me that was a beautiful way to look at what's going on in the movie," reflects Etan, who is from an Orthodox family and briefly attended seminary before finding his true calling. "That there are forces that affect us, even in our day-to-day rational lives." Fate here concerns J's discovery that the price for saving his partner is his father's life. "It's a tough moment. It really makes you understand the love between these two characters, and that the true origin story is the young Agent K, becoming a surrogate father for Agent J. I think it is emotionally true." Walter comments on the story's emotive power, "And so, by the end of it, something has snuck up on you. And you realize that this has been a journey that wasn't just one of science fiction, or comedy or visceral action, but that there was a legitimate emotional journey here." For many, the prequel embedded in this sequel was the epicenter

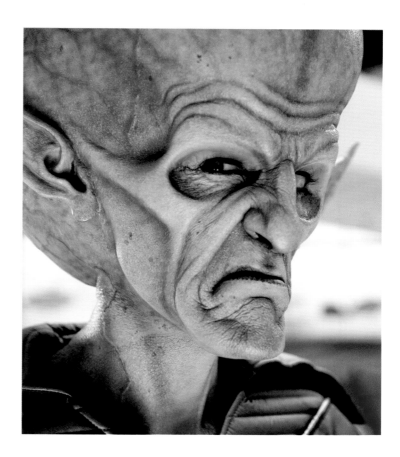

that brings the whole franchise together. If it required taking a swing at a time-travel storyline to get there, it was all worth it.

For *Men in Black 3*, Rick Baker – the alien make up artist – pulled out all the stops. He created more practical aliens and prosthetic make up for this film than the other two combined, and then some. 127 in total. The time-travel plot device was also the perfect conduit for fulfilling his childhood dream: recreating the 'retro'-looking aliens in the classic, sci-fi B movies and TV shows of his youth, and putting his own Baker-esque spin on them. "I was born in 1950 and had watched science fiction and horror movies on TV. I was really fascinated and always wanted to make 60s-looking aliens." From *War of the Worlds* to *Forbidden Planet* and *The Twilight Zone*, which had made way for *My Favorite Martian*, *Lost in Space*, and *Barbarella*, Rick – widely honored as a master of his craft – deftly reenacted the horror and wonder of the dawning space age, as it was expressed through the cinema of the times.

Two time periods in one film meant he could double the trouble. 2012 brought back *Men in Black*-looking aliens, but in 1969 it was all "fishbowl space helmets, guys in space suits with ribbed things on them, exposed brains, [and] bug eyes." This included playing with color. Bright greens! Bright oranges! And watch out for his utterly badass alien cameo.

Most of Rick's amazing creations do get their moment in the sun – but, sadly, not all. Not that that bothers him: he's used to it. "That's fairly common in movie making," shares Rick. "It is an ever-mutating beast." As always, Rick had a team of artisans who helped bring these designs to life – and Barry and Walter, for their part, would both eventually weigh in based on the franchise's now well-established tone.

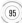

BORIS THE ANIMAL

"THERE IS NO PRISON THAT CAN HOLD ME."

REPORT: AGENT K

CLOSING REMARKS

DATE: JULY 17, 1969

Boris the Animal has been terminated and the Arc Net has been deployed. The Boglodites will now likely starve and die out, but assigning a team to monitor and maintain the Shield is recommended. Further study of the galactic shield's core properties is also needed. Without the Archanans, humanity would have been expunged. A new hero was made and lost today.

SIGNED, AGENT K, MIB NEW YORK

cc: Tech Team

E ven by Boglodotian standards, Boris was mighty vicious. Which made him a perfect scout for his planet's dying race. He was one of a few cast off into the universe on the desperate hunt for food, and first landed on Earth in 1967, twenty light years from home. Although viewed as a home planet hero, it's hard to picture Boris as a Boglodite 'of the people.' What was the driving force behind his pursuit of K? If we're being honest, vengeance. He didn't travel back in time to prevent humanity's race to the stars, he went to get his arm back... and also pave the way for what we saw as global invasion. From their point of view? Lunch.

Like many aliens in the franchise, Boris only *appears* humanoid. He, like all Boglodites, possesses deadly appendages, including projectile venomous arm spikes and a chest tube-tentacle. Boglodites can also survive in open space without oxygen or a protective space suit. No normal prison could hold him, and so he was shipped up to LunarMax.

"Our villain is played by Jemaine Clement," shares Barry Sonnenfeld, "who is an incredibly great New Zealand actor and songwriter, and has a deeply basso profundo kind of voice." Walter and Laurie had worked with him on *Dinner with Schmucks*. "They described him as a kind of erudite psychopath," remarks Jemaine Clement. "So, who wouldn't want to be one of those?" "He has to perform as though he has learned English as a second language," explains Barry.

 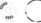 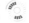

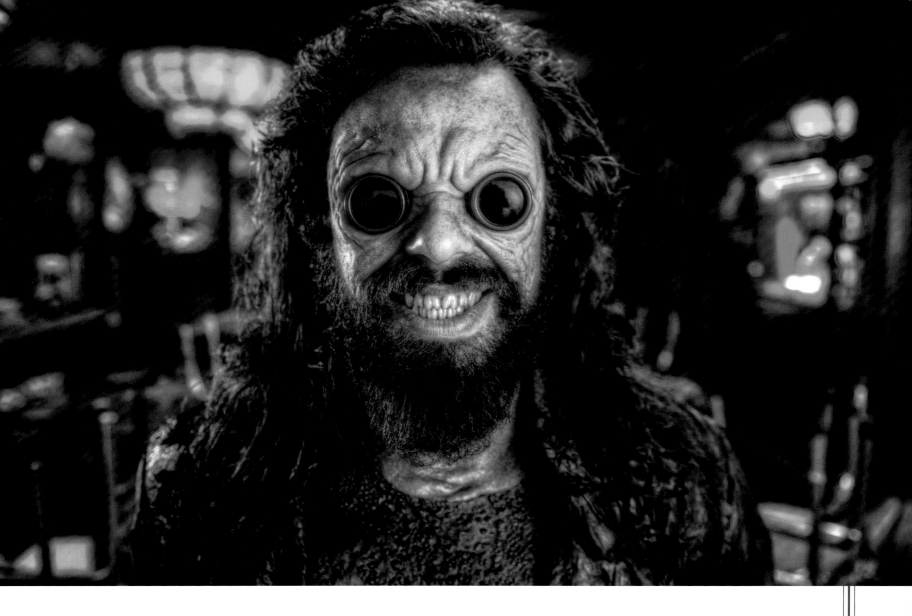

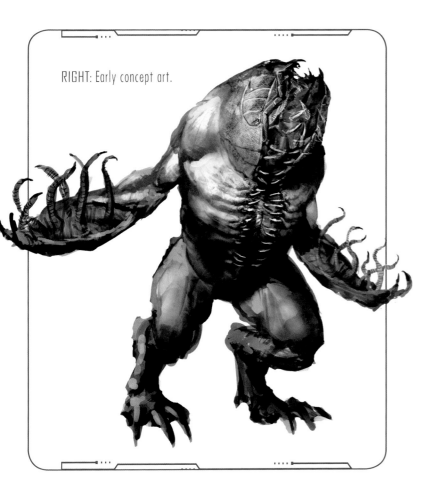

RIGHT: Early concept art.

"So we decided [he'd done so] through British diction tapes."

For Rick Baker, Boglodites embody a form of gluttony – a perversion of the human experience and what can happen when a person embraces outsized appetites. He knew that Boris' features, when in full bloom, would need to be realized in CG. It would require closely partnering with the Imageworks visual effects team, so it was handy that the head of that team happened to be an old pal. "Ken Ralston and I go way back; we've known each other since we were teenagers. We were influenced by the same stuff, and speak the same language. So, I was very excited that Ken was going to do this. And I thought, now we can do a really nice marriage of our techniques." Computer graphic work would do the heavy lifting when it came to Boris' more alien-looking expressions, but when it came to design they took their cues from Rick. "Rick did a great job in trying to figure out exactly what he should look like, *practically*. For us, it was more a matter of augmentation."

This included Boris' Weasel. "I did a design," shared Rick. "It had the this very 'fingery' kind of thing, that was on his arm, that looked like it could be something like jewelry. But then I thought he could use it, and throw that thing on people? And it would attack."

OPPOSITE PAGE: Boris' real feet (top). Deploying his Weasel (bottom).

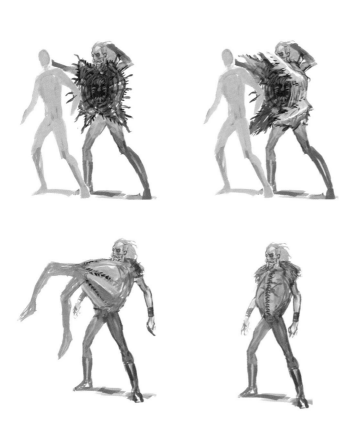

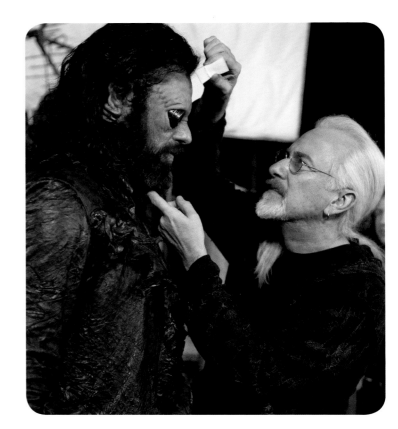

ABOVE: Concepts showing how Boris might feed (left). Rick Baker touching up Clement's face make up (Right).

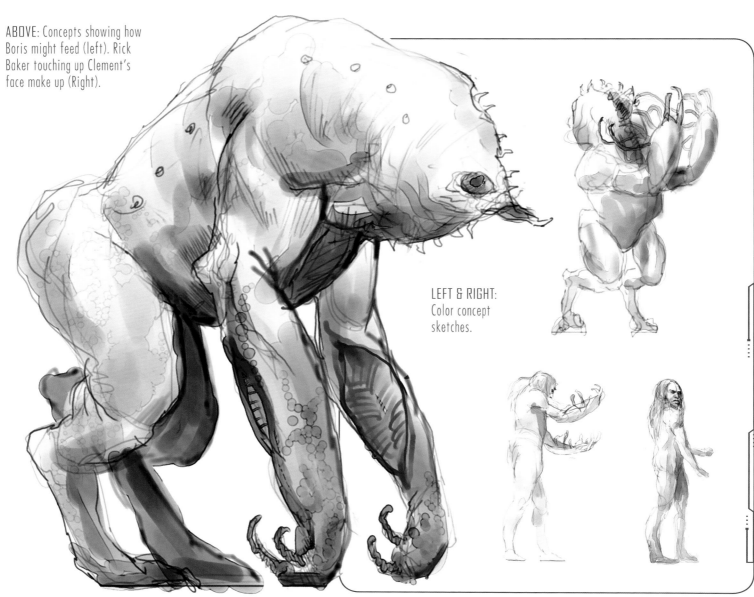

LEFT & RIGHT: Color concept sketches.

FULL METAL CHEST PLATE

Creating a costume for a one-armed character with a two-armed actor did present some challenges for costume designer Mary Vogt. Of course there was also blue screen and digital removal, but still, "*What are we going to do with this arm?!* We had these crazy fittings… and made a lot of appliances for him." But it turns out for Jemaine that was the easy part.

The script called for a metal chest plate. No problem. Mary used sculpted, cast rubber. "We painted it and when photographed, just looked *awful*. Terrible." Real metal was the next, if not only, choice. "He's only going to be in it for like, three days. Jemaine is really strong. He can handle it," Mary convinced herself. She went to an armorer (and bullet maker) in New York, and commissioned an *actual* metal jacket. "It came out beautiful. I mean, it looked *gorgeous*."

Having been in the rubber one before, Jemaine tried it on at the next fitting. "'Well, geez, it's kind of heavy.' I said, 'Well, we kind of had to ditch the other one. You're a big guy. Can you do it?' 'I guess so.'" Plus they'd made a place for his arm so it was stuck in the back, *and* the script called for him to be chained to a wall. So she advised the crew, "'Don't anyone say anything about feeling claustrophobic. Don't mention *anything* like that. It will be over soon.' — he was such a trooper about the whole thing," resolved Mary, sounding relieved.

BORIS' BIKE

"Bo designed the monobike and the Boris motorcycle," shares prop master Doug Harlocker, "but we took it over and were tasked (with his oversight), with embellishing all of the organics. The devil was in the details on both those builds, the engine and parts of the bodywork especially. Boris' bike was built from the ground up."

And what a build it was! "Custom frames from a Malibu chop shop, including the most powerful V Twin custom engines that we could find — all custom parts made by us or by boutique bike builders," says Doug. "The body work was output on multi-axis mills, 3D printed, and molded out of a variety of materials, including some that were translucent so we could light them from behind. The idea was to make the engine look like open-heart surgery. Lots of tech in a small package on that one."

Advancing technologies have made the process of design a very different task for Doug and his team than in years past. "The big change came in *Men in Black 3*. That is where the game changer was in terms of what kind of multi-axis mills we were using, and what 3D printers. We stopped using CAD programs and starting using Z-Brush, Rhino, and different rendering and 3D modeling programs that are much more robust. For all the great things that we accomplished on *Men in Black II*, the technology at the time was limited and challenging. You almost had to engineer each individual little piece and then hope that it all came together. Whereas now, you model the whole piece, explode the model, and reverse engineer it to accommodate whatever technology you need on the inside."

LUNAR MAX PRISON

ABOVE: Art department concept sketch of Lunar Max and its massive signal array dishes.

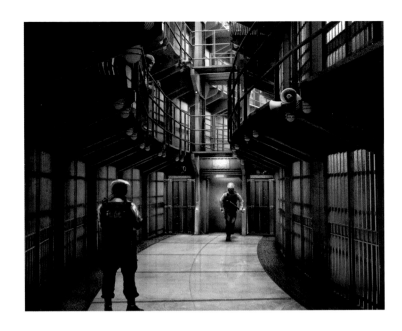

The terrific surprise of *Men in Black 3*'s opening sequence is the fact that Boris is on the moon. We begin in a small room, his home for the last forty years – a maximum-security cell. Inspired by *Dr. Caligari*, production designer Bo Welch's designs ensure no straight walls. It all kind of bends in. Disguised as a meteor crater hidden within the Cressium Basin, the LunarMax Facility is managed by the Intergalactic Department of Corrections. "The prison break was a really important scene for a number of reasons," explains Etan Cohen, including that it set up the trajectory of the film's villain. The prison was severely damaged during Boris' escape, which, with Imageworks' assistance, is presented as one long shot.

Shot at the Kaufman Astoria Studios in Queens, the lunar prison was designed to feel real. Imageworks extended the hallways and added various other set extensions. Prop master Doug Harlocker and his staff built out the armory, including assault rifles, submachine guns, handguns, etc. "Doug is kind of his own little industry," shares New York art director Chris Shriver. "He's a fantastic, creative builder of that. He gets his own illustrators and works out all of those pieces." And then there was the cake.

"A perfectly frosted pink layer cake," says the script, "right off the cover of the Betty Crocker cookbook." "The cake was one of the things that was a little harder for us because Barry really wanted it to jiggle," shares Doug. "He wanted it to feel like there was something *alive* in there. And so we made it out of a springy, silicone unit that was then glazed with real cake frosting and decorated, so it sort of jiggled a little bit." The challenge was silicone is kind of heavy. As often happens with props, he was negotiating the aesthetic vs. the practicality of the piece. "That one we really struggled with, but in the end, it turned out well."

THIS PAGE: Lunar Max hallway, concept sketch (top). Boris with his escape plan (middle). Early ideas for prison guards and aliens (below).

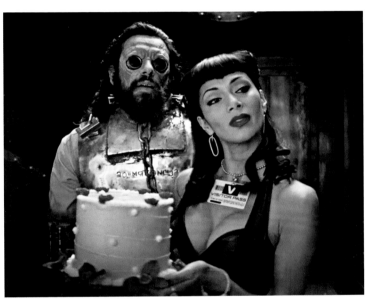

AGENT O 2012

"Don't ask questions you don't want the answer to."

As of Z's passing, Agent O – his chosen successor – became the new head of Men in Black New York. Liked and respected, she leads with an understated but firm command. As a Brit who landed in the male-dominated Men in Black New York of the early 60s, Olivia quickly established herself as a great technical designer, capable of harnessing alien technologies to suit Men in Black's needs, including a portable version of the neuralyzer. She may not be Z, but is politically savvy, having quietly and successfully navigated through the network over the decades. Bobo the Squat was one memorable battle where the real O got to strut her stuff – steely resolve, willpower, and grit under a sheen of elegantly coiffed professionalism. In Z's absence, Agent O 'soldiered on,' with a loyal commitment to the mission that he had exemplified.

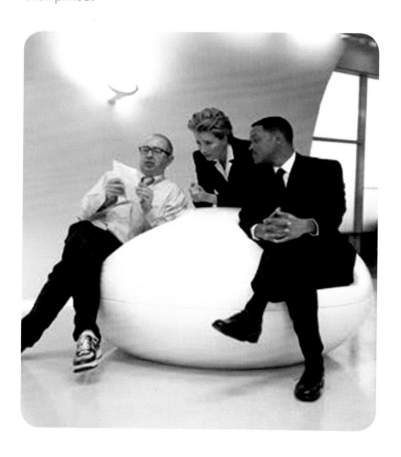

Producers Walter Parkes and Laurie MacDonald cast Emma Thompson to play the part of Agent O. "If you're gonna replace Z, Emma's not a bad replacement... she brings with her the quality which is essential to being in *Men in Black*," reflects Walter. "You play comedy straight." Emma Thompson adds, "My training is all in comedy, so I'm very lucky... You've gotta be funny, and you gotta hold your end up." Training indeed. Like Monty Python before them, "she started out with the improv group Footlights with Hugh Laurie and Stephen Fry, way back when," continues Walter. As a talent "she's just beyond. Plus [she] writes, directs."

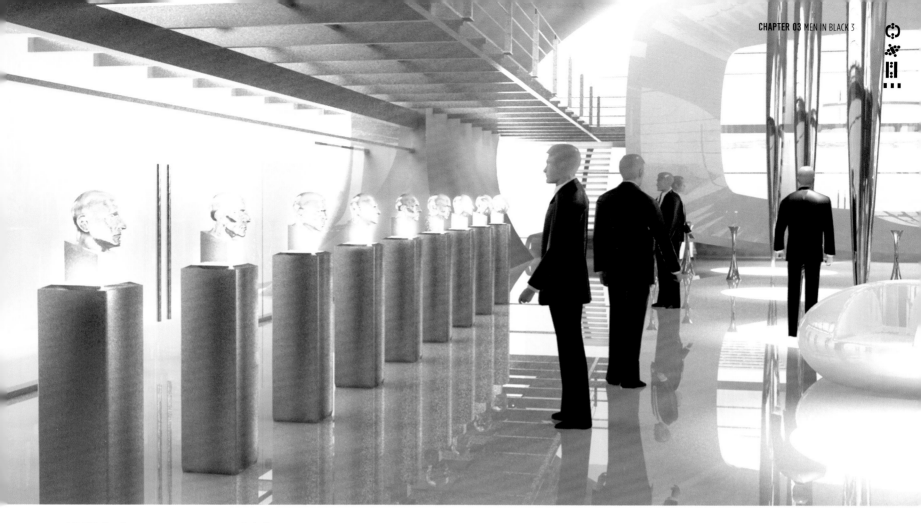

ABOVE: Art department concept art, main hall.

WALL OF HEROES

How does an organization which thrives on anonymity celebrate its fallen? Carefully. The Wall of Heroes is a memorial for exceptional agents who have passed, some in the line of duty. Records then get expunged. Men in Black agents don't exist, of course. But here? Now they never did. Each pedestal-mounted bust contains only a single letter – and the trademark suit and sunglasses. Hidden from the hustle bustle of daily life in Men in Black headquarters, the mounts temporarily rise out of the floor for specific occasions, such as Z's passing.

"Up until three days before we were going to shoot they were [physically] there," shares Barry Sonnenfeld. But the plan for that scene was revised. "We ended up taking them all out and recreating them digitally rising up out of the floor," he says. Originally "the busts were designed/drawn in the *MIB 3* art department," explains Bo Welch, "and sculpted and manufactured within the production." "Every time you see them," says visual effects supervisor Ken Ralston, "they are digital. No matter what the shot is. In fact, there are shots of Tommy, where [the camera's] coming over the crowd, and he's doing a speech about Z – it's all changed. Not just the head, but we replaced the back wall, the floor; everything is digital, except him and [his] podium."

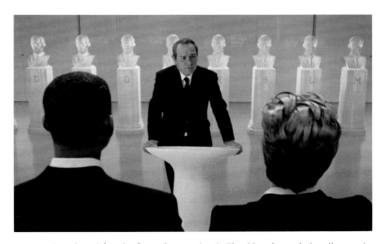

ABOVE: Storyboard for the funeral scene (top). The CG-enhanced shot (bottom).

WU'S DIAMOND GARDEN RESTAURANT

For aliens, Wu's is a place where everybody knows your name. Perhaps aliens kept coming back, not for its garish wallpaper or the lingering smell of brown sauce and sriracha, but because Wu served 'exotic' fare – the kind for which the restaurant never rose above a C health and safety rating. He continued to surprise with rarities such as the illegal Andromedal Crab, Spiky Bulba, and other unlicensed, extraterrestrial 'foodstuffs.' Nestled between Big Giant Fun Electronics and Lizard Wing Fat Wine, Agents J and K know the Chinatown hot spot well. Given how it all shook down, it may be a while before Wu himself dines there once again.

"Mr. Wu's was named after what used to be a Kosher Chinese restaurant in Los Angeles. The Shanghai Diner," chuckles Etan Cohen. "The things I get to do." After checking out a few possible New York-based locations, Bo Welch and Barry Sonnenfeld resolved instead to create the world themselves. "I love filming on set," Barry proclaims. "The clouds don't come. You shoot nights during the day. *And* you have total control. Bo and I love that. We kept scouting Chinese restaurants… but [we] are such style Nazis that we ended up building all of Wu's interior and exterior on the set. It's much more efficient, and you can pre-light everything."

"Wu's was the first thing we built," reports Chris Shriver. The crews had already been set up at Astoria, and "were just costing money. You can't send them

THIS SPREAD: Art department concept art.

REPORT: AGENT J

LOCATION: WU'S RESTAURANT

DATE: SEPTEMBER 19, 2002

RE: ROUTINE INSPECTION – ESCALATION

Addendum: Following encounter with illegally stored super-sized alien fish, will require additional funds added to personal, annual budget for suit, shirt, and tie replacements. Shoes and socks were also pretty seriously slimed in the attack.

Alert field agencies who monitor the south Atlantic to extra extraterrestrial traffic headed to and from Manhattan, specifically illegal trading of Andromedal Crab, Spiky Bulba, and whatever-the-hell that was that I killed.

For species management and ACS database division: This species has an unusually large heart for one that so closely resembles Earth aquatic vertebrates. Not so smart though, continued to attack even while under life-threatening circumstances.

SIGNED, AGENT J, MIB NEW YORK

cc: Chief Z; Apparel Dept.; Accounting – Budgets Division; Melbourne Subsidiary Base – Oceania Jurisdiction

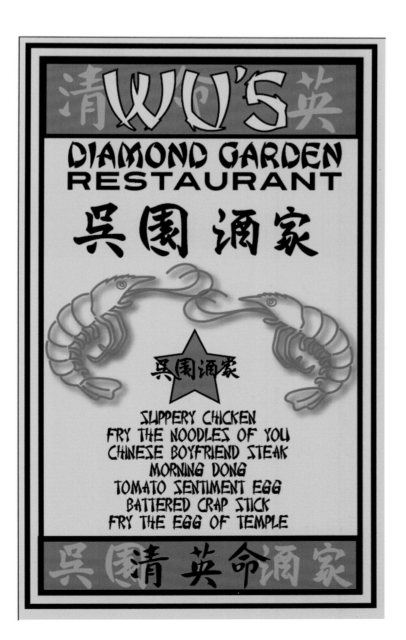

home, they go get other jobs and you don't get 'em back." Even after it was all built, however, it almost didn't get used. "The script went through so many iterations," announces Barry, "there was [even] a moment where it was taken out. Even though we had spent millions of dollars and it was ready to go." Somehow, after all that, "we were able to get it back in."

Rick Baker had a lot to do at Wu's, including what he called 'pass' aliens. "As soon as you see one, he gets shot, basically." He used a couple of UFC fighters, "and there was one very elaborate one that we called Dread." (In the film K refers to these as Chloropods, a Hydronian, and a Tarantabee – so named by Etan's four-year-old daughter.) And then there were the fish! "Barry found this picture on the Internet of this snot-colored lump of fish, with this really sad face, and a big nose," Rick says. "It's too stupid to design. You wouldn't design something to look like that. And it really exists, so [for Barry] we made something that looks exactly like this crazy, big lump fish."

Unlike LA, in New York, "animals fall under the prop department," reflects Chris Shriver. And so it went to Doug Harlocker to 'flesh out' the fishy details of Wu's restaurant. "We bought all the tropical fish – real fish – to fill the tanks," says Harlocker. "Before we blew them, we removed them." (No fish were harmed in the making of this movie.) Glass counters were stuffed with more exotic looking molded or sculpted fish heads, squid, and other rubbery things. Then there were the eyeballs… "I just happened to have some eyeballs on my truck one day and so we just said, 'Hey Barry, what do you think about an exotic noodle dish with an eyeball rolling around in it? You know, with shrimp and noodles?' He was like, 'OK, sure. That's my idea now.'"

THIS PAGE: Harlocker's fish heads (top). K knew where

SPIKY BULBA

Too cute to eat? Not according to Wu, or Boris. A favorite of his (much better tasting than human flesh) and, if correctly served, looks a bit like calamari. Unless you get 'well flushed' after dining, the bulba deposits eggs in the digestive system of any species that eats it. Intricately designed by Rick Baker, his team continued to enhance the little guy. "It's a beautiful sculpt… but we needed [the animatronic] to feel more alive," shares VFX supervisor Jay Redd. So they added some blinking, and a bit of breathing. "The audio track on it (with little squeaks and whines) gives it a whole other personality," adds Jay. "But once Tommy's character gets a hold of it," Rick remarks with a wry smile, "he proceeds to beat Mr. Wu savagely with it."

RIGHT: Another Rick Baker marvel. Sculpt and painting by Joey Orosco. Neck, mouth, appendages, and chest breathing mechanisms by mechanical designer Jurgen Heimann.

"Earth people get fish. Real Earth fis

 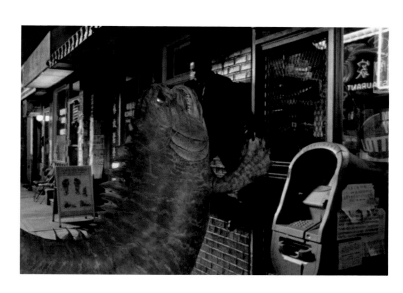

ABOVE AND BELOW: Sony Imageworks' then visual effects supervisors Ken Ralston and Jay Redd spearheaded these special effects.

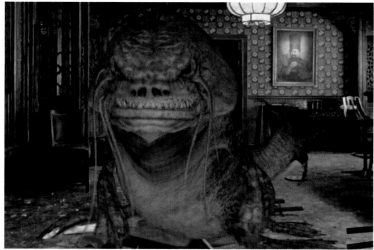

BELOW: Concept art of the explosive scene.

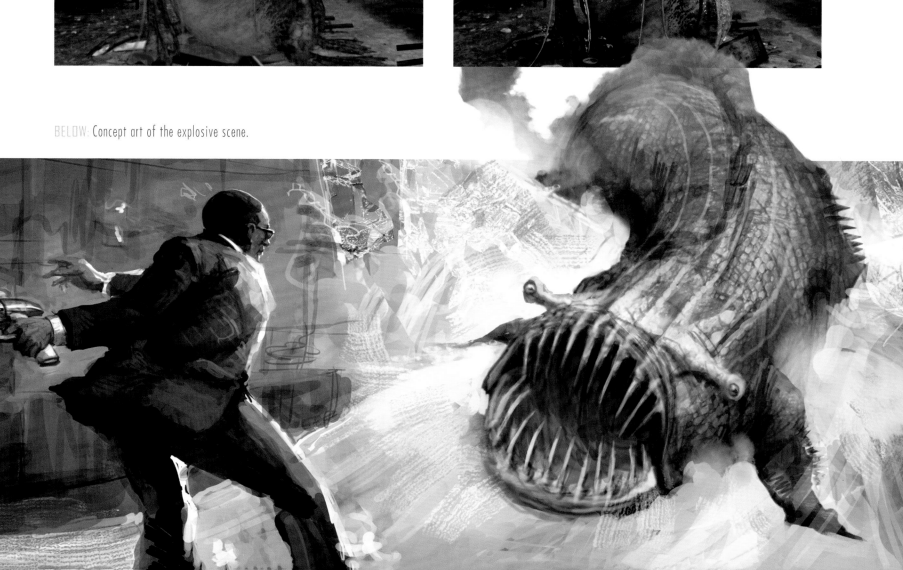

MR. WU

"THAT IS AN EARTH FISH. VERY TRADITIONAL IN CHINA."

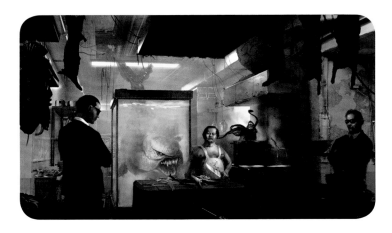

Mr. Wu, the multi-limbed, slug-like alien, emigrated to Earth in 1966. He donned a chef's apron and a faux, broken-English Chinese accent (for 'authenticity') and opened a Chinese restaurant. A former smuggler trying to build an honest life, start a family, and live the American dream? Perhaps. "To them, I'll always be an alien." In 1969, Wu played a role in thwarting Boris' efforts – in 2012, he gave in. Wu does sell illegal, extraterrestrial fish out of the back of his restaurant, but mostly the Men in Black try to work with him. But for helping Boris? Since Agents J and K saved the world from becoming dinner for Boglodites, the very alive Mr. Wu would now have to face an intergalactic court on multiple counts of conspiracy. In another version of the story, Wu has a badass submarine imported from his home world. Its hypercore would allow for supersonic underwater travel. Good for hunting and outrunning.

Wu is played by actor Keone Young. "Wu is revealed as an alien in just one shot," shares Ken Ralston. "He's a slug of some sort. Its all CG bits because we had the actor standing with blue leotards on."

THIS PAGE: Restaurant art department concept art (right). Baker checking on Boris' well-laid weasel quills (below).

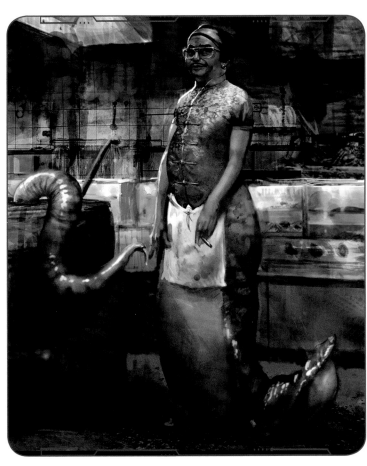

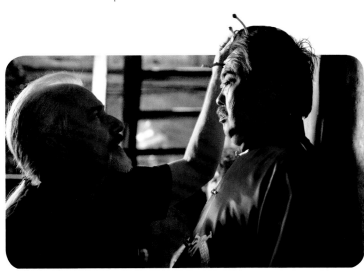

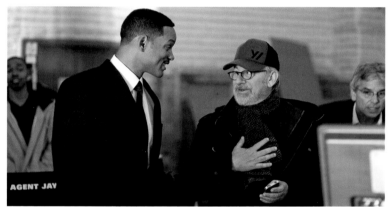

AGENTS' APARTMENTS

Surprisingly warm and lived in, K's apartment also housed a secret back room stuffed to the gills with his personal weaponry collection and other Men in Black agent paraphernalia (assembled by Doug Harlocker). In the 'no K/no Arc Net' version, the family now living in K's apartment are played by Barry's daughter Sasha and her daughter Violet. And in one of the many fun and personal plants, throughout the franchise, the next time you watch the film, take note of the mezuzah. "Barry knew my background… so when J goes to the apartment, he's like, 'That's for you, Etan.'"

The chocolate milk concept played out in that scene was created by uncredited *Men in Black 3* writer David Koepp — and was a much-contested detail. Some loved its specificity, some did not. The Astoria-based shoot also happened to be the one and only day Spielberg had a chance to visit the set, so he got to join in on the spirited discussion. So how did it end? As we all now know, reports Barry: "The chocolate milk is in."

ABOVE: Concept art of Agent K's apartment (top). Agent J's apartment (left). Will Smith, Steven Spielberg, and Walter Parkes on set at Astoria during the apartment shoot (right).

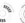

BOGLODITE INVASION

The Boglodite feeder fleets have a range of five thousand light years. They can house up to one hundred fighting Boglodotians and an even larger population of killer Weasels. These interstellar armadas are designed as 'species crushers.' Their home planet (some twenty thousand lights years away on the edge of Crab Nebula's claw) was wiped out by disapproving neighbors. Forced to hunt the galaxy for food, they travel from system to system. Once a tasty target is found (such as the Archanans), these voracious predators attack, harvest and transport. They've come far to reach Earth. In this 'no K/no Arc Net' version of reality, the Boglodites can enter our atmosphere and, with ships that resemble zeppelins, or giant floating squid, their vast network fills the sky, hovering above the landscape. In an homage to *War of the Worlds*, each ship's tentacle array can harvest prey species in large swaths. In the 'K lives/both Borises die' version, the Boglodites die off.

THIS SPREAD: Art department concept art.

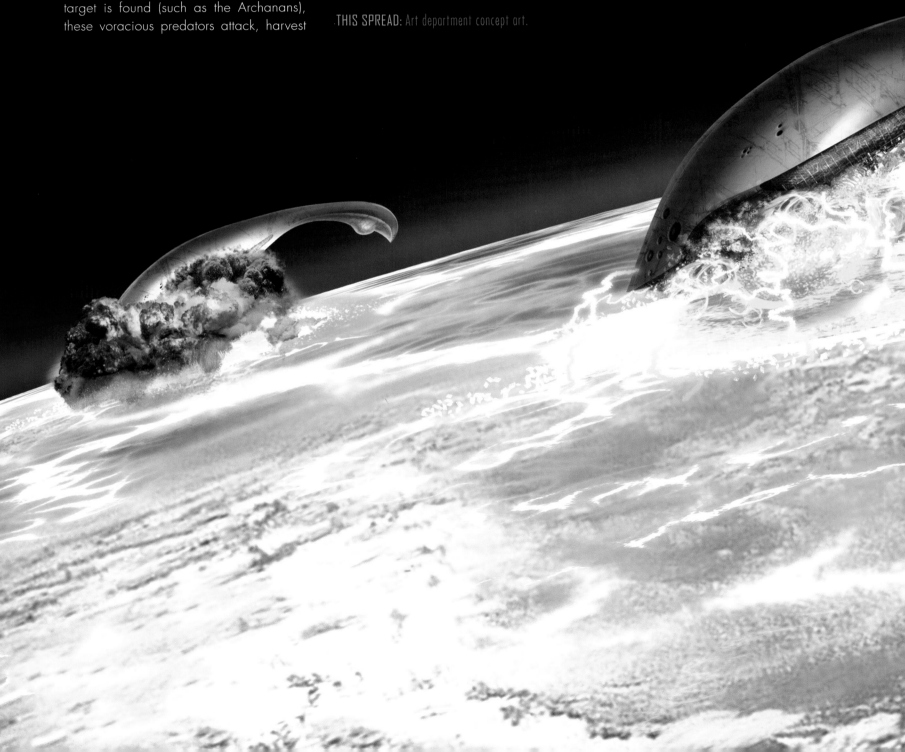

TIME JUMP DEVICE

"That design was a tricky one," reflects Doug Harlocker. "Barry really wanted that prop to be unique. It had to be interactive and yet not feel like a piece of technology. More reminiscent of a piece of jewelry or Swiss watch complication, it was important to have an alien date and time calendar component, moving parts, and an ethereal glow. I kept an illustrator on that project for a long time, trying to strike that balance. Eventually we got there. Like most things *Men in Black*, the final product was polished aluminum – in the shape of a tear drop, with buttons and lights." The hi-lo tech combination is a sweet spot for *Men in Black* designs. "That was half the fun. Whenever you thought you were getting a little too sci-fi? That's when you injected a bit of analog realism into it."

BELOW: Agent J takes a huge leap of faith.

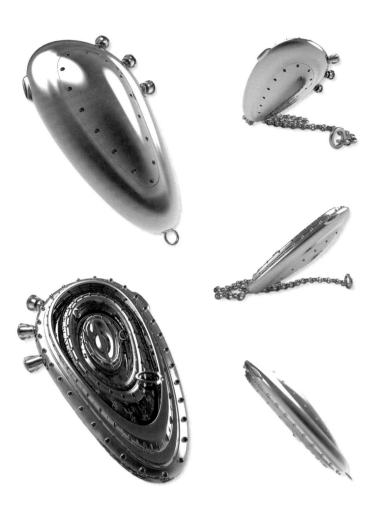

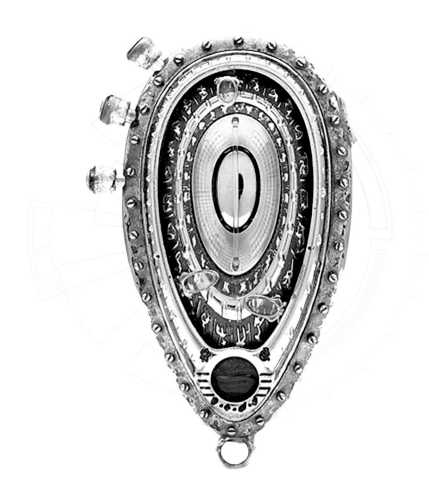

ABOVE: The time jump device from various angles. Designed and built by Doug Harlocker.

JEFFREY PRICE

Jeffrey Price is a bit of a squirrely dude. But relatively harmless – your basic, run-of-the-mill, New York-based alien masking as human. Although he barely knew his dad, he did develop a taste for Obadiah's line of work, selling trips into the past with Time Jumpers. (He'd held on to the few his father had stashed away.) Once old enough, he began using his unassuming customer service gigs (such as an "Always Going Out of Business" electronics store clerk – an homage to Crazy Eddie?) to peddle illegal adventures in time. Known to the agency since before Boris escaped, the Men in Black went easy on him for having helped J – after returning all the Time Jumpers, of course.

RIGHT: Jeffrey Price is played by American actor Michael Chernus.

"IF YOU SURVIVE YOU GOT TO COME BACK AND TELL ME EVERYTHING, OKAY?"

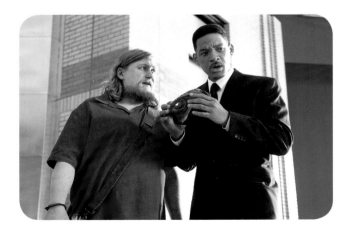

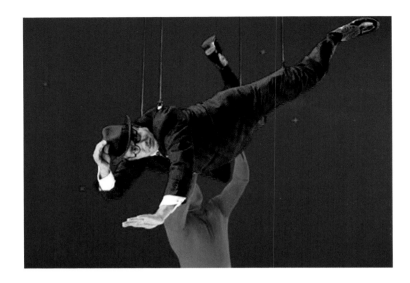

ABOVE: "That's me committing suicide," shares Barry Sonnenfeld. "When Will is jumping off the Chrysler Building? He goes through 1929 and the stock market crash. He looks over."

ABOVE: Imageworks built out a small, gargoyled corner of the art deco skyscraper.

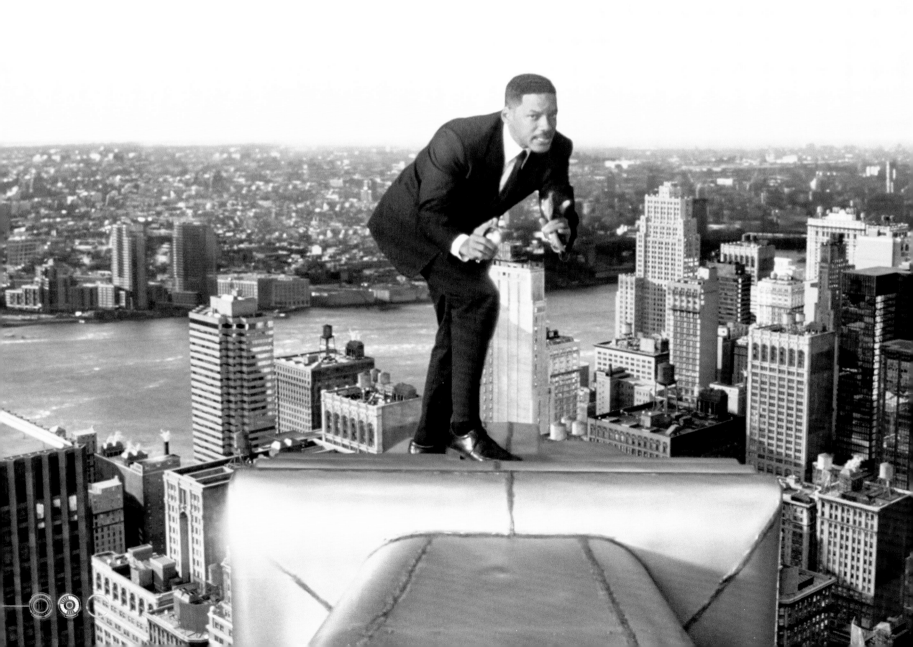

TIME JUMP
THROUGH PLANETARY HISTORY

Time jumping is forbidden to humans. The Men in Black outlawed time travel throughout the universe *for a reason*. Aside from causing temporal fractures, there are so many other ways such a leap can go sideways – only the foolhardy or the desperate would attempt it. Don't do this at home! If you don't manage to erase yourself from the time-stream or break the laser-line before hitting terminal velocity, you could still lose that time device and end up stuck wherever you landed forever. The Archanans used their devices because jumping could also create temporal vortexes outside the realm of time and space. Probably a nice break for them, but for humans? Not the wisest choice, if it can be helped.

Obadiah Price was not a very crafty thief. In fact, he stumbled upon that crate of Archanan Time Jumpers accidentally; he never *intended* to steal them. Luckily for J, once both Borises had been killed, his return back to the 'future' via the time jump's boomerang wave was without incident.

Jumping puts planetary history on visual speed dial, and it was a major special effects scene for the film, managed by Ken Ralston and his team at Imageworks at the time. The entire scene is very stylized. Surreal. "What I wrote for that scene," Etan Cohen explained, "is that Agent J would travel back in time, and see every type of person, every type of creature, who has ever lived on the island of Manhattan." "We got to not only see the dinosaurs," reflected Ken, "but the Wall Street crash… it was just nuts, the whole sequence, which is what was so cool about it."

BELOW: Barry Sonnenfeld and Etan Cohen have a taste for historical irony. Circa 1930, the Chrysler Building enjoyed a brief window as "The Tallest Building in the World!"

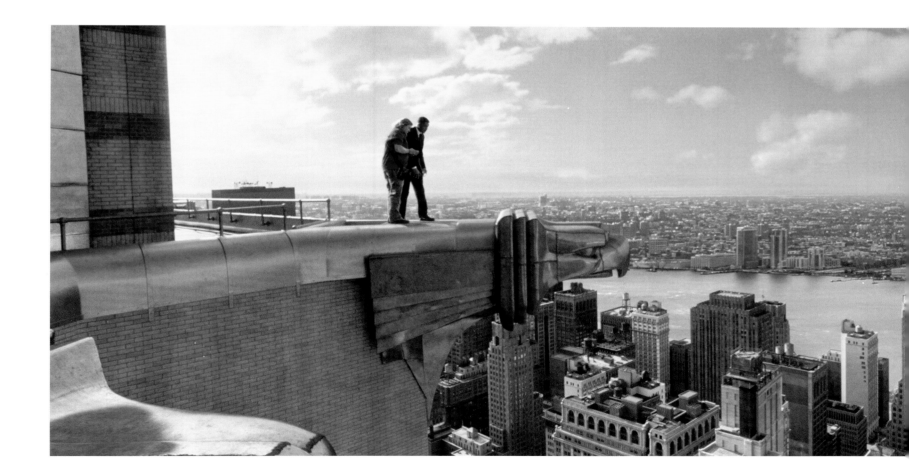

 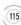

MEN IN BLACK IN THE 60s

One of the many themes running throughout the *Men in Black* franchise is optimism about the future. Without digressing too far from its core sensibilities, each decade has a look. And for the 1960s, the filmmakers wanted to embrace the complex spirit of the times. From the space race to the rise of pop art, to miniskirts and electric-green brain guns, "the campiness of the 1960s *Men in Black 3* was completely intentional," explains Walter Parkes. It's particularly good fun watching future Will/Agent J confronting racial tensions head on, with a knowing smile and his endlessly suave comedic sensibilities.

The women's costumes were slightly sexier, and there's much that's bigger, boxier, and more cumbersome. Will's suit is a 'smidge' looser. Josh's, a bit boxier but not to the point of being unflattering. "It's still a very square shoulder and a little more buttoned-down," explains Mary Vogt, "which is more 60s than we ever did before." And the sleek, two-door 1964 Ford Galaxie, with its fastback roof design, and those tails! All Men in Black cars have a certain amount of cool to them, but everything about this one evokes space travel.

BELOW: Barry Sonnenfeld directing the first scene. With Will Smith acting opposite, this was Josh Brolin's first scene on the production (left). Bo Welch concept art for the main hall (bottom).

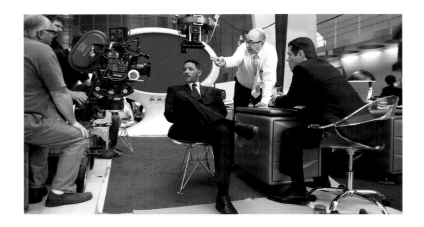

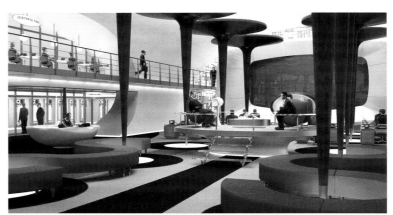

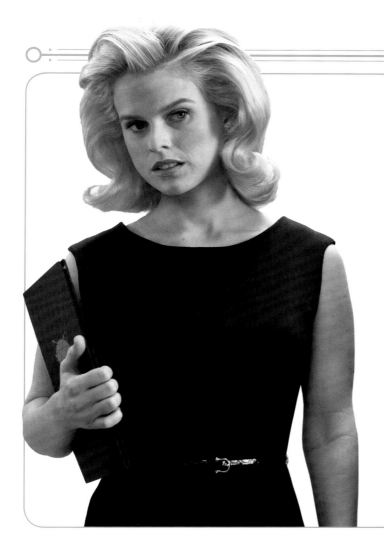

AGENT O 1969

A woman ahead of her era, young Olivia (now Agent O), had been recruited out of the UK field office to work as the secretary for the head of the Men in Black New York, Agent X. The chief thought O would make a terrific secretary — in time she proved to be vastly more capable than her boss. Olivia spearheaded the creation of both the jetpacks and the handheld prototype neuralyzers. (Based on the version Agent J brought back with him.) This tiny device became the backbone of Men in Black secrecy, thus securing a future not only for the organization but also her rise to agent status. In the years that followed, she catapulted up through the ranks. Eventually Chief Z handpicked O to be his successor. Did Olivia and K begin a semi-serious, on-again-off-again relationship back in the day? They'll never tell.

LEFT: Agent O is played by British actress Alice Eve.

The 1960s headquarters favored the wood-grain and earth colors of that period's time. Bo Welch, of course, maintained much of what makes the headquarters recognizable, but "I also took license in tweaking black towards a little bit of brown," shares Bo, "and I have one other color introduced: orange. Because to me, orange just *screams* 1969." And where 2012 is devoid of details? Let the carbon paper fly. Desks were strewn with 5-lb, hardwired, jet-black phones, punch cards, and other state-of-the-art office equipment and supplies.

"What's interesting is that some of the devices in 1969 seem even more futuristic than what we have in 2012," reflects Barry Sonnenfeld. And that was by design. "If you stay too far ahead of your time," explains Bo Welch, "then you haven't capitalized on the joy and fun of time travel, so the decision was, they are slightly ahead." Whether futuristic or retro, technology is where the art department really stretched. Bo and his team aimed for clunky, outsized, and ironic, not outright hilarious. "When I get into the design of the weapons I'm not designing them to be humorous," shares Bo. "I have to put myself in Men in Black in 1969 and ask, 'What would it really be like?' So none of it is ever for laughs, it just happens to be funny." The guns, for example, are all based on tube technology.

RIGHT: For the headquarters, Bo Welch was also inspired by the work of many architects, including Frank Lloyd Wright's Johnson Wax Building.

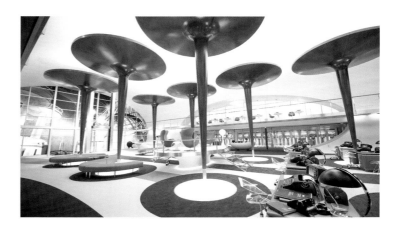

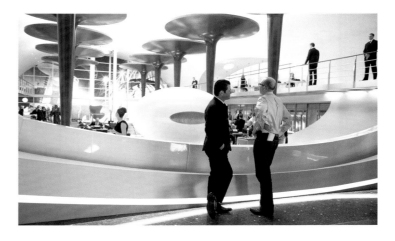

ALIEN ADVENTURES
RICK BAKER'S MAKE UP SPECIAL EFFECTS

Prior to *Men in Black*, Rick Baker had already burnished a reputation as one of the great make up artists of his generation. By 1996, he had four Academy Awards under his belt (now seven, including *Men in Black*), and stands out in a passion-driven business as one of most devoted students of his craft. He's always sought mentors throughout his life, and is quick to share opportunities with young talents, often mentoring and advising them on how to navigate the quixotic world of make up effects. With a thick mane of Gandolfian, ponytailed white hair, he's known for his playful generosity – and was a bit of a jokester on the *Men in Black* sets.

"You want Rick," shares Barry, "because he's the best in the world. And you never think you can get him." At ten years old, this self-described "make up geek" knew what he wanted. With no familial ties to the world of filmmaking, he made his dream come true, and reshaped the industry through his contributions. He remains in awe of the work of greats that came before. Jack Pierce (*Frankenstein*), Lon Chaney (*The Wolf Man, Phantom of the Opera*), and his close friend – and mentor for over forty years – Dick Smith. "Rick led by example," shares his long time animatronics specialist, Mark Setrakian. "He's a great artist, but he's also a master

of all of the crafts of special make up effects. He could design a character, sculpt it, make the molds, run the foam, seam the pieces, paint them, apply them, do the hair work, all at the highest level of skill. Rick attracted the most talented artists in the world."

The list of directors and talent he's worked with is staggering. He's done make up for Angelina Jolie, Eddie Murphy, Jack Nicholson, Jim Carrey, and Jeff Bridges. He's worked with Steven Spielberg, Guillermo Del Toro (*Hellboy*), Tim Burton (*Planet of the Apes*), Mike Nichols (*The Wolf*), Michael Apted (*Gorillas In the Mist*), Michael Jackson's mask creation for *Thriller*, George Lucas's band in the cantina scene in *A New Hope* and recently consulted on *X-Men: The Last Stand*.

From *Gremlins* onward, Spielberg's Amblin has enjoyed a congenial long-term relationship with Baker. For *Men in Black*, Steven and Barry gave Rick a lot of room to create (no *Star Wars* cantina redos here). When it came to creature details, the scripts left everything to the imagination. What designer doesn't love that? "The worm guys," for example, reports Barry, "were totally Rick's idea." I always wanted to do unique stuff and make him head towards a more slightly

BOTTOM LEFT: Rick Baker and many of his *Men in Black 3* creations.

BOTTOM RIGHT: Rick on the *Men in Black II* set with "Flapjack."

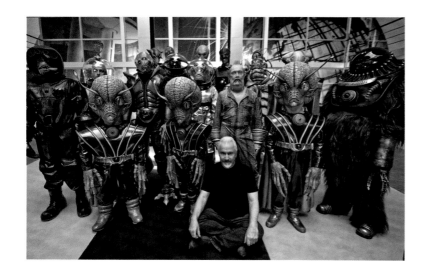

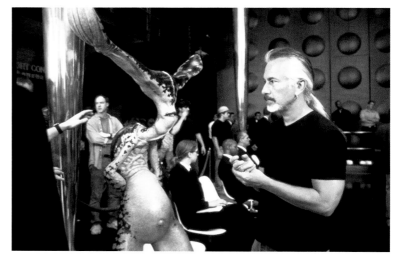

banal, humanoid, kind of feeling, so Rick was very patient with me. But I loved working with him."

It took a beat to land on the film's tone, but the humorous strain was always present, and this is the thread Rick tugged on the most when it came to *Men in Black* creature designs. Character, and a sense of everyday realism (vs. a showcase for special effects), was also a design goal. The worm guys, Mikey, Mr. Gentle, all had distinct — and equally memorable — personalities. "Rick's stuff is not just imaginative, but really witty. There's a spin on all of it, and a great sense of humor operating in his work," remarks Walter. (Renowned critic Roger Ebert perhaps said it best, in remarking that he felt he was seeing the next generation of the seven dwarfs: Slimy, Gooey, Icky, Creepy, Sticky, Barfy, and Pox.)

His contributions always far exceed the make up chair. And in the ironic world that is *Men in Black*, Barry Sonnenfeld appreciated that — like Bo Welch and Doug Harlocker — Rick thinks like a filmmaker. Where Bo brought the whimsy, Rick brought the wit — and a playfulness to his creature design. Bo began before Rick, and did some pinch-hitting to fill his spaces with… *something*. "When you try to do it, you realize how good Rick is. It's a very difficult design job. Leave [it] to the geniuses of alien creation, among whom Rick is the king." Out of respect, each did stay in his lane. What Bo *did* create was a headquarters that would best showcase the colorful, vastly intricate and wildly singular characters coming out of Rick Baker's shop. They are why Bo chose stark whites, and an overall monochromatic look — so Rick's aliens could pop. "The stuff that's cool is the aliens. So you want to create an appropriate frame for them," explains Bo.

Over the arc of *Men in Black, II,* and *3,* Rick's Cinovation Studios, a 60,000-square-foot facility, was one of the busiest make up effects studios servicing the feature film industry. For *Men in Black,* he had a staff of seventy, and added contract specialists in puppetry (Tony Urbano) and other fields across the spectrum, from low to high tech. While ramping up his team for *Men in Black,* he invited a little-known animation designer, Carlos Huante (*Blade Runner 2049, Prometheus, Arrival*), to interview. "MIB is where I established myself. I got a call from Rick Baker to put some of my work into the pot with everyone who was anyone. The first meeting at Rick's place was [like] the great knights at the round table. It was all the guys I respected but didn't know. Pretty cool."

Until the onslaught of the CG era, the suite of skills and materials required to ply his craft had changed very little since the days of silent black and white films — and the fine art of shading and highlighting goes back to the ancient Egyptians. Within that long legacy, Rick Baker's studio was unique for our time. And for *Men in Black,* he pressed all his studio tricks into service. "I made more aliens for [*Men in Black 3*] than both of the other two *Men in Black* combined. Times ten. [And] we did more drawings on this one film than I've done in my whole career put together." Overall, he delivered 127 unique aliens for *Men in Black 3.*

Rick's win in 1997 for Vincent D'Onofrio's make up on *Men in Black* was his 5th Academy Award, and in 2012, he received a well-deserved star on the Hollywood Walk of Fame. Now, in the twilight phase of his career, he keeps quite busy, and chooses his projects very carefully.

MEN IN BLACK HEADQUARTERS
THROUGH TIME

"You know, that's the trouble with sequels," chuckles Bo Welch, "is you try to outdo yourself." His first reaction to the *Men in Black 3* script? "I thought, 'Oh, no. I've painted myself into a corner. [I'm] supposed to show something earlier than the previous headquarters? And then a later version?!'" Barry Sonnenfeld's thinking was the same. "Bo and I didn't want to update the headquarters. Our feeling? It's been this way forever; since we first saw aliens [in 1961]." They've got bigger fish to fry than to bother with a remodel. "Once you know that there's so much more out there," suggests Barry, "your concept of fashion, what's in and what's out, goes away."

But then again, they are making a movie. So they tweaked their previous thinking on the subject. "For *Men in Black 3*, we basically had to chuck that idea and say, 'OK, the first one predated the original one,'" shares Bo. And for Men in Black

2012? "As it turns out, they did upgrade. So, it was a real challenge, design-wise." Barry also embraced the revised approach. "It's been ten years," he reflected, "And we thought 'Let's have some fun. Lets design two different Men in Black headquarters. Let's decide that there was a changing aesthetic.'"

And so they proceeded. "In bringing the Men in Black headquarters deeper into the twenty-first century," describes Bo, "I wanted to have a clean, modern look. Because all of the aliens, and the agents, look better in a well lit, clean, and crisp environment. But moreover, there is also a slight modern, futuristic, sterile quality that we don't have in the rest of the world, that I find refreshing." So the 2012 headquarters is a more stark, white, grey, and black environment. "We made a conscious effort, for instance, to not see any paper," shares Doug Harlocker. "Files are passed by media cards and flash drives. And so,

BELOW: Bo Welch concept art for 2012 headquarters.

OPPOSITE PAGE: Headquarters (2012), built on stage at the Kaufman Astoria Studios (top, center). Hey, is that a spaceship hovering above the Brooklyn-Battery Tunnel? (bottom).

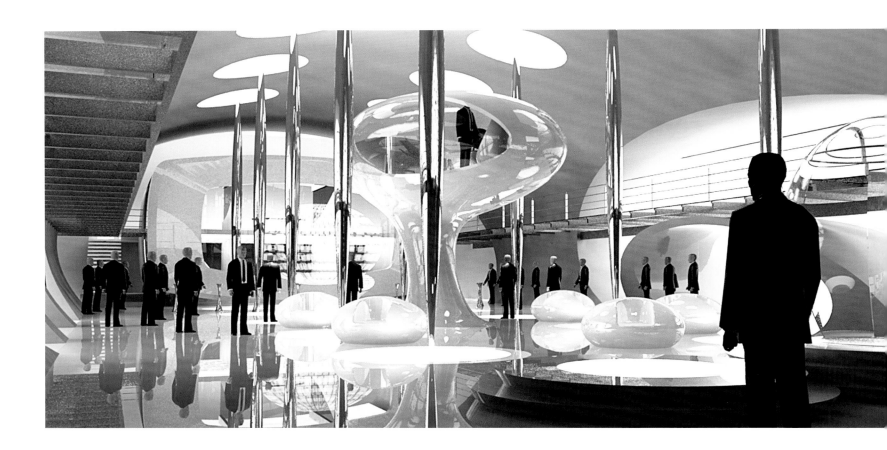

very austere, very beautiful."

The lobby, however, is one space that did not change much across all three films and four sets. But the experience of set dressing the fan room responded to the times. "Because 9/11 had happened," reflects Chris Shriver, "security was much higher and they wouldn't let us just expose it the way we had in the first one. So, we had to redo all those security fences. We didn't change it, design-wise, but because of the circumstances we had to approach it a little bit differently."

Overall, designing the headquarters for *Men in Black 3* was a big squeeze for everyone in terms of both budget and schedule. "It was a real challenge," reflects Bo, because "you're asked now to do two Men in Black headquarters within the same shooting time frame." So how'd they pull it off? "We basically built it once, and then remodeled it." It was a very complicated shape, so "it was the same space, and it was the same shell." There were other factors as well. "We built it in the Armory, which is not really a proper stage. Normally on a sound stage you can hang chains and scaffolding and stuff from the ceiling. In this case, the ceiling was so high and it wasn't really designed to have things hung from it. So we had to build our own grid, basically, from which to hang the set. It was an enormous undertaking… and there was a lot of steelwork involved." The change of seasons was a factor as well. "In that building, in the middle of winter it's freezing cold. And then in the summer it's boiling hot. So it [was] complicated." There were two full construction departments, reports Chris. "The Armory had its own department, own coordinator, own crew, own everything. And they built everything in [there] — both versions of the headquarters, plus the jetpacks."

How did it all turn out? The original (*Men in Black*) remains Barry's favorite. "I think it's the purest. Each time we tried to make it bigger, but sometimes when you [do that], and you make things wider, you stop seeing the edges of sets. So you get less of a tunnel feeling? At it's purest was the Saarinen [-inspired] TWA at JFK headquarters design. I think the more we tried to make it better, the less perfect it was."

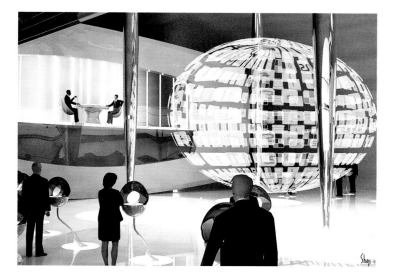

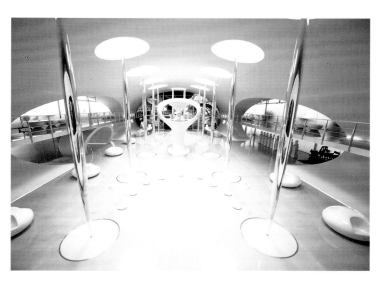

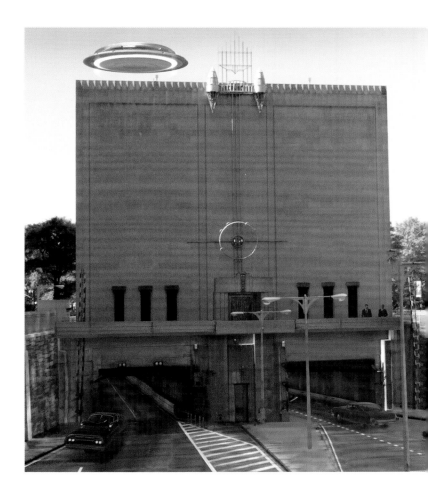

> **"** I PROMISED THE SECRETS OF THE UNIVERSE, NOTHING MORE."
>
> AGENT K

> "SO WHAT, ARE THERE SOME SECRETS OUT THERE THAT THE UNIVERSE DON'T KNOW ABOUT?"
>
> AGENT J

AGENT K
1969

> **"YOU SURE HAVE A LOT OF INFORMATION FOR A FELLA WHO DOESN'T KNOW ANYTHING."**

"I tell you, there's one hero in that movie for me," proclaims Walter Parkes, "and it's Brolin. He's unbelievable. He's the most perfect Tommy Lee Jones imaginable." Did he prep for the gig? You bet. While doing fittings with Mary Vogt, Josh was constantly running tapes of Tommy Lee talking. "He was trying to get his voice down. He put a huge amount of work into it."

"The greatest thing that came out of *Men in Black 3*," confesses actor Josh Brolin, "selfishly, was being able to pull off that character." The lucky chemistry between Tommy Lee and Will is the stuff of movie history. The question might not have been who would play Tommy Lee, but who would dare?

It all started with a bit of fun. Barry Sonnenfeld met Josh at the DGA Awards Dinner, when he and the Coen brothers were up for *No Country for Old Men*. Barry was the Coens' director of photography way back when (and won that night for *Pushing Daisies*). While doing impressions, including Tommy Lee, Josh made a good impression. "I knew, that night, he'd be a great TLJ," shared Barry. "Nobody had ever done Tommy," comments Josh. "No comedians had ever gotten on stage to do Tommy. I think part of it is because of his cadence? It's constantly changing with him. The way he speaks is so utterly, completely and absolutely HIM. Tommy also has this way of speaking, as though he's messing with you all the time. That he's not taking what you're saying seriously. Ever."

Josh could not have prepped any harder. "I think the only other role I've researched that obsessively was George W. Bush." He hauled off to Mexico (no phone reception), and studied Tommy's past performances. "I would watch *Men in Black* over and over and over... and say a line until I got it. You try to make it personal? So that you can do it no matter what. If you're just mimicking, it doesn't really work." Or as Walter says, "Josh couldn't do an impersonation of Tom, he had to do an interpretation of the character that Tommy plays." But again, reflects Josh, "even if I pull off the character? You either have that chemistry or you don't."

Using the Alexander Technique, he worked on Tommy's movement as well as his cadence. His secret sauce, however, may have been prosthetics. (Who knew?!) "We had cheeks for Tommy, [and] my buddy Christian Tinsley (make up artist, *Westworld*, *American Horror Story*) had found a bust of him." They used Tommy's actual nose, lengthened the ear lobes, and darkened Josh's brows. They worked up nearly his entire face. The physical challenge was to 'bear down,' so it didn't appear cartoonish. "I've worked a lot with prosthetics. So it was fun to be able to find a character through that."

It might be fair to say it worked out. "What was amazing was... I kept thinking I was directing one actor," reflects Barry. "The performance was so consistent that it was really hard for me to tell where Tommy Lee Jones ended, and Josh Brolin

began." Will's experience was the same. Known at the time for serious dramas, Brolin has since taken an even deeper dive into the worlds of sci-fi/comedy blockbuster franchises with *Avengers* and *Deadpool 2*. "It was a big learning curve," reflects Josh. "It's such fun watching us. Hard to pull off, but fun."

And so what happened to K? Well, we know love lost had a big something to do with it. Here is Etan Cohen's take: "Forever thereafter he would have to deal with the reality of J's dad's death. He inevitably, through no fault of his own, or no forethought of his own, ultimately (in this sort of philosophical world of the movie), was the cause. And so he was forever making that up to him by... keeping tabs on him the whole time he was growing up. And when he was ready? He came to get him."

ABOVE: Agents J and young K heading for the surface.

> **"It really was a dream come true, being asked to do something like this. But then, how are you going to break up one of the iconic duos in movie history?"**
>
> JOSH BROLIN

WEAPONS
1969 VS 2012

Men in Black 3 required two new looks. One for 1969, and the other for 2012. And by this third film? "We were all like, 'This is gonna be *really* fun,'" shares prop master Doug Harlocker. The art department made it their mission to distinguish this line of weapons from the first two films. At first Doug thought, "'Oh, it's gonna be tough.' [Because] we really wanted to go a different direction."

Time travel gave them an opportunity to do retro, *Men in Black* style. In designing them, however, Bo Welch never intentionally goes for the laugh. "I don't design funny… they just happen to be ironic." In his imagination, he put himself inside this alien-infused, highly stylized world of the Men in Black, 1969. "We made some really beautiful, powerful weapons for 2012, that are very sleek and next-generation," Doug remarks proudly. They really nailed it. All the new weapons have a slight retro-y thing going on. Slightly oversized, and yet streamlined. Plus fins. "I'm *really* in love with the new standard issue that we made," says Doug. "And then, based on tube technology, we made standard issue weapons for 1969 [that] look like a tube TV, combined with a gun." And with today's methods? "Milling aluminum can now be done effortlessly."

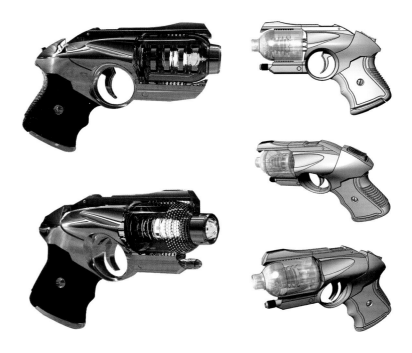

ABOVE: Agent K's 1969 ankle gun.

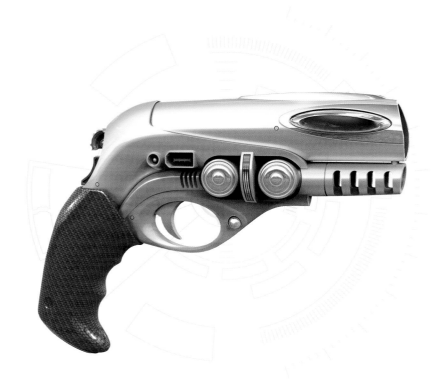

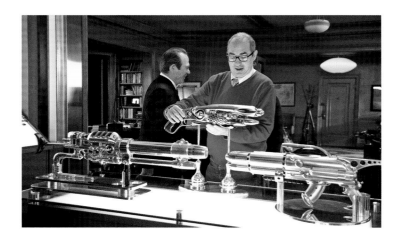

THIS PAGE: 2012 Particle Randomizer Gun (above). Will at Wu's (above right). Barry Sonnenfeld and Tommy Lee Jones in K's apartment with his weaponry (bottom).

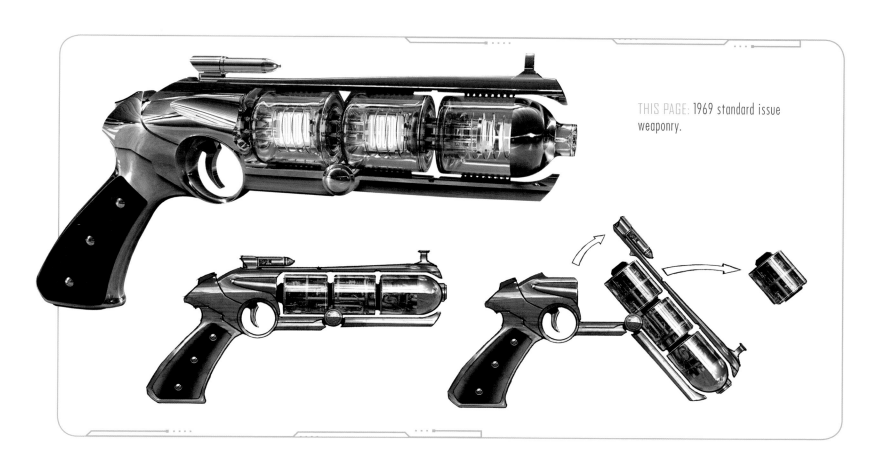

THIS PAGE: 1969 standard issue weaponry.

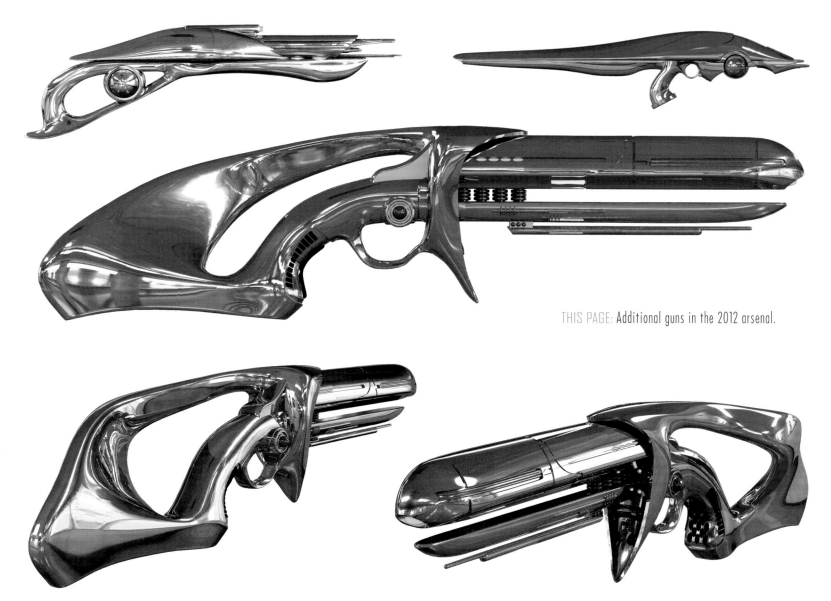

THIS PAGE: Additional guns in the 2012 arsenal.

NEURALYZER ROOM

The neuralyzer, a mind-wiping instrument, was the first alien technology the Men in Black perfected. If the Men in Black were knights, it would be their sword. But back in 1969, their first prototype, powered by tubes, was far from portable. The official Men in Black neuralyzer got its own room (Room 43), and was "about the size of a cement mixer," remarks producer Walter Parkes. But not like any kind of mixer we've ever seen. With space to spin, a gurney, straps, and a bite guard, Bo Welch drew inspiration from the MRI, where witnesses get rolled in one at a time, have a few memories erased, and

are spat back out. The 'portable' version fit on an 18-wheeler. "For 2012, our technology got smaller and cleaner," remarks Bo. "For 1969? Large and clunky." It had some future tech aspects to it although, at four inches thick, the hefty flint-grey barrier young Agent K stands behind perhaps has more in common with a submarine door or an army EOD shield. Both pieces were tributes to irony and exaggeration. In later years the Men in Black tech unit learned the optic nerve was the proper target area. Back then? Their machine successfully removed conscious knowledge of the past — and sometimes motor function as well.

BELOW: Art department concept art for the interior of the 1969 neuralyzer (left). J desperately trying to get through to young Agent K (right). Art department fashioning the mechanics for the neuralyzer gurney (bottom).

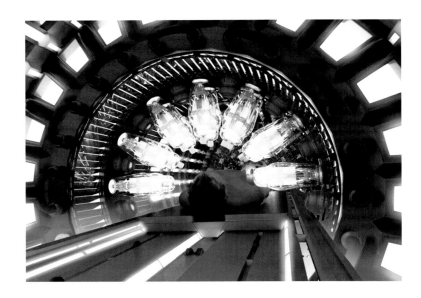

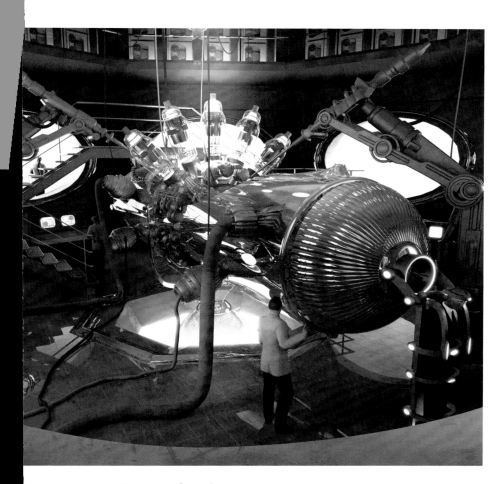

ABOVE: Concept art of neuralyzer room.

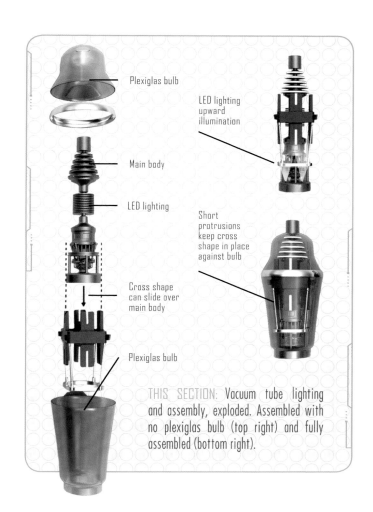

Plexiglas bulb

LED lighting upward illumination

Main body

LED lighting

Short protrusions keep cross shape in place against bulb

Cross shape can slide over main body

Plexiglas bulb

THIS SECTION: Vacuum tube lighting and assembly, exploded. Assembled with no plexiglas bulb (top right) and fully assembled (bottom right).

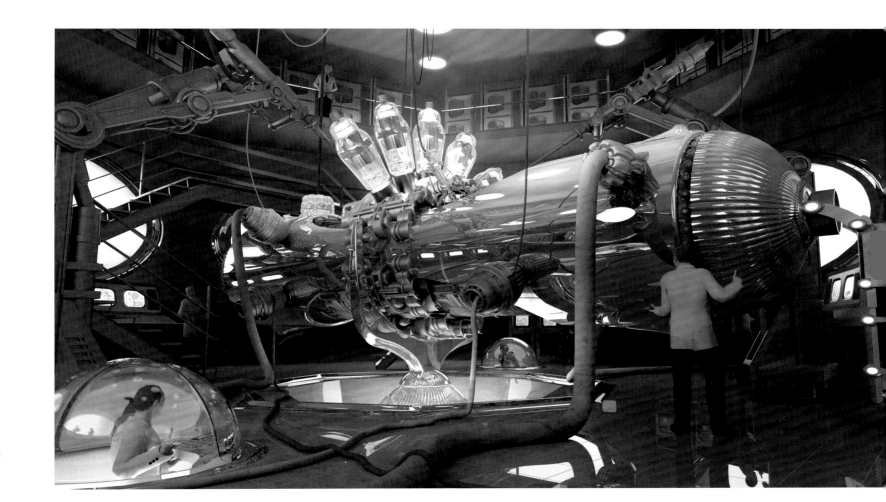

GRIFFIN

"It's always October, and November, and March... so many futures. And they're all real. Just don't know which one will coalesce. Until then, they're all happening."

REPORT: AGENT K

CLOSING REMARKS

DATE: JULY 20, 1969

SPECIES: ARCHANAN (LAST) STATUS: RESIDENT ALIEN

Within our known space/time continuum, was introduced to a powerful new Earth ally in the last few days, while chasing down Boris the Animal of 1969 and of 2012. Our planet and all living upon it were spared by the compassionate action of Griffin the Archanan. He was here to fulfill that mission on orders from home. Our newly installed Arc Net is of Archanan origin.

Note that in our space/time continuum, Griffin the Archanan is the last of his species. However, although Archanans do not time travel, they exist outside of this and so the entire species may be encountered in our future from our past. Should an agent cross paths with an Archanan, make note that they are inherently peaceful and should be protected. Advise agents to take any stories they report, no matter how fantastical they may sound, as likely truth.

Recommend granting Griffin a permanent residence visa immediately, and an Men in Black-issued round-the-clock guard, should that be acceptable to him.

SIGNED, AGENT K, MIB NEW YORK

cc: Security Subdivision, NY Passport Control

"Think of Radioman," replied Barry Sonnenfeld when Mary Vogt inquired about Griffin's outfit. Well known in New York film circles for doing cameos and cycling around the city streets sporting a lot of layers, Barry applied Men in Black logic: "My theory is that someone who wears three down jackets in August is from a planet where it's usually 180°, so 90° is really cold for them." But it was his boom box (a gift from Whoopi Goldberg) that gave Mary the idea to use the monk's traveling box she'd picked up at a local shop. Meanwhile, this McGuffin kept Boris away from the real prize, hidden within Griffin's open cranial cavity, shrouded by a crop-circle infused Sami hat – hand-stitched by Mary's knitters. The blue eyes, however, were all Michael Stulhbarg (*Call Me By Your Name*, *Boardwalk Empire*). From a stack of hundreds of Mary's images, Michael had chosen a young girl from the Sami tribe in Northern Lapland. She explains: "'What?! A six-year-old, Norwegian girl from the eighteenth century is what you want to look like?' 'Yeah, that's it.' She was a really extraordinary looking child [with] amazing

blue eyes," Mary then quickly ordered up some contacts for the brown-eyed actor. Then there were the twelve (matching) pairs of striped Nepalese pants rush-shipped from a market high up in the Himalayas, thousands of miles away.

"There were a lot of things about Griffin that were magical," reflects Mary. "Fans love Griffin… I think they really responded to that character because Michael is such a serious actor. He infuses [Griffin] with depth." While the actual Radioman may have more in common with Robin Williams in *The Fisher King*, Griffin is otherworldly, literally.

"When I sat down to write him," shares Etan Cohen, "to me he represented a really important theme: fate. And whether or not you can escape it. He was written as a hybrid between string theory physics and a Zen master." Originally Griffin was more than one person, sort of. "He was a kind of Dalai Lama figure with a bunch of 'spiritual retinue,' or sort of 'co-beings' with him," says Etan. "Michael brought to Griffin an incredible sense of positivity and… optimism." Michael reflects on the direction he was given for the character, "Barry was very specific, in terms of how to play him. He has a remarkable inner meter of what he wants characters to be about. We found a very interesting balance of someone who is curious and anxious about the situation that he finds himself in."

Griffin only *appears* humanoid; Archanans are fifth dimensional beings, after all. Barry referred to this Mork-like alien as a quantum mechanic. "He can see all futures, all possibilities, all quantum things that could happen… so, every single thing that happens in the world is a result of every second before and afterwards – and that's a very quantum mechanics kind of thing." You know what's also very Archanan-like? Talking fast. They have to, "because if you talk too slowly, by the time you finish your sentence a different version of reality could have happened," advised Barry to Michael. Plus, "I thought it'd be funnier." It took a bit of back and forth, but Michael finally nailed it.

Griffin's character was a fitting bookend to the film's time travel conceit. An alien version of exposition and the only one to break the fourth wall. "I do think the third movie became very emotional," reflects Etan. "Maybe even subconsciously because it was the end of this series, and everyone has a lot of affection for these characters." It became personal for Etan as well, "We started talking about the butterfly effect." This reminded Etan of his maternal grandfather, a former meteorologist and academic. "He had been at MIT… when all those meteorologists were figuring out chaos theory. It always stuck with me… was always powerful."

THIS SPREAD: Concept art of Griffin (left). The real Griffin (below).

SHEA STADIUM

The *Men in Black* franchise is full of well-known public landmarks. Many mysterious, anonymous, and historical alien-related events often transpire in and around them. But Shea Stadium, that very public, cultural icon, figures more prominently than the rest. To Mets fans, Shea Stadium is holy ground. Construction on it began in 1961, the year of 'first contact' in neighboring Flushing Meadows and where the newly landed spaceships hid in plain sight. Three years later, New York hosted the 1964 World's Fair there (with the theme "Peace Through Understanding"), meteorologist Edward Lorenz first introduced chaos theory, and the stadium opened its doors. Shea Stadium serves as the *Men in Black 3* backdrop for Agents J and K, where, by stepping inside Griff's aura, they catch a glimpse of the 1969 World Series, Game five. The day the 'Miracle Mets' win it all. (Technically speaking, official Men in Black records indicate there *was* some intervention, of an alien variety.)

BELOW: Griffin showing the agents Game 5 of the World Series, 1969. Except for the actors, this scene is nearly all digital.

OPPOSITE: Concept art for Boris' drive-by snatch.

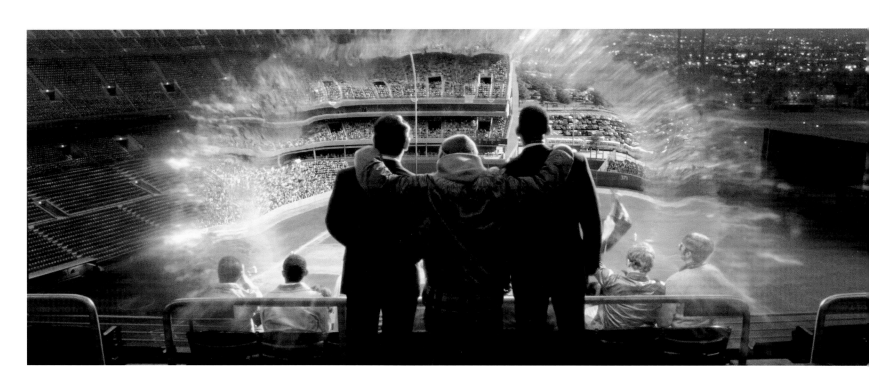

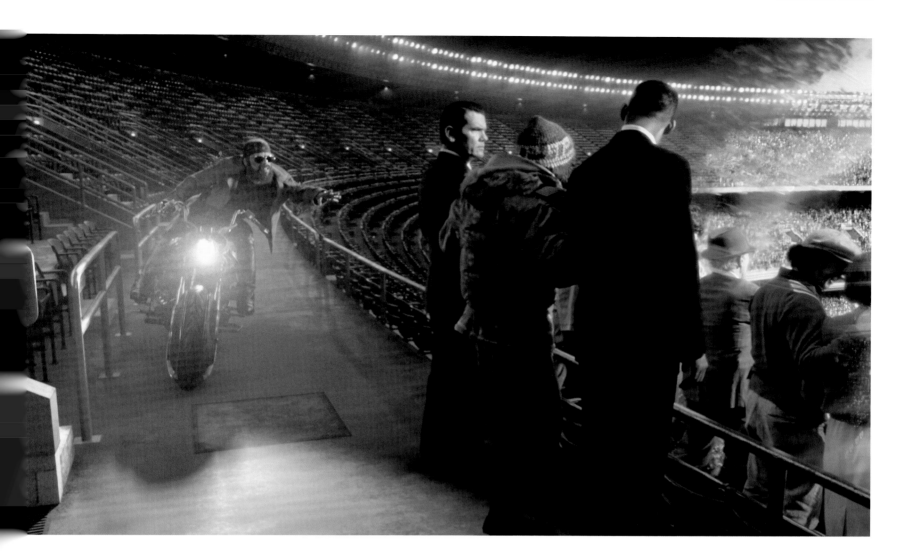

For Etan Cohen, it felt a bit more personal. "I *do* love baseball but I'm a Red Sox fan. So glorifying the Mets was a horrific thing to do. The 86 Red Sox losing to the Mets was one of the formative moments of my childhood. I really felt like a sellout, maybe most in my career."

Prior to this – *and* later? – older Agent K and younger Agent J take down the Edgar Bug. As Edgar lifts off in one of these 'circular observation towers' and flies over Shea Stadium, real world Mets outfielder Bernard Gilkey, poised to catch a fly ball, becomes mesmerized by the spacecraft as it comes into view. The ball beans him just as the ship bursts into flames and begins its death knell descent back through the Unisphere. Roaches check in, but they don't check out.

In 2008, to make way for Citifield, they paved Shea Stadium over and put up a parking lot. So how did they build the Griffin scene, circa 1969? All CG. This meant drawing from historical footage to recreate the Shea Stadium of that era. "Barry really wanted to keep that as real as possible," remarks Jay Redd. "It's floors, even the color of the seats... it got to the point where major league baseball actually got involved... to make sure things were accurate." Except for the actors and a tiny set piece shot on blue screen," remarks Ken Ralston, "the rest of that scene is digital."

RIGHT: Concept art of Griffin sharing his unique ability with the agents.

MONOBIKE
THE ONE-WHEELED MOTORCYCLE

In the mid-twentieth century, the Ford Motor Company developed a one-wheeled motorcycle, a.k.a. the monocycle. They weren't the only ones to take a crack at this; many have tried before and since. But regulatory issues deflated any serious commercial development and the concept was abandoned. The Men in Black of the 1960s appropriated Ford's designs, developing and deploying their own high-tech version of these gyroscopic wonders. With a single seat in the center, Men in Black's design was collapsible, and the speed and line of sight were stellar! With a quiet whir, the look of a sea horse and a

range of 600 km, a single rider could dart and dash around in ingenious ways not available with most other vehicles. Writes Etan Cohen: "When the monocycle rolls, the rider stays upright in the middle, but the wheel rolls around them. When the thing turns, the wheel leans over, but the rider always stays upright, ninety degrees to the ground."

With Men in Black's unlimited resources, they managed to create something that is "very agile," says Bo. "And like everything else in their world… it's going to be beautiful, and you'll want one." Barry Sonnenfeld originally suggested

BELOW: Will Smith approaching the bike. Shea stadium in the background.

OPPOSITE: J trying to get the hang of it (top). Barry Sonnenfeld appreciating Harlocker's creation (center). Young Agent K going with plan b (bottom).

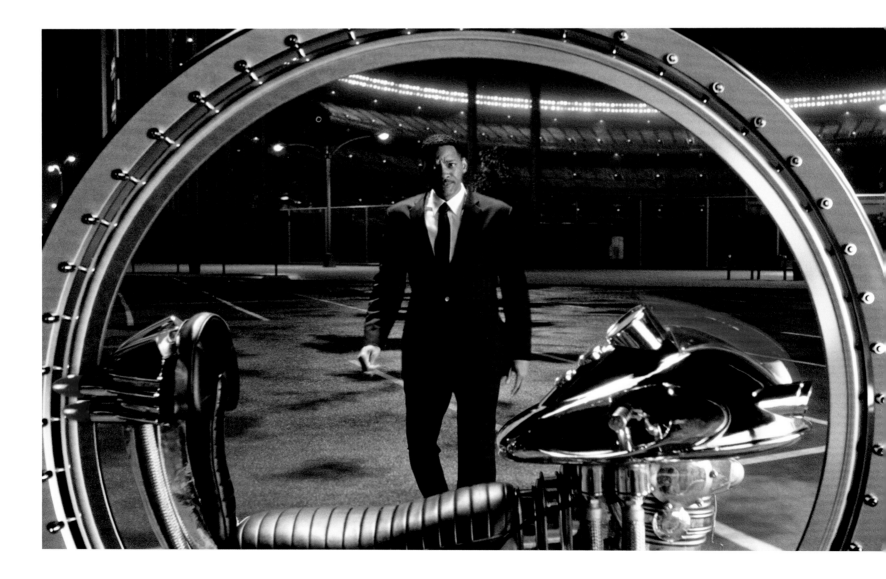

creating these vehicles. "The monobikes was my idea. When Bo started to do research, I found out that they really exist. I mean we didn't use real ones but there is such a thing as a monobike where you sit inside a giant wheel." So why don't we see more of them today? "All of them are plagued by practical problems," chuckles Welch. "They don't really work that well."

Doug Harlocker pitched to take on Bo Welch's designs – jobs that size aren't typically assigned to the props department. "[We] are notorious for doing the small things," remarks Doug. "And in most movies, you often hear, 'Oh God, who's gonna do *that*?' but with *Men in Black* we had been saying for years, 'We'll do it!! Yeah, let us do that. We want to do that.'" Barry remarks, "Harlocker took Bo's design and created this amazing chromed vehicle. I love the teal and that Plexiglas hood. I loved that we could pull those things around." Ken Ralston echoes the director's opinions, "These creations that Doug Harlocker came up with are so beautiful. They're like art pieces that these guys ride." Doug continues: "So we could flex our muscles; it was really fun, and I loved taking on these really fun, whimsical, and over-scaled things."

Good for toolin' around or chasing alien scum, these collapsible monocycles were usually only rolled out for extreme emergencies, like when the roof of your 1964 Ford Galaxie has been run over by an escaping Boglodite.

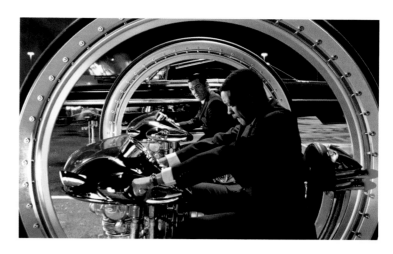

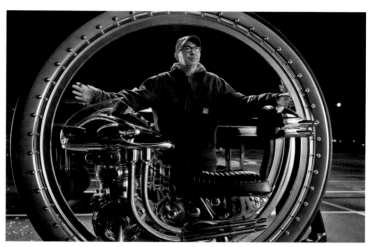

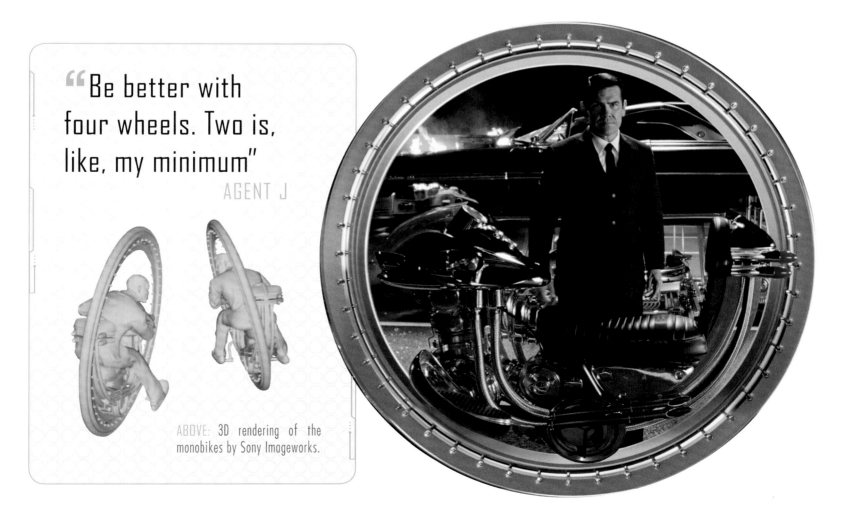

"Be better with four wheels. Two is, like, my minimum"
AGENT J

ABOVE: 3D rendering of the monobikes by Sony Imageworks.

JETPACKS

Designed by the ever-resourceful, young Agent O, the jet packs were derived from alien technology that Men in Black never quite fully understood. They are modified jet engines, of a sort, and the first Men in Black vehicles to deploy hyper-drive (usage by the 87 Crown Victoria and J's 03 Mercedes came later). Each allowed for a single pilot and room for one standing passenger. Because the Men in Black were unable to decode the safety mechanisms housed within, these flight devices offered, at best, a bumpy super-sonic flight and a rough landing (if you were lucky). They were finicky, and prone to blowing up. With a range of 3,500 km, they did serve Griffin and Agents J and K well in their race to get to Cape Canaveral in time to kill both versions of Boris and deploy the Arc Net. The jet packs were abandoned in later years.

Designed by Bo Welch and fabricated by Wild Factory, Doug Harlocker and his team created the operational part of these pod-like, super-sonic capsules. While visual effects managed certain elements, Harlocker "kludged" on the standing platforms and the whole back unit, including "the funny little headrest as well as all the joy sticks they used to fly them." All physical builds were done at the Armory in Queens.

ABOVE: Concept art closely resembling the final build.

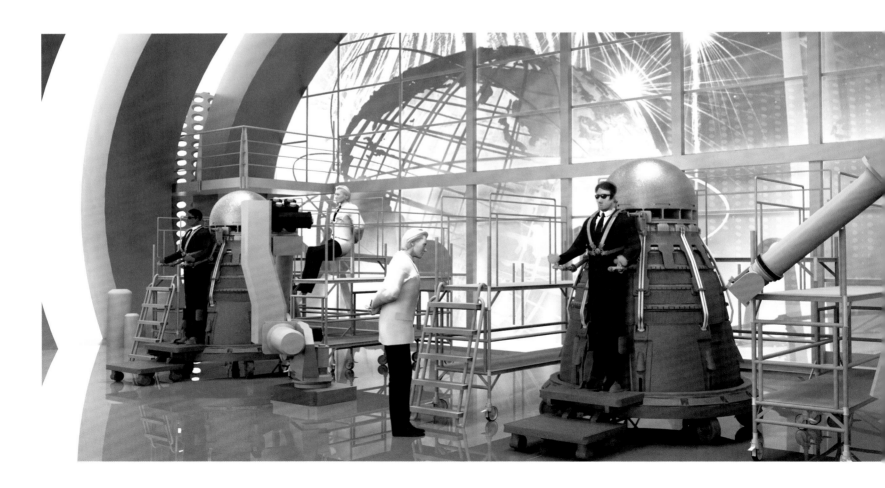

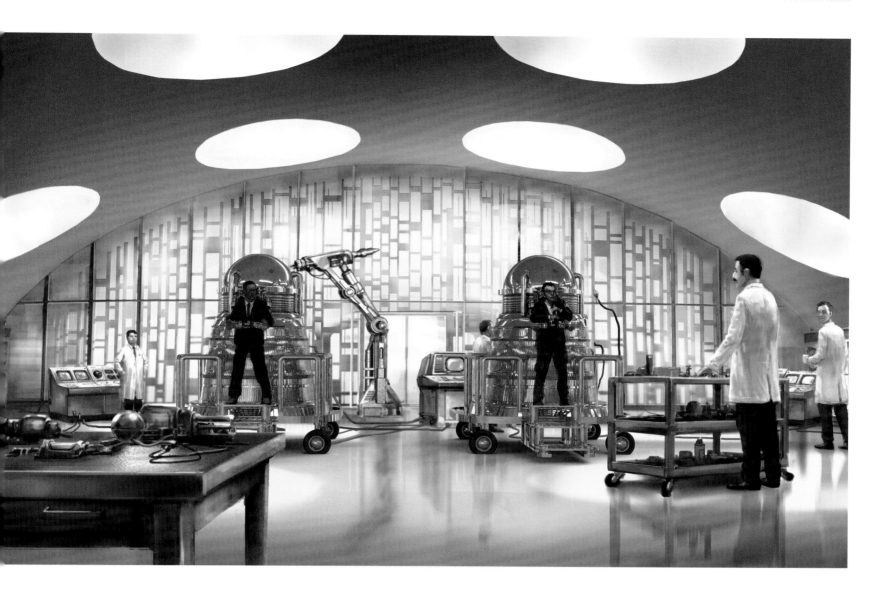

ABOVE AND RIGHT: Concept art for the jet pack room at headquarters.

CAPE CANAVERAL

Cape Canaveral. July 16, 2009. The fortieth anniversary of the historic first manned rocket launch to the Moon. This was the news story that inspired the solution for Etan Cohen's story problem. "All of a sudden I realized, of course that's where this has to end!" The filmmakers all agreed that NASA's landmark Apollo 11 rocket launch of 1969 would be the perfect backdrop for *Men in Black 3*'s finale and a fitting location for the concluding arc of J and K's story at this point in the franchise. Every inch the executive producer, Walter Parkes echoes this reasoning. "It gave us a focus for where this movie had to hit. But, it certainly also gave us a big production headache. It's challenging to try to pull off contemporary action in an historical context."

Using actual newsreel footage, these final scenes were infused with the hopeful spirit of the times. A prosperous, democratic culture on the brink of a space age, which began with President Kennedy's historic commitment to the space program in 1961 – the same year of 'first contact' and the establishment of Men in Black's New York-based headquarters. (It was also the year they broke ground on a new stadium for the New York Mets.)

Sonnenfeld and crew made several trips to the Kennedy Space Center (formerly Cape Canaveral) with the expectation of shooting there. But "everything looked so wrong and new and not the right gantry and so messy," said the director, so they built part at Jones Beach and all the gantry-related scenes on a stage instead.

THIS PAGE: Concept art of the rocket launch (bottom and left). Actual footage was licensed from NASA for the film (right).

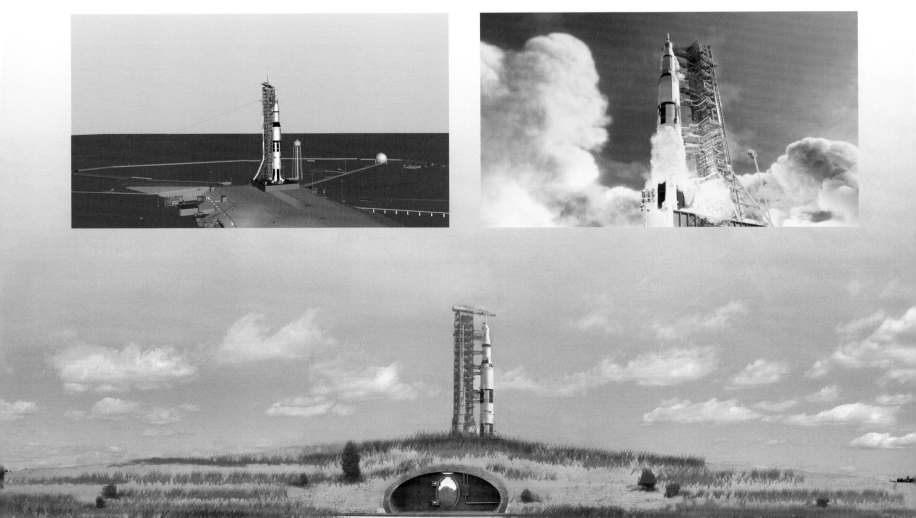

COLONEL JAMES EDWARDS SR.

"**SOME JOB YOU GOT THERE.**"

"**F**orties, trim, sharp-eyes, and means business." The script provided a rich picture of Agent J's father, Colonel James Darrel Edwards, Sr. (played by Mike Colter). Despite the challenges of race in that era, this talented former soldier and Army Engineer secured a position at NASA and a coveted role as one of the engineers of the Lunar Module. Head of Tech Security during the 1969 Apollo 11 launch, this proud and devoted father brought his son, the future Agent J, to this historic launch for his birthday. Who knew courageous action would inadvertently lead him into some "next level shit." The tragic, ultimate sacrifice agents and soldiers make, the anonymity – and great service no one can ever know – started here for this father-son duo.

Watching the final cut with his son, Etan Cohen quickly grew verklempt. "He was really little and it was just incredibly powerful because it's so much about father-son bonds. When you watch the movie…. knowing what's going to happen? When Griffin touches J's dad and you realize that what he's showing him is he's about to sacrifice his life for his son? And *also*… as a parent, seeing that your son is going to be OK, and a good person? It's like one of the great fantasies of a dad."

"Where there's death there will always be death" started out as a screenwriting problem. "I had written myself into a corner," remarks Etan, "of why this would actually happen on this timeline." The writers had been floating around these ideas about death, energy, and the universe. And that "even though things can change, there are certain immutable things – a kind of net energy force in the universe. Where if you take away, and someone stays alive, somewhere else? Something has to 'zero out' the balance of life in the universe. So, we just started to think that for Tommy. To survive someone else had to die. To me it became a very beautiful idea."

THIS PAGE: Colonel Edwards with young Agent K (top). Griffin showing Edwards what he needs to see (bottom).

ARC NET SHIELD

As the wise pug Agent F once said, "Just because something's important, doesn't mean it's not very, very small." The Arc Net Shield did arrive in a small package, literally. Or so it seemed. When Boris whizzed by and snatched Griffin at Shea Stadium on his tricked out ride, he soon learned the ornate metal box was nothing more than a crafty deflection from the last of a now lost species. And someone accustomed to being hunted. The Men in Black credited Agent K with implementation of the global defense system, but it began as a gift. "Griffin removes his hat," writes Etan Cohen in the *Men in Black 3* script, "revealing the delicate curviform bones of his bizarre alien skull. And floating in the empty void between them… a tiny, latticework glow of light." Griffin then transferred the Arc Net from his Archanan brain into a hollow silver orb the size of a pocket watch. Prop master Doug Harlocker called on his favorite jewelry designer for this task. "Heidi [Nahser Fink] is a fabulous artist. She has made pieces that have been become a centerpiece, plot wise, on every *Men in Black* film. She dropped everything and helped synthesize all of our ideas into this unique and very beautiful prop."

The Arc Net Shield only functions in zero gravity. Once deployed, it gets a whole lot bigger. "A gossamer web of warmth and security explodes out," and the script continues, "Ten million tiny tendrils of light expanding and crisscrossing, whipping around the globe at incredible speed, wrapping the entire planet in a glow of its protective embrace." How does it work? It creates a web of anti-ionizing particles that destroys all fast-moving objects that enter its range.

Although electric blue, the ultimate pattern of the shield mirrors the black Men in Black icon — a series of three spinning circles forming a sphere. A symbol of benefic protection from the scum of the universe.

"I lost my planet. I don't want to see you lose yours."

GRIFFIN

ABOVE: Prop from the film, currently housed at Sony Archives in Los Angeles.

BELOW: Concept art showing an early development of how the Arc Net would look when deployed (left). Griffin presenting the agents with his gift (right).

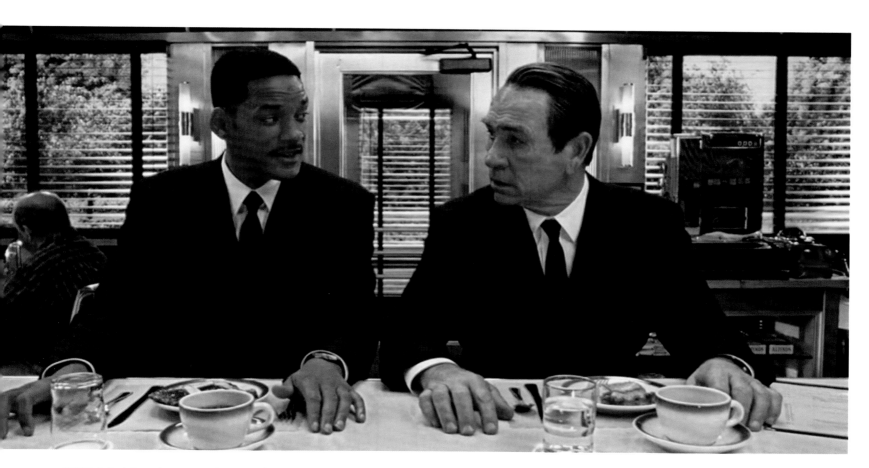

ABOVE: I think I may know some things you don't.

K'S LEGACY

Young Agent K survived his toe-to-tentacle encounter with Boris for two reasons. Because his 2012 partner, Agent J, came back to save him, but also because in the original time stream of 1969, J's father pushed him out of the pathway of one of Boris' deadly projectile quills. This led to a fatherless boy being watched over and later recruited by Agent K to become said Men in Black Agent J. It's the stuff of time-bending and mind-numbing conundrums, but all that really matters are the decisions made in 'now' moments and how a person feels about those decisions. Sacrificing your life for another is the kind of debt a man such as K takes quite seriously. Colonel Edwards' murder left a young boy without his father, and an agent with a heavy heart. One that hardened over the years as, rightly or wrongly, inescapable feelings of guilt and accountability caved in on him. Once J returned via the time rift to his present day, they acknowledge their tragic, shared history. Relief from painful emotions can take many forms. Now he and K can choose to begin a new chapter together.

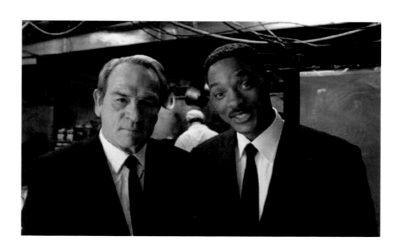

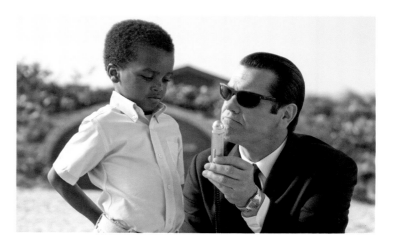

RIGHT: These agents have been working together for quite a while (top). Turns out the young actor (Cayen Martin) was rather fidgety, so Josh Brolin volunteered to do his lines separately (bottom).

INTRODUCTION

BEYOND THE STARS

❝I don't think there was ever the idea of, 'Oh, it's time for a new *Men in Black* story'," says Walter Parkes, of how the franchise returned to the screen two decades after it had first taken the box office by storm. "All of these movies are character based," the producer adds. "We'd had this thought that it would be interesting to tell the story of a young woman who, as a child, has an encounter with an alien and the MIB, but somehow escapes. She spends the next 20 years of her life trying to find them. That seemed like a really great character premise to get into a new retelling of the story under very different emotional circumstances."

In fact, *Men in Black International* was the second time that Parkes and fellow producer Laurie MacDonald had explored the development of that central idea. "We'd persuaded the studio to let us develop one version and, honestly, it didn't really work," Parkes admits. As a result, that script was shelved – but the kernel of what would eventually become Agent M stayed with both producers.

"For us, it's always about having an idea we feel is strong enough," adds Laurie MacDonald. "We have to have a strong motivation, a reason to be."

"This is why I like working with Walter and Laurie," says producer Riyoko Tanaka. "I don't know that there ever was a *wrong* time but, unlike a lot of producers, they never say, 'OK, it's time to do *that* story, or *this* story'. We don't do it until we have the story we want to tell, and that's refreshing."

Still looking for a way to tell M's story, Parkes and MacDonald commissioned the writing team of Matt Holloway and Art Marcum to work on a new version of the script. Holloway and Marcum had previously written *Iron Man*, the smash-hit that launched the Marvel movies juggernaut. With this film they artfully combined the tricky bedfellows of science fiction and comedic wit – a distinct hallmark that had always been a touchstone of the *Men in Black* universe.

"I think they asked us something like, 'How would you continue this franchise without the original guys?'" recalls Holloway. "We loved the first movie, it's a classic. So to even be asked to consider how would we contribute to that world was great. We said to each other, well, we have to give it a reason to exist outside of the other movies, how do we do that? That's when we came up with, 'What if New York was just one of many offices around the world?'"

"When you have a franchise this beloved, you want to honor those three movies rather than trying to erase them," adds Marcum. Knowing that Agents J and K had never left the confines of the US, they started to ask, "What does MIB look like outside of that? It was great to have that kind of a canvas to play on."

Over the course of two years, the writers and producers crafted and honed a new script that not only recalled the previous three films but also succeeded in taking the concept of the *Men in Black* to new horizons. Instead of being a New York-based cop drama, the fourth film would be a spy thriller that traveled the world.

THIS SPREAD: Concept art of the portal in Paris.

"I think the thing that resonated with the studio was the idea of making this one more international," says Parkes.

With the script greenlit, the challenge became to put together an entirely new team both in front of and behind the camera. E. Bennett Walsh was brought on as line producer, and work on the new film started rolling in earnest. The producers brought director F. Gary Gray on board to helm the film, picking up the reins from Barry Sonnenfeld's first three franchise outings.

"Walter and I were both fans of a number of his movies and thought *Straight Out of Compton* was remarkable," says MacDonald. "We spent time with him, talking mainly about script and character, and just connected with him on that. These are the toughest movies to direct, because they have to operate on so many different levels. Obviously you have to build a world, and because we'd made the three we had a skeletal idea of what

that is, but there were so many decisions to make. It's always about this balance, because you don't want to reinvent it so much that it doesn't feel right tonally or aesthetically – there's a distinct tone to *Men in Black*. It has to have this mix of cool comedy, but underneath some real heart and real stakes, something deeper. The original three are very spare scripts, and this is different, this is a little more comic, a little richer. We thought Gary, with his background, could bring something different to it."

Assembling the rest of the creative departments was also a big task, since none of the department heads that had worked on the previous films would be returning. "One of the biggest things was the alien design," says Emmett Walsh, "because Rick Baker, who is now retired, is a legendary creature designer and without him, well, what are we going to do?" Jeremy Woodhead was brought on

BELOW: Walter Parkes and Laurie MacDonald behind the scenes on set of *Men in Black International*.

RIGHT: Producer Riyoko Tanaka with VFX producer Deven LeTendre, costume designer Penny Rose, and scriptwriter Art Marcum on set in Leavesden.

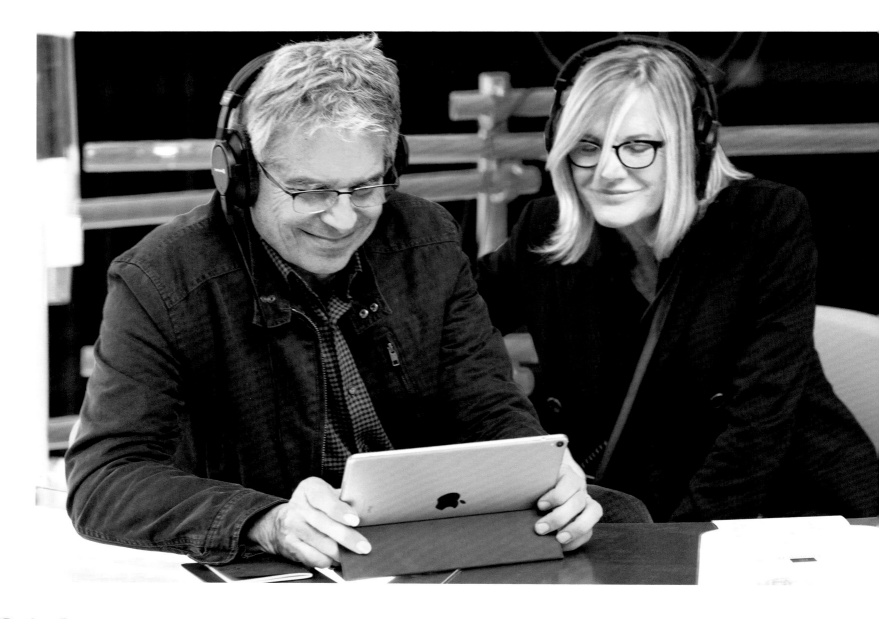

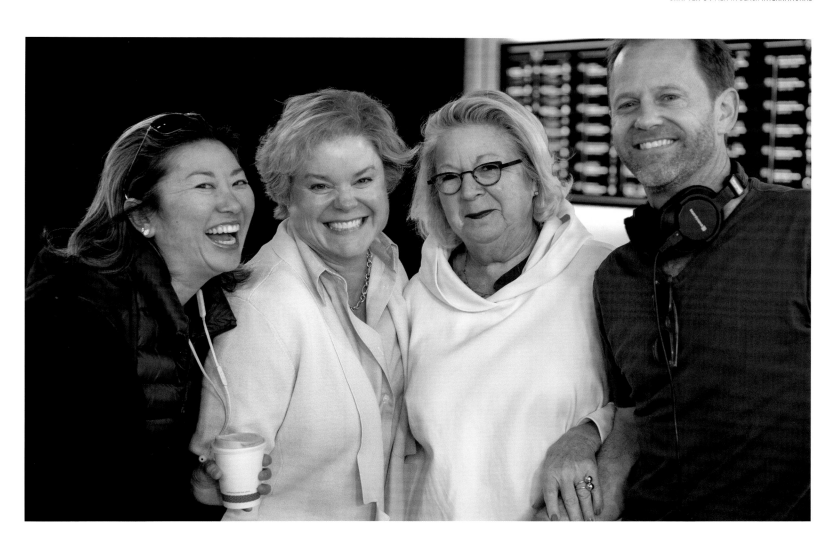

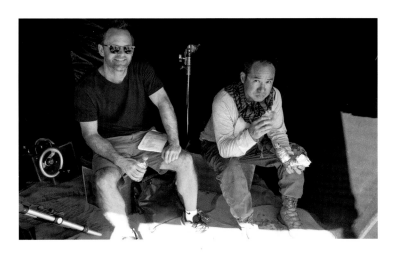

to design and produce the physical alien prosthetics, while the production commissioned concept art from artists all over the world, looking for a character style that would recall the previous films while also forging a new approach. Meanwhile, production designer Charles Wood, who had worked with F. Gary Gray on *The Italian Job* and had gone on to design many of Marvel's superhero films, was tasked with the mammoth job of creating a distinctive yet reminiscent *Men in Black* look for the new London headquarters.

Then, of course, there was the matter of casting. How to follow the iconic duo of Will Smith's Agent J and Tommy Lee Jones' Agent K? As producer Laurie MacDonald points out, the list of actors with the multiple skills required to carry a *Men in Black* film are few and far between. "Finding an actor for H who had the weight, the dramatic ability, who's a great action actor, and who is really, truly funny – it's a very small list," she says. "We didn't offer it to anyone else. We said, 'Chris Hemsworth. He's the only one who can do it. We *have* to get Chris!' Thankfully, he liked a very early draft. Then, looking at who to play against him, Tessa blew everyone away. She's a beautifully skilled actress and there's no one like her."

With their lead duo in place and the production crew deep into pre-production, it was time to snap shut the first clapper board of *Men in Black International*…

LEFT: Scriptwriter Art Marcum with visual effects supervisor Jerome Chen on location in Morocco (top). Tessa Thompson and F. Gary Gray at the headquarters.

SPARKING CURIOSITY
THE START OF MOLLY'S JOURNEY

Molly's epic journey to becoming Agent M starts with a chance encounter with an alien one night when she's just a child. Rather than running screaming to the mysterious Men in Black who are speaking to her folks downstairs, Molly helps the funny little creature and then hides as her parents are neuralyzed – although, of course, it's not until years later that Molly discovers what actually

happened to them. The events of that night convince her that there are truths out there that only a chosen few are privy to – and Molly is determined to become one of them.

For the producers, establishing the character of young Molly was really what made a fourth installment in the *Men in Black* franchise viable. "Sony had been very interested in the potential of developing a new film for a while,"

THIS SPREAD: The interiors of Molly's childhood bedroom and the encounter with the Men in Black were shot on a set in Leavesden Studios, England. The exterior of Molly's childhood home was filmed later on location in New York state. After filming, the blue screen seen through the windows was replaced with a view of the suburbs at night.

says producer Laurie MacDonald. "But for us it's always about having an idea we feel is strong enough. Our bigger story changed many times in the course of years, but there was one key element that has remained constant. That was the idea of a young girl having an encounter with an alien and observing these strange and wonderful men in black suits showing up at her house. We see this already very curious child's mind being opened to this other world, but then it's immediately closed off because her parents are neuralyzed. So her search, that motivation really became a fresh way in, and created a character we felt that we could really explore."

"It's always great to have an access character," says writer Matt Holloway. "In this film it's M. The thing that we always loved about developing M's character is, typically what happens in the secret agent movie is that you get recruited – they find you and they bring you in somehow. We thought, what if she finds them? That would show how smart she is. It would also just be a wholly different way into this kind of movie."

"It's a reversal," Tessa Thompson points out. "In the original film the Men in Black find Will Smith's character and in this one, Molly finds them. It's great because no one has ever done that, and I just love the idea that this young woman does the unthinkable and finds this organization that is supposed to be without a trace." For Thompson, Molly's difference in the world is what makes her so compelling as a character. "That's the thing that I think is really cool and accessible about Molly," she says. "There are plenty of people that are misunderstood, they're outliers that don't really have a place. Molly is one of those people, but she's also resourceful, and smart, and curious."

LEFT: The actress who played young Molly is Mandeiya Flory.

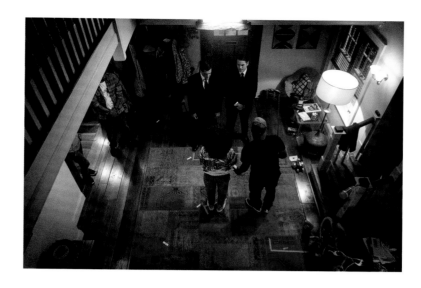

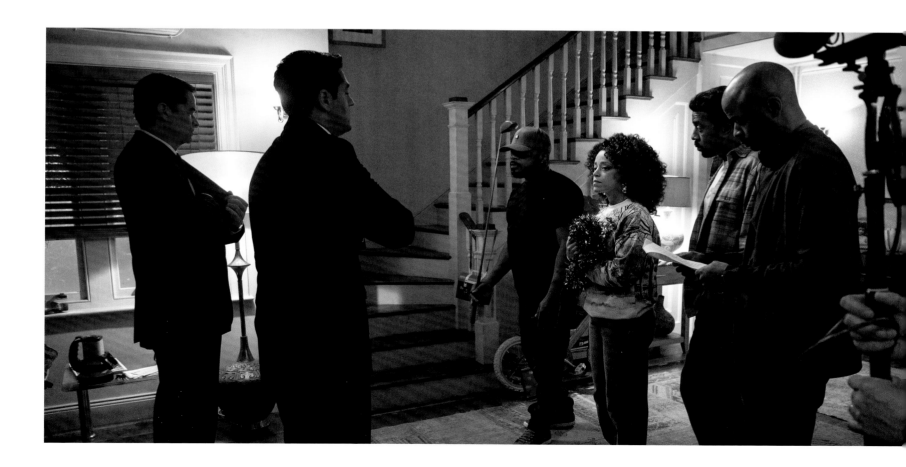

ABOVE: After years of searching, Molly found the New York headquarters.

ABOVE: The famous entrance to the Brooklyn-Battery Tunnel Building.

DISCOVERING MIB HEADQUARTERS

Molly's determination leads her right up to – and through – the doors of **Men in Black New York.** Molly's approach to the famous doors was actually shot on a meticulous recreation set, built on a sound stage at Leavesden Studios in England. The doors and their surroundings were then added to by the visual effects department to match them seamlessly to their surroundings in New York City – so effectively that it's possible to imagine agents J and K might appear at any minute.

Inside, Molly finally finds what she's been searching for since she was a child, the organization she's always known existed beyond the veil of 'normal' life. A slick, secret government outfit called Men in Black – led, ironically, by the formidable Agent O.

"I'm just thrilled to be back in my role, O, the leader of the organization," says the inimitable Emma Thompson, reprising her role from the third film. "Although she still doesn't have the authority to change the name from Men in Black to anything more acceptable, so that's hilarious," she laughs. "But if you think about it, 'People in Black' just… it's not really the same thing, is it? 'Men in Black' – it's just cool."

It's an issue that had occurred to the producers and the writers, too, especially since the first time the name is spoken, it's in an interrogation room containing two women and no men. It was an important beat to acknowledge, while also handling the scene with the franchise's trademark humor, a task that both Emma and Tessa Thompson took to with relish.

"Emma and I had the greatest chats about how do we answer that question," recalls Tessa Thompson. "To set it inside this franchise, to have one of the central characters a woman, but still have it be called Men in Black, I think that's a question that audiences might have, and that I certainly had when joining the project. So we did some work with the writers. It's always fun to turn those themes on its head together, and to play."

Additionally, for Tessa Thompson, working with Emma Thompson was one of the highlights of the whole shoot. "Some of the finest acting that I probably have ever done in the course of my career is playing cool around Emma Thompson," she laughs. "I have been a fan of hers for such a long time. We were doing one scene, and Gary [director] came up to me in between takes. He came in and he goes, 'Uh, Tessa. I'm not quite sure what you're trying to do, the way that you're staring at O? You're really staring her down. Is there something I don't know about that you're trying to play? And I was like, 'No, I'm so sorry. I'm just staring at her act. I just forget to look away because she's so good!'"

FAR LEFT: Molly finally found herself in a Men in Black interrogation room.

BELOW: Tessa Thompson and Emma Thompson on set in Agent O's office before the bustling background of the NYC headquarters was added in by the VFX team.

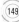

AGENT M

> "I WANT TO KNOW HOW IT ALL WORKS."

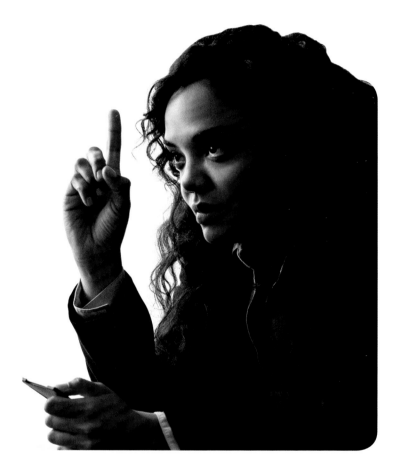

"Molly has curiosity about the world in spades, and also about people," says Tessa Thompson. "She is hugely accepting. I think one of the cool central themes of all these movies is this idea of accepting the 'Other.' That different species can cohabit, that they can build relationships, can care for each other. To me, that's always been the metaphor inside the *Men in Black* films – that there are no beings that we can't accept. Even though we do occasionally kill some aliens!"

Sitting alongside Agent M's easy acceptance of alien life on planet Earth is her undisputed mental acumen. It's what allowed her to track down and break into the most secretive agency on the planet... and it also helps her deal with Agent H's tendency to go with his instincts rather than what some might call common sense.

"He's about his gut and his heart, and she's about her head," says writer Matt Holloway. "That's a classic pairing, but the way that Tessa and Chris play it is great. You just try to find something new with these characters. I think we have, and it's really fun. "

"Those two characters are naturally so opposed," agrees co-writer, Art Marcum. "It's always interesting when you have two people who come from different worlds and are totally different character types. Throughout the movie they realize, 'We're not so different, you and I.'"

"Tessa's character embodies a huge amount of intelligence and intrigue in this world," adds co-star Chris Hemsworth, who had previously worked with Thompson in the Marvel cinematic universe. "There's a suspicion about it all because of what happened to her character as a child. So you have a combination of this wide-eyed appreciation and excitement about what she's now part of, but also with this skepticism and searching for the truth."

THIS PAGE: Molly's search for the mysterious Men in Black led her to many government organizations.

RIGHT: Tessa Thompson filming Molly's first glimpse into MIB life.

REPORT: AGENT O

DESIGNATION: AGENT M

YEAR OF ACTIVATION: 2019

PLACE OF RECRUITMENT: NEW YORK CITY

CURRENT FIELD OFFICE STATION: MIB LONDON

RECRUITER STATEMENT:

Bit of a tricky one, this. M wasn't so much recruited as acquired. She found her way into MIB New York and in a subsequent interrogation by myself, declared that she wanted to become an agent. I would have neuralyzed her as per standard procedure, but something about her tells me she'll be an asset to the organization. Besides, by her own admission, she doesn't have a life and frankly, I know the feeling. Fast-tracked on my authorization, so if anyone's got a problem, send them to me…

…If you think they're hard enough, obviously.

SIGNED, AGENT O, MIB NEW YORK

REPORT: AGENT M

AGENT'S PERSONAL STATEMENT:

First off, I KNEW IT.

Secondly, when do I get a neuralyzer?

Thirdly, M's not a very imaginative codename, is it? I was expecting something a little more… I don't know, alien secret agent-ish? Also, I'm now going to spend my time trying to fit names to Agent designations. Agent O, what's hers? I bet it's something really British… Olivia? Octavia? No, wait – Ophelia! That's got to be it, right? H's will be something really boring. Harry, probably. High T is definitely a Tony. And as for Agent C… yeah, well, probably best not to go there.

Wait, did I ask about the neuralyzer?

SIGNED, AGENT M, MIB LONDON

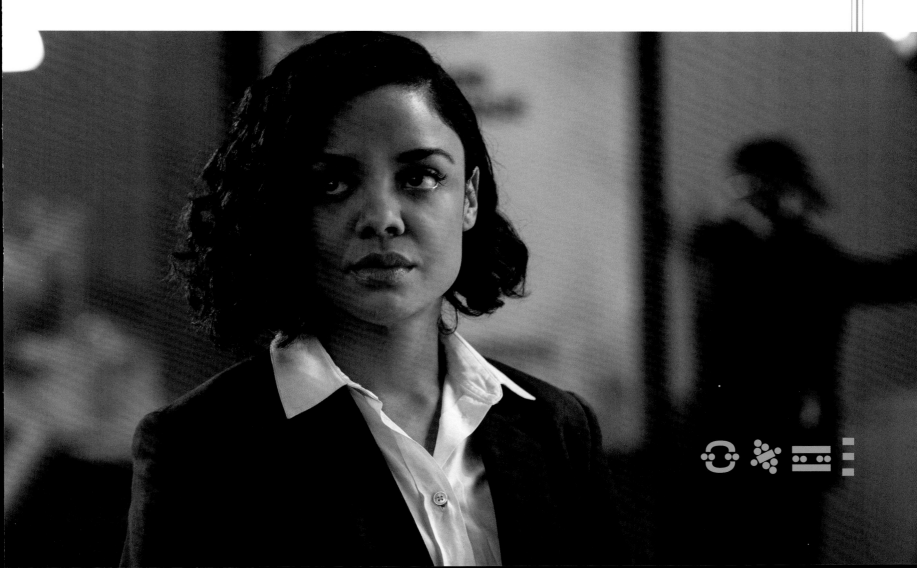

THE HYPERLOOP

One of the first elements Charles Wood's production design team began work on during the early weeks of pre-production on the fourth film was the 'Hyperloop' transport system. This would serve several functions in terms of story – it would introduce the audience to the idea that Men in Black was a long-standing international organization; it would be the newly minted Agent M's first taste of life inside Men in Black, and it would, in a very literal sense, transport both directly into the film's main plot.

"*Men in Black* has always been about playing with forms and interesting shapes and keeping everything quite simple and interesting," points out concept artist Alex Caldow. "Ivan [Weightman, concept artist] and myself worked on the train and for ages we were coming up with different ideas, playing with forms and shapes. We did hundreds of sketches, just to get the ball rolling."

"What we wanted was to come up with some mad machine," says Charles Wood. "You're in MIB New York and you come down into this very beautiful, controlled space. The way it works in the movie is that this old tram car appears and she gets in and it morphs into this Bugatti, essentially, into this beautiful machine. What Gary [Gray, director] wanted was something crazy, so that the film is all about surprises for the audience as well. They did it beautifully in the first three films with the cars and so on, so we're trying to do our version of that and create something that has great noise, a great sound. This is M's first introduction to the journey she's going to take, and it's absolutely bonkers. It's a lot of fun."

THIS SPREAD: Concept art displaying different designs for the Hyperloop.

THE GALAXY CHRONICLE

with Weekend Supplement **$1.09**

Nearly every 3 in 4 visitors from Mars has no respect for human laws

MARTIAN MIGRANTS CAUSE RISE IN CRIME

ALIEN MIGRANTS may be responsible for most of a recent rise in violent crime in the world, research comissioned by the government suggests.

The study used data from New York, a state where more than 90% of the rise was attributed to young alien migrants.

The researchers say the findings are not surprising because many migrants who arrived on Earth in recent years are single Martians aged 14-30.

This group is most likely to commit crime, irrespective of nationality.

The researchers also said that migrants were twice as likely to be reported to police for alleged violent crimes as human nationals.

Both groups were seen as being hurt by their apparently liberal migration policies in September's election. Should Earth pay its migrants to leave?

The report used statistics from New York state – regarded as an average state – where police saw an increase of 10.4% in reported violent crimes in 2015 and 2016. Based on figures from the state's interior ministry, which keeps a separate record of alleged crimes by migrants, the report suggested that 92.1% of this increase was attributable to migrants.

New York has seen a significant increase in arrivals of alien migrants in recent years.

However, the researchers also said that a third of all victims of violent crimes by alien migrants were other alien migrants.

What conclusions did the report reach?

The researchers said that the best chance of reducing violent crime among Martians was to offer more help with integration through language courses, sport and apprenticeships.

But it said that many male migrants fell into the 14-30 age catagory, the most likely to (cont'd on page 26)

(cont'd on page 26)

SPOT THE SIGNS
Take the test to see if you have alien brain cancer

SEE PAGE SEVEN

THIS SECTION: The Hyperloop has a smooth, aerodynamic design.

"That was a big challenge," says Pierre Bohanna, head of the prop modeling department, of building the Hyperloop interior. "Although it's a tiny set, there's a lot of artwork. We did a lot of interior chairs, and there was a timeline challenge in trying to keep the finishes up, because they have to be fully upholstered and there's stunt work that has to happen in there, so there's a lot of safety concerns to make sure there's no risk to anyone. So as well as getting to the point in being able to make it, there's also practicality in a filmic sense."

Once the physical set had been built and shot, it was then down to Jerome Chen's visual effects team to blend it into the film. This meant not only creating the scenes in which we see the exterior of the shuttle rocketing across the continents – the Hyperloop itself – but also smaller elements to do with the design of the Hyperloop, including the closing doors.

"A set like this, we simply wouldn't be able to build it all," says Wood. "We could never make the doors move fast enough. So as we develop these things we're talking to Jerome all the time."

"The Hyperloop is amazing! All of that is visual effects," says visual effects producer Deven Letendre. "The Hyperloop is all visual effects. Our set was a bunch of green pipes and some seats. We start with Charlie's designs – his designs are brilliant, really, really spectacular, his whole crew. We couldn't have asked for better – and they did rough animations for it so that we know where to go, we know where to take it. Because the creative impetus is already there. That was one of the sequences that we did a fair amount of pre-vis on."

RIGHT: The Hyperloop exterior has all the elements of a subway station – including alien commuters, escalators, and an inter-galactic magazine stand.

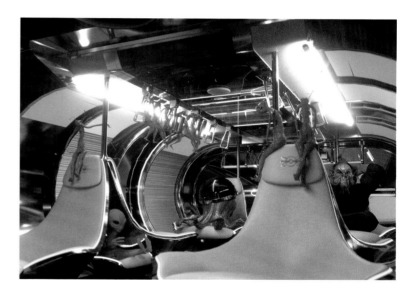

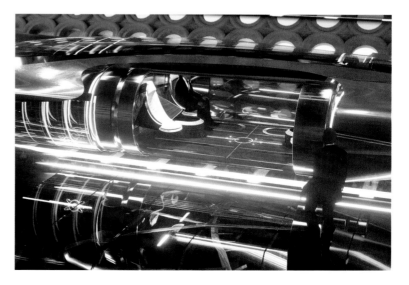

BACK IN BLACK

If there's one thing the men and women of Men in Black all need, it's a good black suit – preferably one that travels well, is alien-slobber and end-of-the-world-cataclysm resistant, but most importantly looks really, really good with sunglasses. Who better to create the staple wardrobe of London-based Men in Black agents than legendary British designer Paul Smith?.

"Will Smith and Tommy Lee, over the first three movies, had changed the style of their black suit," points out Penny Rose, the film's costume designer, who was instrumental in bringing Paul Smith on board and who worked with the label to come up with the look of the Men in Black suits. "This is MIB London, so we wanted to lift it visually, make it more sartorial, more elegant."

The setting and the need for perfect tailoring naturally led Rose to Paul Smith. "We had a lovely collaboration with them," she says. "Emma Thompson they didn't really have anything appropriate for, except for a jacket, so I said, 'Paul, can I reinterpret some of your things?' He said, 'You just help yourself.' So I found some old Paul Smith designs but I reinvented them a bit. And for Liam Neeson, because he's the head of MIB London – he's the only one in a waistcoat."

"Paul Smith's fantastic," says Chris Hemsworth. "I've worn his suits before and loved them. They've always fit so perfectly and this was no exception. What I liked about the costumes was there was a little different flair. My character had a unique lining inside

THIS SPREAD: The Paul Smith-*Men in Black* collaboration extends beyond the production itself. The designer and his team created a real-world collection specifically to tie in with the release of the film.

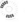

the jacket and some non-regulation Paul Smith socks. We were allowed to have something a little personal for our characters. When you put the glasses on and you have the whole suit, it all comes together. Tessa and I, on the first day for the camera test, looked at each other and thought, wow, this is pretty cool. This is the iconic shot we've seen in the previous movies and now here we are, a part of it. So it's pretty special."

It's a transformation that's mirrored in the story, as the newly minted Agent M is given her very own perfectly tailored suit to replace the crumpled thrift store ensemble she'd thrown together for her attempt to infiltrate Men in Black New York. "There was a debate about whether it would be trousers or a skirt for Tessa, but we went for trousers because there's so much action," says Rose.

"I'm a big fan of suits just in my daily life," adds Tessa Thompson, noting that a suit always makes her feel ready for business. "I love them. I started to collect them a couple of years ago. There's something really powerful about wearing a suit. But this particular *Men in Black* suit, it really is the final thing that makes you feel like you are in the world. Mine is double breasted – it's fun to find the touches inside this uniform, how each character expresses themselves."

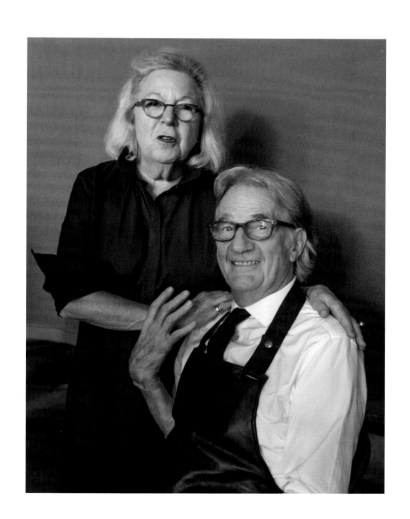

RIGHT: Paul Smith prepping for his cameo role behind the scenes with Penny Rose.

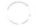

MIB LONDON ENTRANCE

Finding an appropriate location to use for the entrance to Men in Black London was tricky. After all, it had to follow the iconic stature of the Brooklyn-Battery Tunnel Ventilation building, which had done such sterling work as the front for Men in Black New York over the course of the entire franchise's history. It also, as locations manager Jamie Lengyel points out, had to firmly position the film in its London setting.

"The location we put the most effort into was deciding what was going to be the entrance to Men in Black London," he says. "It's got to have comedic value. It's got to have something unusual, a sort of surprise. We had a mood board with different ideas, whether it was a door into the Monument, or a door on Tower Bridge, a door at the end of Westminster

Bridge… We looked at places in the City, and the Bank of England – just places you wouldn't expect a door, places you wouldn't expect to be the entrance to something. We ended up using the river and a location that I've always liked – a pub called The Black Friar, a really art nouveau building which has somehow survived all the demolition around it. It's a triangle, just at the end of Blackfriars Bridge, with a weird door at the front of it. It's a beautiful building with an unusual entrance amid good geography, which meant we could add to it – we could add buildings, make it bigger. So we ended up with a pub, which is very London! The interiors we didn't actually use – in the creative process it went from being a pub to a pie and mash shop to a typewriter shop."

BELOW: Concept art of the London MIB Headquarters entrance (top left). The Black Friar pub during filming (top right). Paul Smith in his role as the proprietor of the typewriter emporium (bottom).

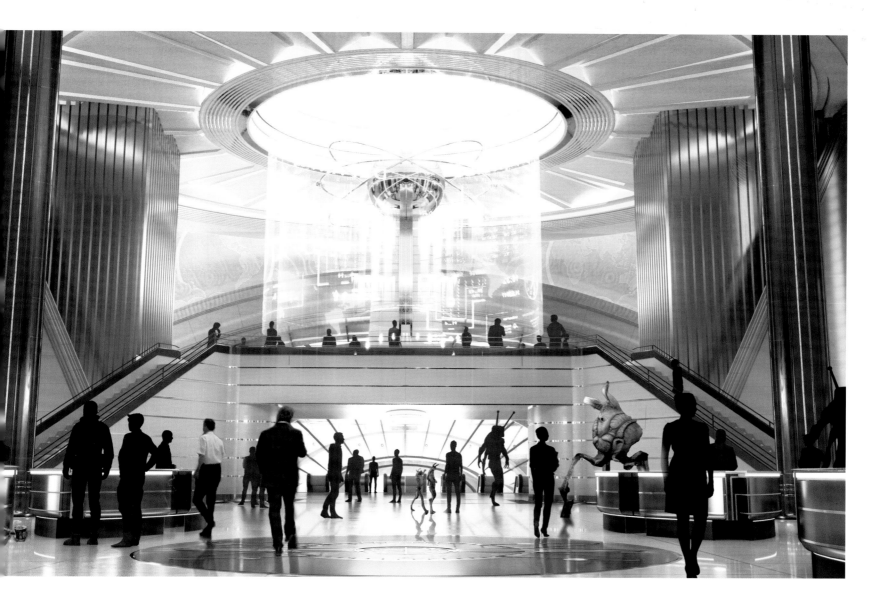

MIB LONDON HEADQUARTERS

"One of the first areas we focused on was MIB London," says designer Charles Wood. "Because that's almost the soul of the film and everything else would come from it."

Early discussions inevitably turned to the previous three films. The big question was whether *Men in Black International* would follow the look established in the original *Men in Black* movie, or do something entirely different with its design. The answer had a lot to do with the plot of the fourth film and what it would say about the expanded, 'international' Men in Black organization.

"MIB New York had its own aesthetic," says Wood. "It was post mid-century modern, 1960s era, the space race.

What we spoke about from the get-go was whether we wanted to set our new world of MIB London in a more historic setting. The first thing that the producers said was that in the first three films, their history only dated to the 1960s. But there are no rules to say that the organization hasn't actually existed since the turn of the century or even earlier. As soon as that was decided, the architecture of that could become earlier or indeed later. The world of anything from turn of the century through to the 30s brings up a lot of different architectural styles. So we tried to be faithful in the sense that we wanted to make it architecturally have notes from the previous films. But MIB London has existed for a century."

ABOVE: Concept art of the London Men in Black headquarters. Note the familiar alien silhouettes.

"Bauhaus was a very strong influence in this – Deco/soft Deco," says Wood of the key Men in Black London set, a vast construction the size of a football pitch built inside one of Leavesden Studio largest sound stages. "Parts of this were taken from the Queen Mary, those kind of huge ocean liners – the columns and sweeping staircases in particular. The whole idea of the 'snooker ball' in the middle, in the original films they had that beautiful egg shape, so this is our version of that. We've changed the shape and we played around with a lot of more updated technology, but you still have that focus to the set."

The Bauhaus influence can also be seen in the color palette the designer chose for the set, which recalls the clean white, black, and chrome accents of Men in Black New York while also delivering additional bursts of color.

"The original one was white and very lovely," says Wood. "We wanted to have a memory of that but put our own version into it. So this is actually very much based on a Bauhaus color system, where it's high contrast and you've got creams, blacks, reds, and bronzes. The other thing to all of this when you design these sets is that, because they're in black suits, you want to try to find images where someone in black will stand out, because the image can become very complex very quickly."

Color can also be seen in the 3D displays overlaying the set – an addition to Men in Black London that takes advantage of the ever-improving domain of visual effects.

"This is a collision of a world that has existed for 100 years, and then on top of that, when you actually see the movie, they'll do some sort of cutting edge holographic work in it. But it still follows the format – when you walk in, there's an immigration area, and all of the other areas that you're processed through. But at the back of the set there's this area where you have the MIB bull pen area below and then you have H and C and the other agents' upper mezzanine surrounded by all of these holographic images."

THIS SPREAD: Many of the set's larger props incorporated a practical element that added to the site. "We were in constant dialogue with the design department," says Stuart Dryburgh. "We ended up with all these beautiful desks that had glowing tops, which is great, as it meant that the actors working around those places were already lit in a really interesting way. It meant that, although we put in a lot of set lighting above, we turned it right down to minimum levels and shot most of the scenes with the practical lighting, to give a more interesting look."

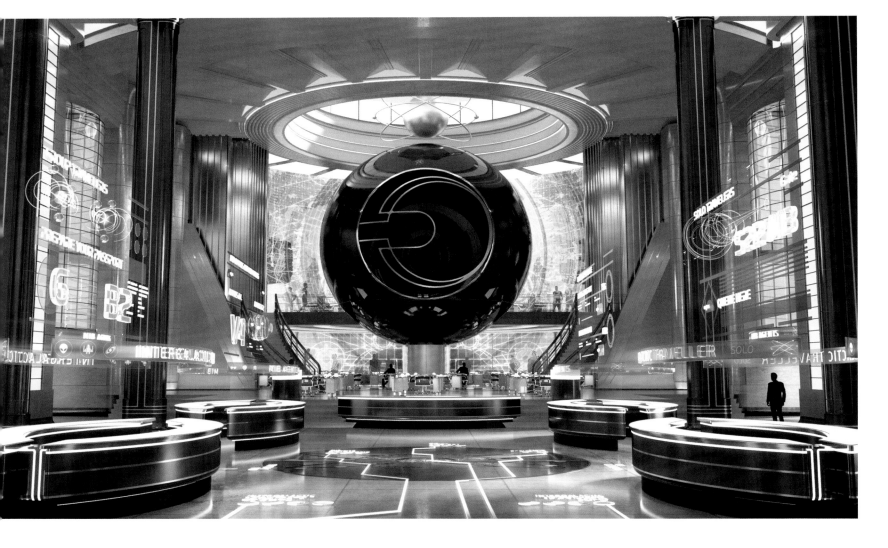

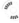

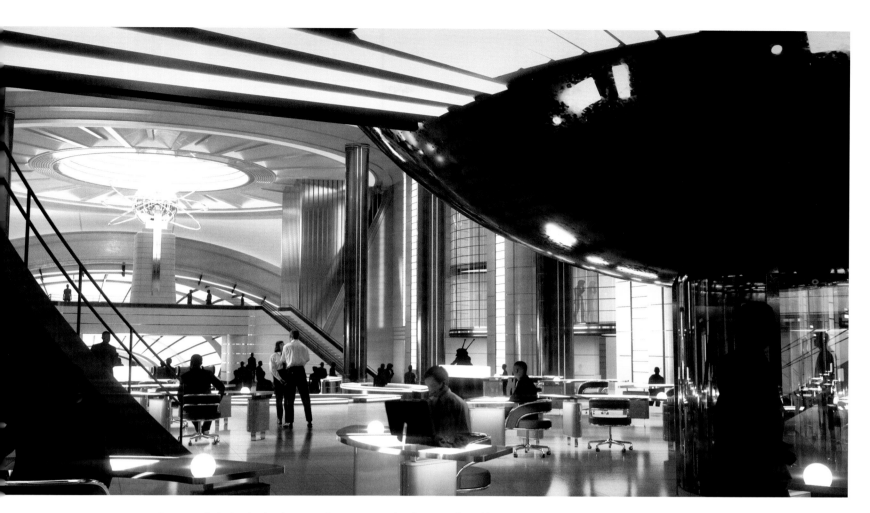

ABOVE AND BELOW: Concepts of the London headquarters demonstrating the classic circle emblem that was also featured in the New York office.

"MIB London is pretty intricate," agrees Deven Letendre. "There are a lot of layers to it, a lot of data, a lot of aliens, a lot of different aspects. There's set extensions, there's surfaces, there's ceilings we put in, there's data in the floor… You always look at what's come before, because you don't want to repeat yourself, you want to stay new and fresh. But you also want to make sure it stays within what the producers are expecting and looking for. It's new, but there's always that tether to keep it in the world."

Lighting the set was the task of director of photography Stuart Dryburg. "When you're working with a good design team, a good place to start is with their concept art," he says. "Charlie and his visual artists had already set a look for the place in terms of where they were placing the set lighting. It's a big, art deco place and up above is one huge circular lighting dome and then there are these lights that go up the columns. So we had a pretty strong reference to how it should look from the design team and we really just followed that. Then on the day, on the set, it's about the levels – do we want it to be darker or lighter?"

"We were trying to do something that was sympathetic that wasn't too dark," Wood agrees. "It's easy to go dark, but you've got to be careful there – we wanted lots of hits of color all over the place, lots of up lighting, but at the same time we were trying to deliver a space that was actually quite simple."

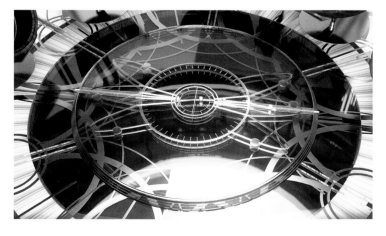

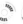

ALIEN CONCEPTS

The aliens seen in *Men in Black International* are a mix of physical prosthetics shot during filming and visual effects added in post-production. F. Gary Gray had a clear idea of what he wanted to see on screen in terms of color for the extraterrestrial elements.

Make up designer Jeremy Woodhead wanted to give the aliens in *Men in Black International* a different color palette from the first three films. "It tends to be the more reptilian colors. We've tried to break out of that, so it's combinations of colors that make it bright, cheery, and fun. The director was very explicit that these aliens should not be frightening, nor should they be completely comic."

Some of Woodhead's sketches can be seen here. "We're bound by the human form," the artist points out. "From my point of view, I have two eyes, a mouth, and a nose. They can be distorted a bit, but I can't change that, so they had to be done with that in mind." While many of the heads were straight prosthetics that needed no CG help, Woodhead also designed aliens that would require augmentation by Jerome Chen's visual effects team in order to work.

"We give them the bare bones – a still, effectively," says Woodhead. "The faces don't move much, so that's for them to animate. There's one wrapped in snakes, so it's up to the visual effects team to make the snakes move."

BELOW: Two alien Men in Black agents on set (top). A variety of aliens created by Jeremy Woodhead and his team of make up designers (bottom).

OPPOSITE PAGE: A selection of Woodhead's many alien head sketches, including 'snake head', who was augmented in post production to allow his snakes to move.

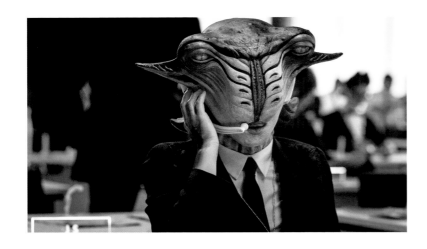

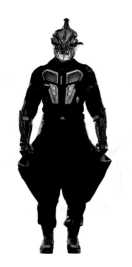

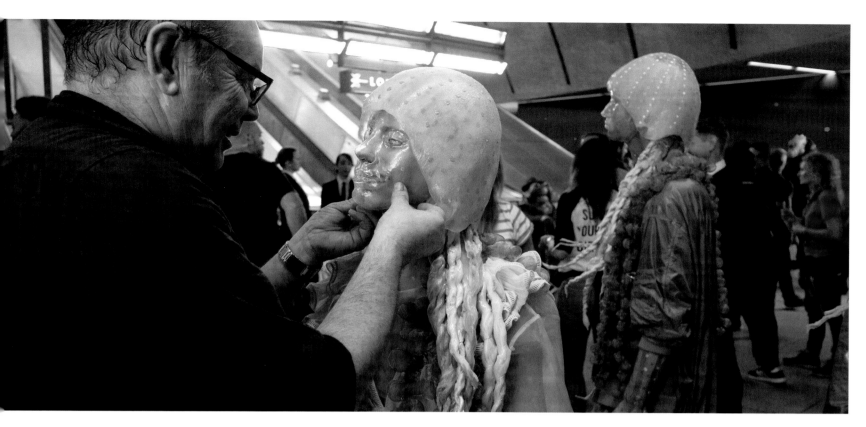

ABOVE: Jeremy Woodhead preparing one of his prosthetics for shooting.

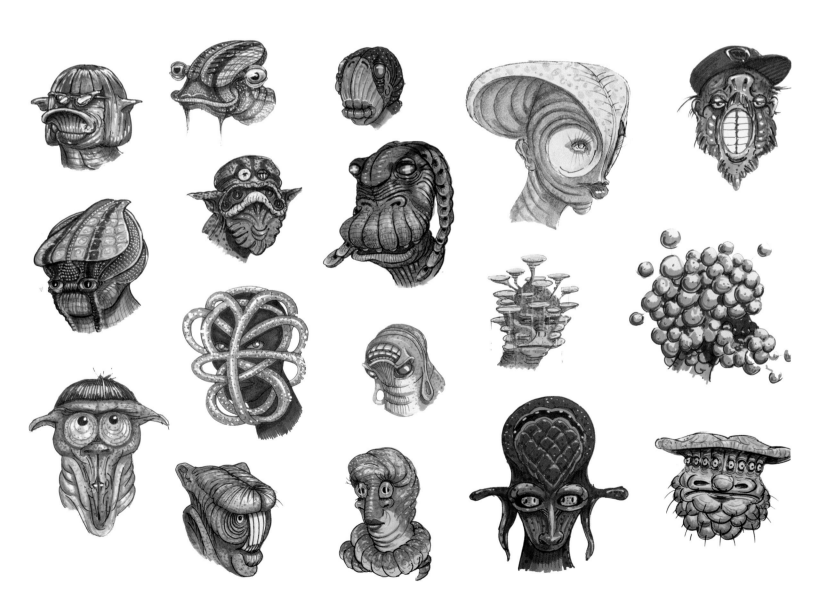

AGENT H

> **"HIGH T AND I WENT UP TO FACE THEM, WITH NOTHING BUT OUR WITS AND OUR SERIES 7 DE-ATOMIZERS."**

REPORT: AGENT T

DESIGNATION: AGENT H

YEAR OF ACTIVATION: 2009

PLACE OF RECRUITMENT: BRIDPORT, ENGLAND

CURRENT FIELD OFFICE STATION: MIB LONDON

RECRUITER STATEMENT:

Agent H is without a doubt the most capable and loyal Men in Black operative that it has been my good fortune to serve with. While his methods can at times seem somewhat counter to strict MIB regulations, it is no exaggeration to say that, without him at my side, the Earth would have ended at least once. I find it impossible to imagine a better replacement for me in my position as head of MIB London when the time comes.

SIGNED, AGENT 'HIGH' T, MIB LONDON

AGENT'S PERSONAL STATEMENT:

I saved the world, you know. Well, me and High T saved it together. We went up against the Hive with nothing but our wits and our Series 7 De-Atomizers. That's worth a drink or two, right? Maybe a nice cigar? No? Fish and chips, then. It's got to be worth fish and chips.

SIGNED, AGENT H, MIB LONDON

" **A**gent H has a pretty unorthodox approach to things," laughs Chris Hemsworth. "He tends to operate under his own banner and that certainly rubs a few of the agents the wrong way. There's a bit of friction with a few of them. He's gotten away with that approach for a long time. We open the film understanding from other people and from him that he had saved the world and so he's enjoying the fame and recognition that came with that. He uses it to his advantage to do things that aren't necessarily company policy."

For Hemsworth, part of making Agent H his own was ensuring that the character traversed a real learning curve during the course of the film, something that he felt would make H sympathetic despite that touch of arrogance. "He has a large amount of self-assured confidence – he has a swagger to him," says the actor. "He has a great sense of humor, and prefers to not do things by the book. I wanted to set that up to have somewhere to go, so there'd be lessons to learn throughout the film. I wanted him to have this journey that didn't start and finish in the same place."

It's not common to find a leading man who is also willing to play a lot of the comic relief in a film, but walking that fine line is something Hemsworth excels at. As they were penning early drafts of the script, writers Matt Holloway and Art Marcum had tried not to impose actors onto their characters, but soon found themselves with Hemsworth firmly in mind.

"I usually start with a blank slate and say, who is this person really, and try to take them seriously as a person first, and then think of them as a character and then think about who's going to play that character. But yeah, there aren't that many people who can play what Chris is playing, so I'd be lying if I said that didn't creep into your consciousness," says Art Marcum. "We had kind of thought of him as the Roger Moore version of James Bond, and added just a little more 'louche-ness' to that idea, if you will – though we never wanted to go off into Austin Powers land. You have to keep yourselves in the lane."

"Chris and Tessa brought a lot to the table in a great way in terms of how they felt about their characters," adds Matt Holloway. "We were honored that they wanted to do it. We were so lucky, we have the most fantastic cast. They really made them their own."

THIS SPREAD: H kept calm under pressure, even when poisoned by a snake.

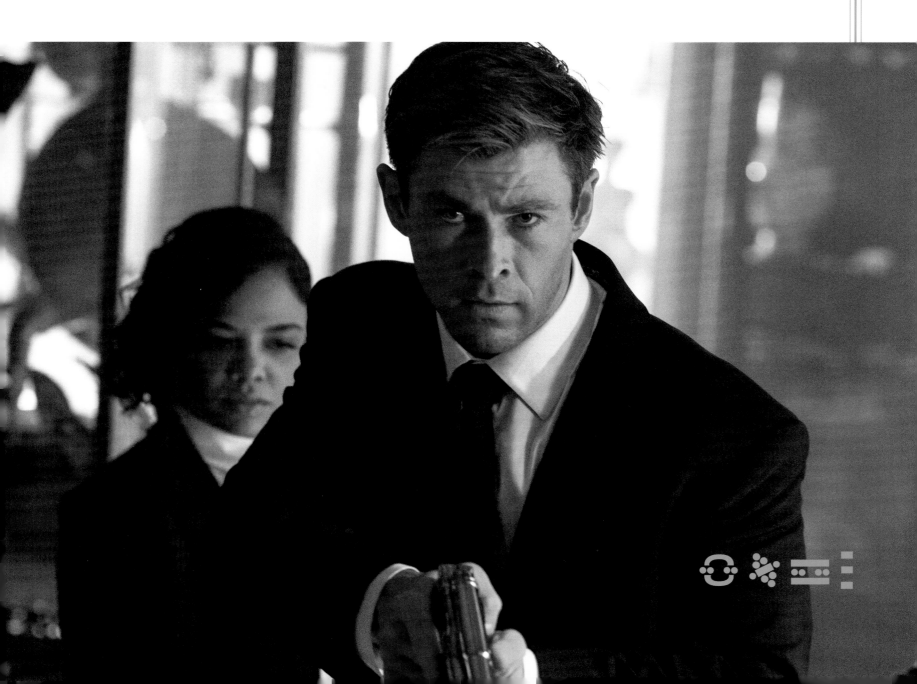

THE NEURALYZER

Besides the sleek monotone look of their wardrobes, the Men in Black's most iconic trademark is the Neuralyzer. For the franchise's return to the screen, the production decided that this item of equipment would need a redesign and update, but no one wanted to reinvent the wheel. After all, it still needed to be recognizable as the piece of kit that 'did the flashy thing,' as Agent J so memorably called it way back in the first film. As a result, it took a long time and many drafts to nail the design.

"It's such an important prop in the film, and we had a lot of designs done," says prop master Ben Wilkinson, whose team was responsible for creating the look. "We just kept addressing it and doing more and more designs. I think we got up to about thirty-nine different concepts. It's such a tricky mechanism, there's a lot of work in it. It has a button and a spring, with LED lights inside."

Although the brightest flash would be enhanced by the VFX department in post-production, the actual movement of the neuralyzer was practical – meaning that when you see, for example, H use it on screen, the motion of Chris Hemsworth pressing the button did actually activate the prop on cue during filming – it slides open and lights set into the interior power up.

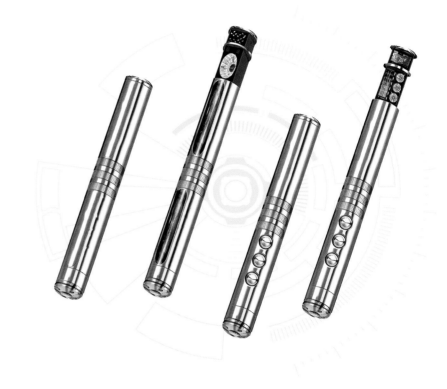

ABOVE: Early concepts of the neuralyzer by WETA Digital.

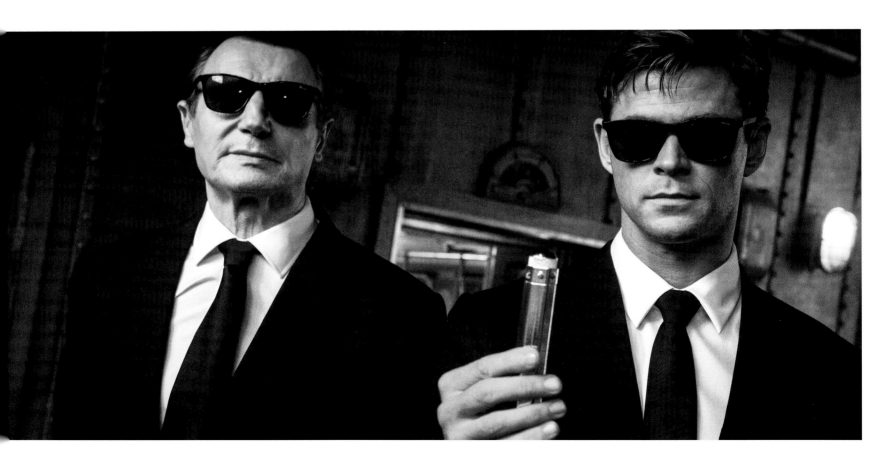

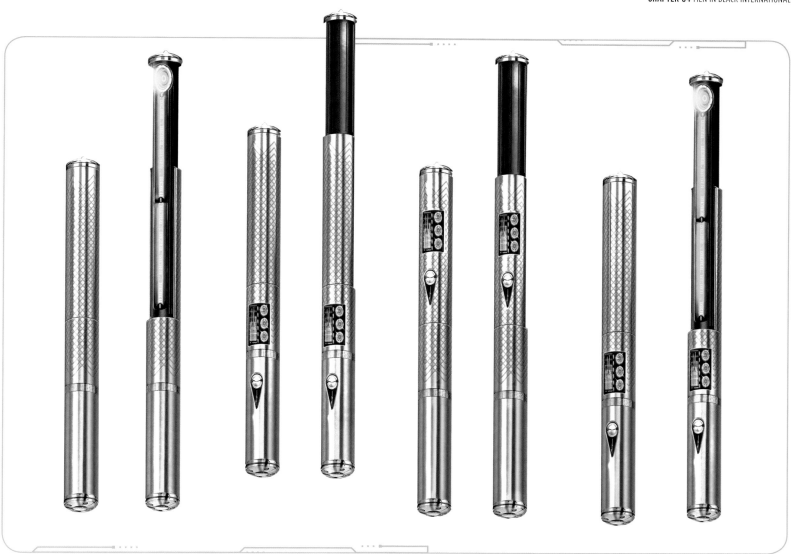

It is, to all intents and purposes, a real tool (albeit not one with the power to actually erase someone's memory!)

"As the concept guys were doing ideas, we were trying to show different mechanical ideas of how the lights come on and so on," says Pierre Bohanna, whose task it was to create the physical prop and make it work. "There were many, many versions. It literally is a tooled piece of material, made from carbon steel." An injection-molded material, carbon steel is extremely weighty and requires specialist equipment and skills to work it. It was a necessary process, however, given the complex design the production chose for the neuralyzer. "The mechanics of getting the doors to open sideways and parallel like that is actually very difficult," explains Bohanna. "Things normally work around a pivot, but these had to slide parallel to each other, and it telescopes out. That's why we used a very high quality material, to be able to get that mechanical accuracy, and also to get the finish. Normally what you'd do with is that you'd silver plate or use a different surfacing process, but with this it's the raw material, polished."

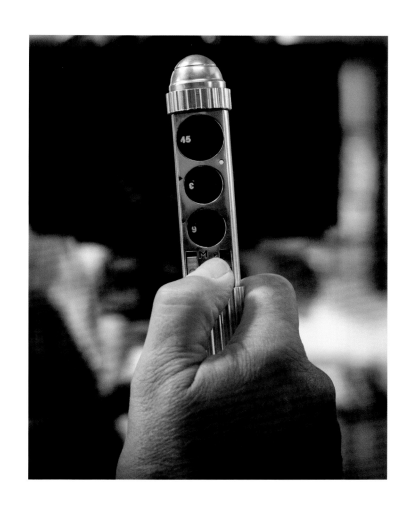

THIS SPREAD: When asked what they'd erase from their minds if they had the choice, both Tessa Thompson and Chris Hemsworth said they'd be happy to remove the memories of bad auditions from the past!

HIGH T

"UNTHINKING RESPECT FOR AUTHORITY IS THE GREATEST ENEMY OF TRUTH."

ALBERT EINSTEIN

REPORT: AGENT O

DESIGNATION: AGENT HIGH T

YEAR OF ACTIVATION: 1972

PLACE OF RECRUITMENT: BELFAST, IRELAND

CURRENT FIELD OFFICE STATION: MIB LONDON

RECRUITER STATEMENT:

High T was recruited before these official file things were instigated, so I'm taking it upon myself to slot one in, so to speak. Agents of the caliber exhibited by High T are, in my experience, few and far between. The younger generation would do well to read up on his history with Men in Black and ponder on the level of dedication and self-sacrifice embodied by his years within the organization. His case files make for quite the education. I for one am proud to know him — even if it is an acquaintance that has largely been conducted across the Atlantic Ocean.

SIGNED, AGENT O, MIB NEW YORK

"It's sort of the heart of the film," says Chris Hemsworth, of the relationship between H and High T. "They have a very close bond. There is a definite father-son mentorship there. High T is the father figure that H probably never had. Liam has a wonderful sense of humor, and a great collaborative approach to how we could bring these things to life. He was very specific on the relationship between H and High T, and making sure that mentorship was clear, and the father-son relationship was evident."

For Tessa Thompson, seeing a screen legend like Neeson at work was a real highlight of playing Agent M — especially for that sense of humor. "He has such a commanding presence, and is so incredible to listen to," she says. "The other day we were shooting this scene, and we were all getting the giggles — but the scene is serious. I will never forget him trying to hold it together. Because here's a man who arguably has the most gravitas of, like, any human being, and to see him just be in stitches internally, and then externally, was really sweet."

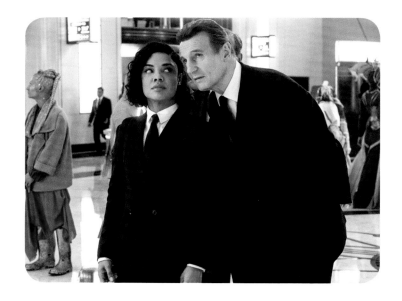

"We can't believe we got Liam," says Laurie MacDonald, of the casting of High T. "Really it was key that it was someone you would believe could be H's father-figure, and he also needed both the dramatic and the physical scale to work with Chris. And Liam — he shares with Tommy [Lee Jones] a gravitas, but besides the body of work it's a very specific thing. It's *Liam Neeson*. He's been in so many tough action movies and done really dramatic work, the weight that he brings and legitimacy was really important."

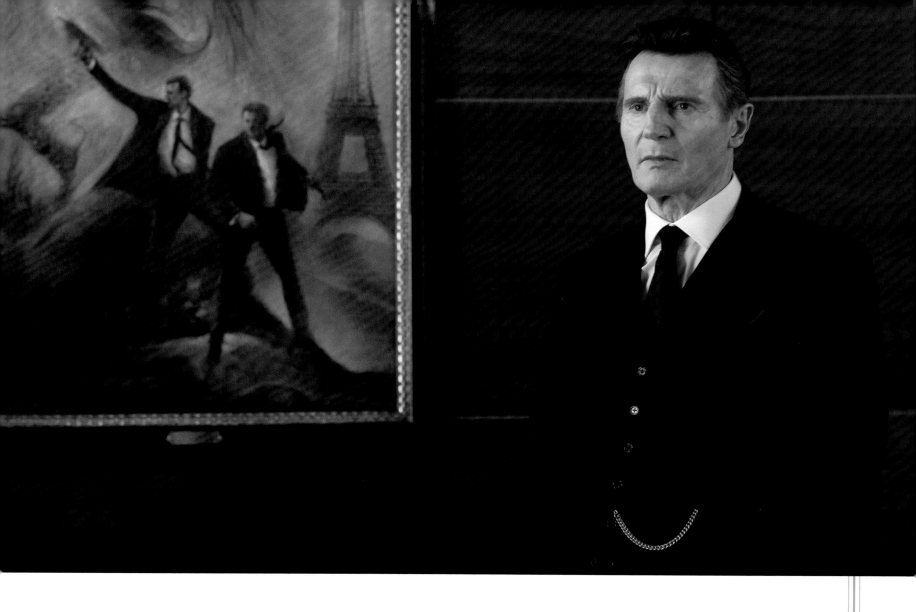

UNDERGROUND CLUB

M's first real foray into the [hid]de world as a Men in Black [is t]he field trip she takes with H [and] Vungus. As with Will Smith's [M i]n the original film, now that she's [indu]cted into the organization, M [is fu]lly confronted with the truth: that [aliens are] all around us and nothing is quite [as it s]eems. "As we like to say," says [producer L]aurie MacDonald, with a laugh, ["it's a world] where humans look like aliens [who]... try to look more like humans!"

[The pro]duction's original plan was to [build the c]lub as a set at Leavesden Studios. [But it] was actually shot on a location [in] London found by Jamie Lengyel.

"That was Old Billingsgate," says production designer Charles Wood. "We liked the arches and the simplicity of the space. It was much bigger as a location than we could ever afford to build, and Gary wanted to have a two-leveled club so he could do tracking shots." As a result, it made far more sense to dress the location to suit rather than building it from scratch. "We looked at a lot of César Manrique's work, a wonderful Spanish sculptor, to come up with these playful shapes. It's all about lighting, this space."

THIS PAGE: Concept art for the underground club.

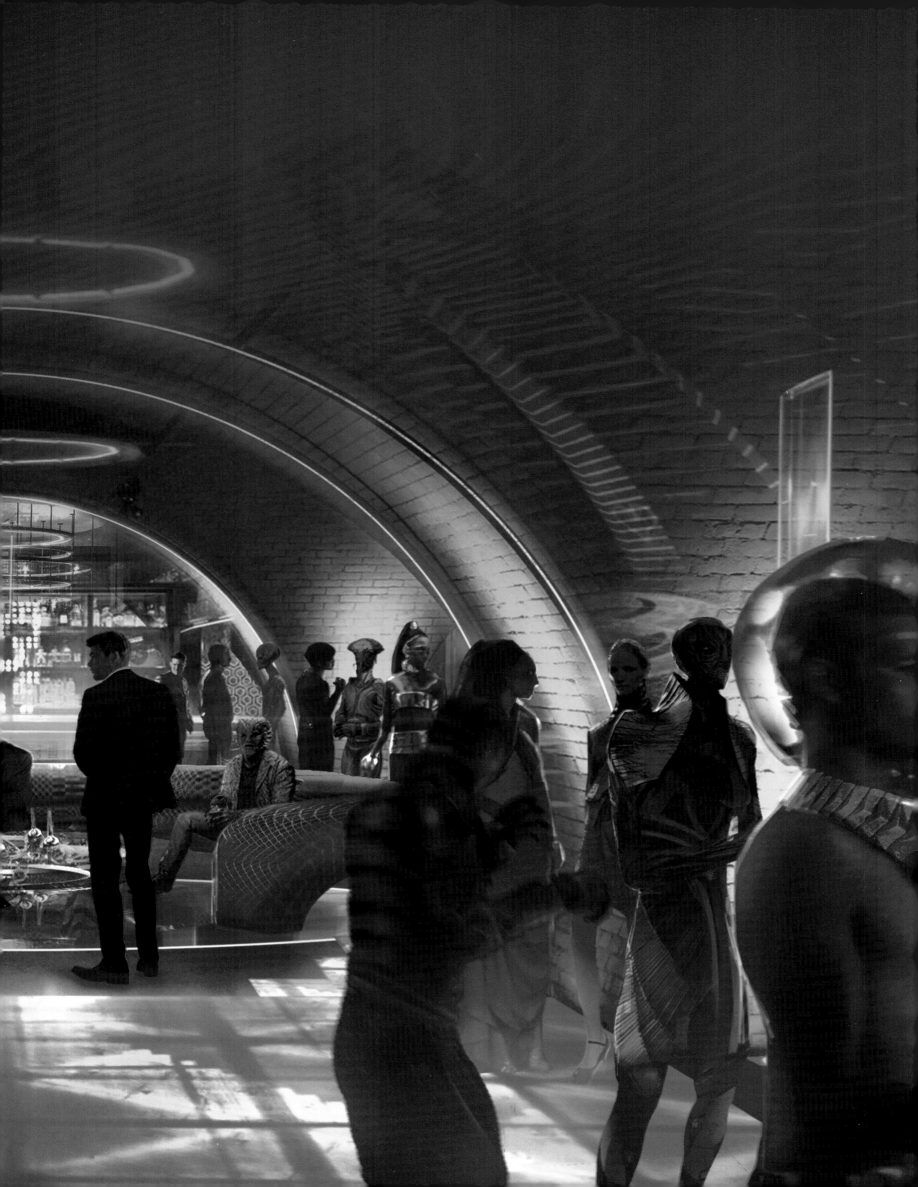

"The shapes of it are beautiful to begin with," agrees director of photography Stuart Dryburgh. "It used to be the ice cellar for the fish market. We outlined the arches in LED tube lighting, and we used a lot of lasers as well. We also had an under-lit dance floor so that it was itself a light source."

The result is a beautifully colorful contrast to the clean lines of Men in Black London, but one that still retains similar shapes. This was a deliberate choice on the part of Charles Wood. "We tried to follow the theme through the film," he says, "so you'll see it all over the place."

Though finding the perfect location had removed the need for the production to build the set from scratch, dressing it for the shoot threw up issues of its own. The most notable of these was the lit dance floor, which was constructed from individual panels designed to fit together, a product already on the market and in use in real nightclubs – though not usually on this scale.

"It was huge," Dryburgh recalls. "Just getting it all together was a massive thing. A rave tent at a musical festival would maybe use half of what we had." As a result, sourcing so much of the flooring became an issue, because no single lighting outfitter had enough to fill the production's requirements. In the end, the supplier had to scour the country. "We had to scramble around and find every available piece in the United Kingdom," Dryburgh laughs.

Another challenge came in dressing the set, specifically in building the bar that dominates the space as M and H arrive. This became a joint endeavor between the construction department and Pierre Bohanna's prop modeling team.

"The biggest single piece we built for the film was the bar in the nightclub," says Bohanna. "The construction boys built the steel frame and we produced all of the glass spheres and the domes at the top, the lights around it and the dressing elements. We purchased Perspex spheres that are actually light fitting elements. The tapering necks we molded and cast ourselves. We cut the spheres and glued the two sections together and then filled them with a mineral oil (which doesn't go green like water) and added a little bit of color."

BELOW: Stills from the underground club set demonstrate how closely the production design team followed the color palettes of the concept artwork.

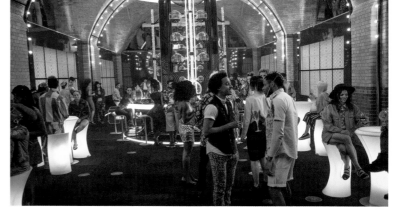
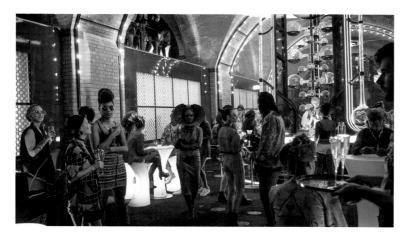
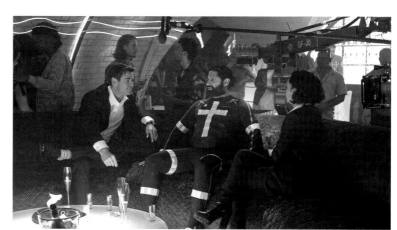

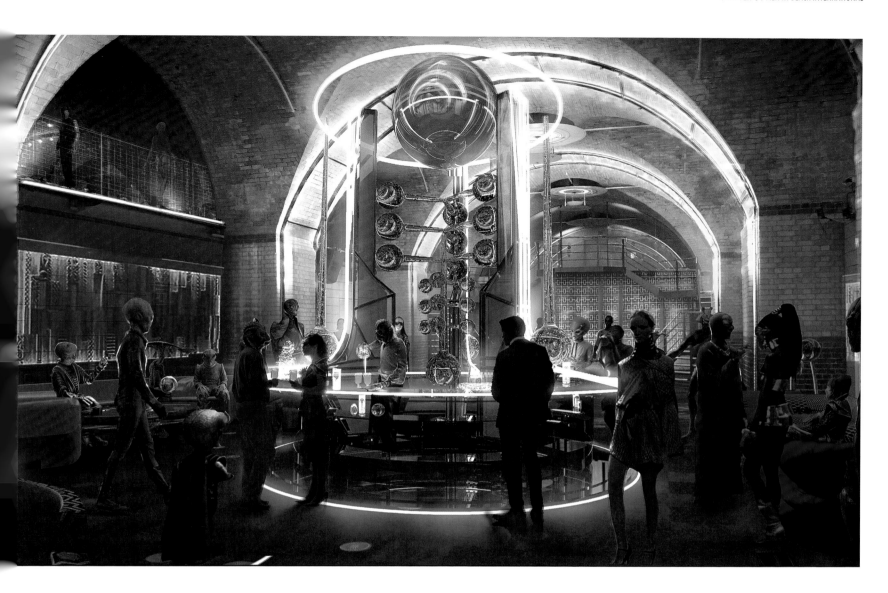

THIS PAGE: Concept art for the underground club.

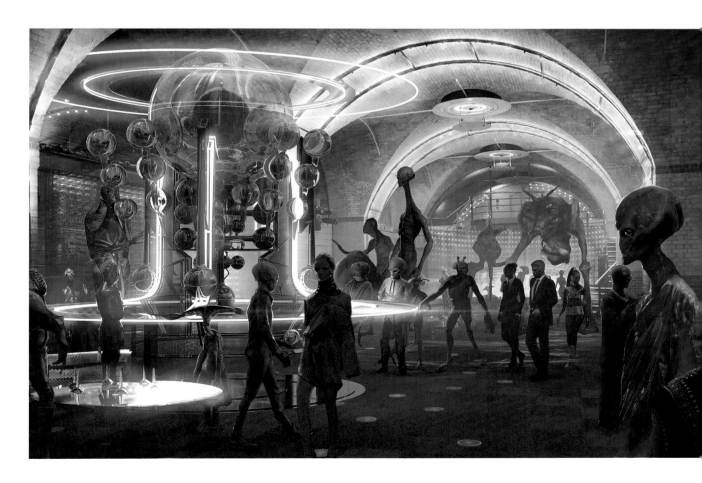

Once the set itself was ready to shoot, it was filled with nightclub attendees of both the human and alien variety. Although some of these aliens would be added at the post-production stage as computer generated creatures, many others were to be physically on set during filming. The challenge of creating these aliens fell to hair and make up designer Jeremy Woodhead and his team, in collaboration with costume designer Penny Rose.

"There has to be a connection between the alien design and the wardrobe, or it can start to just look crazy," says producer Laurie MacDonald. "It was challenging because we had the big scene in the club, which is a mix of humans and aliens. Penny Rose and Jeremy are very close and have a tremendous respect for each other, and they found that balance well. Jeremy is incredibly inventive, I just love what he's done."

"That was the great big fun bit of the job," says costume designer Penny Rose, of creating the aliens' clothing. "In summer 2018, there were masses of 'alien' clothes in the shops." Rose's team began buying the most unusual pieces they could find.

"We went to Dover Street Market, which has the most extreme fashion," says the designer. "It was just full of mad, weird clothes. Who wears a silver jacket of paper with points all over it that stick out? Then everybody in my team went charity shopping. That was a good source. We got quite a bit at Angels, which had lots of Thierry Mugler and 80s clothes that had those weird shoulders. Lots of vintage Japanese: Yamamoto, Issy Miyake." With a store of pieces as a basis for the aliens' outfits, Rose and her team really went to town. "We bought individual components and reinvented the whole muddle. Initially we were playing, and then when Jeremy started to produce the heads, we dressed for the heads."

BELOW: Executive producer E. Bennett Walsh, first assistant director Lisa Satriano, F. Gary Gray, and his assistant Charley McLeod on set.

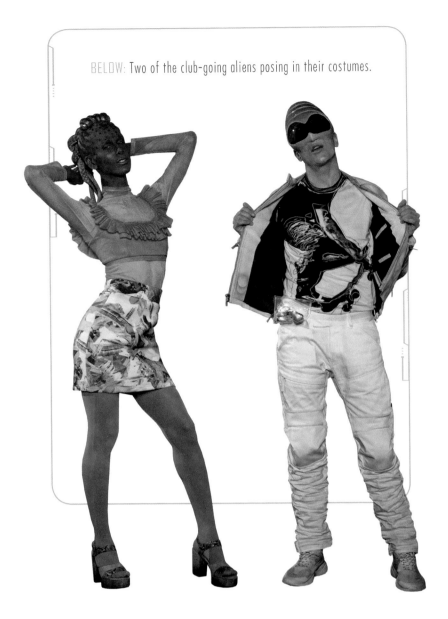

BELOW: Two of the club-going aliens posing in their costumes.

MIB: ALIEN DATA

VUNGUS THE UGLY

SYSTEM OF ORIGIN: JABABIA

DESCRIPTION: MEMBER OF THE JABABIAN ROYAL FAMILY

AGENT HANDLER STATEMENT:

Some people would write Vungus off as a bad sort, but really you just need to know how to handle him. Find a way to relate to him on his level, and he's a good chap to deal with. I've always found that works, particularly if there's vodka included in the equation, or even better, tequila. As a result, Vungus and I go way back and have a good working relationship. I mean, there was this one time in Bangkok where our working relationship was so good that we woke up handcuffed to a horse, but there's not enough room to finish that story on this form, so you'll just have to take my word for it.

SIGNED, AGENT H, MIB NEW YORK

BELOW: Vungus is played by British actor Kayvan Novak. Novak worked in a motion capture rig so that his actions and expressions could later be incorporated into the CGI version of Vungus.

PAWNY'S DAGGER

The dagger that causes Vungus so much trouble – and that leads M and H on their international chase – was designed by concept artist Alex Caldow.

"I thought it was a really cool idea, because it was supposed to be really tiny," says the artist. "*Men in Black* is great at doing that – twisting scale and turning things on their head." In his early designs Caldow created fourteen different concepts and referenced a lot of Asian weapons, including daggers, swords, axes, and maces. "For the one they chose, I was looking at a Moroccan dagger," he says. "But I've extruded some elements to make it a little bit more alien. It's a poison dagger and I was trying to make it look ergonomic and sleek, so having the vial in the middle rather than on the outside meant it was all contained in the blade."

"Pawny's dagger," laughs prop modeler Pierre Bohanna. "It's such a tiny thing! We made one that I think was about 8mm long, and it was actually a piece of etched stainless steel, with a little artwork on it. It was like confetti! But then we made a version that was about 14 inches long, so that the guys had something to film, to do lighting on and for close ups and so that visual effects can then take that into different shots."

The minute dagger is intended to look like a very intensively tooled piece of weaponry, forged with care and precision. "It has a Damascus blade," Bohanna explains. "It's a patination which is classically done by folding and forging steel many times. It's the process they use for making Samurai swords and quality shotgun barrels. They wanted that in the design, but we didn't actually do that – it would take months."

Instead, Bohanna's department turned to modern 3D printing to create the basis of the prop, giving a greater level of accuracy. "We made the models and then they are silver plated," says Bohanna. "We used real silver and gold plating, because that close up, you need the quality of that investment. The patination is in the form – on the blade there is a very subtle difference, a kind of texture change that comes through the plating. It was a really nice piece to make, because it's very artful but it's a very technical challenge too."

THE TWINS

> "THEY DID THIS WITH THEIR BARE HANDS — TURNED SOLID TO LIQUID, THEN BACK AGAIN."
> AGENT M

MIB: ALIEN DATA

SYSTEM OF ORIGIN: DRACO

DESC.: ASSUMED TO BE INFILTRATORS SENT BY THE HIVE

MIB AGENT ASSESSMENT:

Dyadnum is in known Hive territory. The DNA of these Dyads is riddled with Hive DNA. All agents are therefore urged to be vigilant — these two must be neutralized at all costs. They are foot soldiers of the Hive and, as such, are extremely dangerous. The fate of the world depends on their destruction. All agents of Men in Black are urged to be on their guard.

SIGNED, AGENT T, MIB LONDON

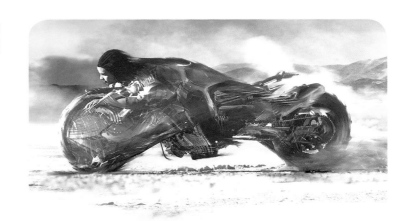

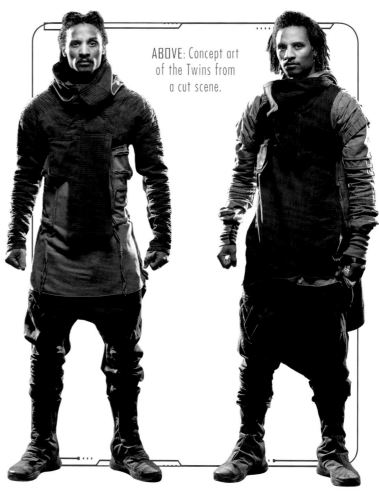

ABOVE: Concept art of the Twins from a cut scene.

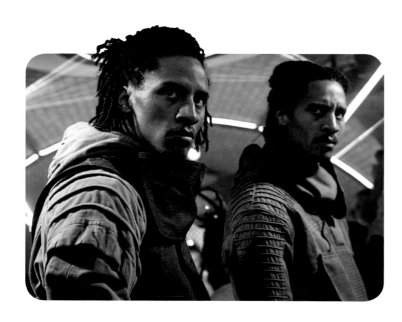

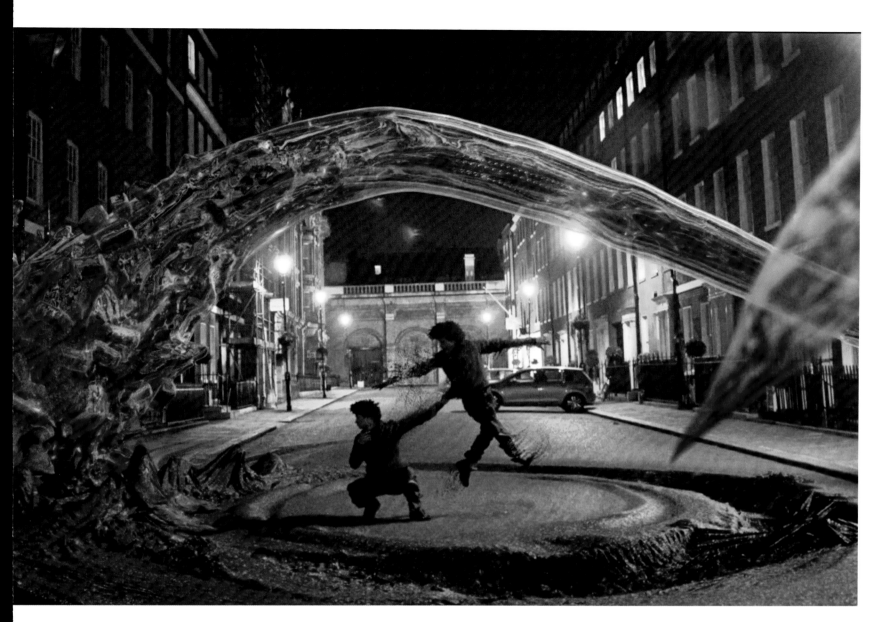

DANCE BATTLE

The inclusion of French dance sensation Les Twins as *Men in Black International*'s main antagonists was the suggestion of director F. Gary Gray. He'd had contact with the duo before and had been trying to find a way to work with them for years. As the production discussed just how their bad guys would work, Gray realized that he'd finally found the perfect role for them both.

"We originally started with four antagonists that combined into one," explains writer Matt Holloway. "We were in a meeting one day, talking about how we were going to do that and whether it was really going to work. Gary showed us this video of the twins and everyone was just blown away."

It's not difficult to see what it was about the duo's act that made Gray imagine them as adversaries for M and H. They have been dancing together for so long that their movements are completely attuned to each other in a way that seems telepathic. They also have the ability to move incredibly quickly but with a strange, jerky movement. It's as if they are on a format that has been artificially speeded up, so that even watching them live on stage, the audience feels as if they are seeing a special effect, though in actual fact it's just Les Twins displaying their extraordinary abilities. It's almost as if they're... alien?

ABOVE: Concept art of the battle scene on London's streets showing an early rendition of their powers.

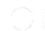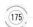

For Laurent and Larry themselves, getting the call from F. Gary Gray was quite literally a dream come true. As children, Will Smith had been a hero for them both, perhaps not surprising for two youngsters just beginning to dance themselves.

"Oh my God," exclaims Laurent, "Like every kid in the world at my age, from the first *Men in Black*, we have been wishing to be Will Smith!"

"Gary is a special guy," adds Larry. "I love working with Gary. It is just a dream to work on *Men in Black*, one. And to work with Gary Gray, two."

Once Les Twins were on board, the challenge was to find a way to integrate them smoothly into the film. They are live performers, and their dance is largely spontaneous, meaning that they do not choreograph their sequences – they react to the music, each other, their audience – and in doing so, create something unique each time they move. The reality of making a film, however, requires a performer to be able to remember and repeat not just lines but also movements over and over again, often from different angles and sometimes only a portion of an action rather than the entire sequence.

"Les Twins were great," says stunt coordinator Wade Eastwood. "They're just so professional. The hardest part was, I can't have them dance in the movie. They're so good at what they do dance-wise, but you can't fight with an element of dance because it looks like you're doing dance fighting, which is cheesy." The key, Eastwood discovered, was to use those signature movements separately. "You can't do *that* arm movement with *that* leg movement, because it's a dance. But if you isolate the leg movement then it's not. Then it's a move and it's quirky."

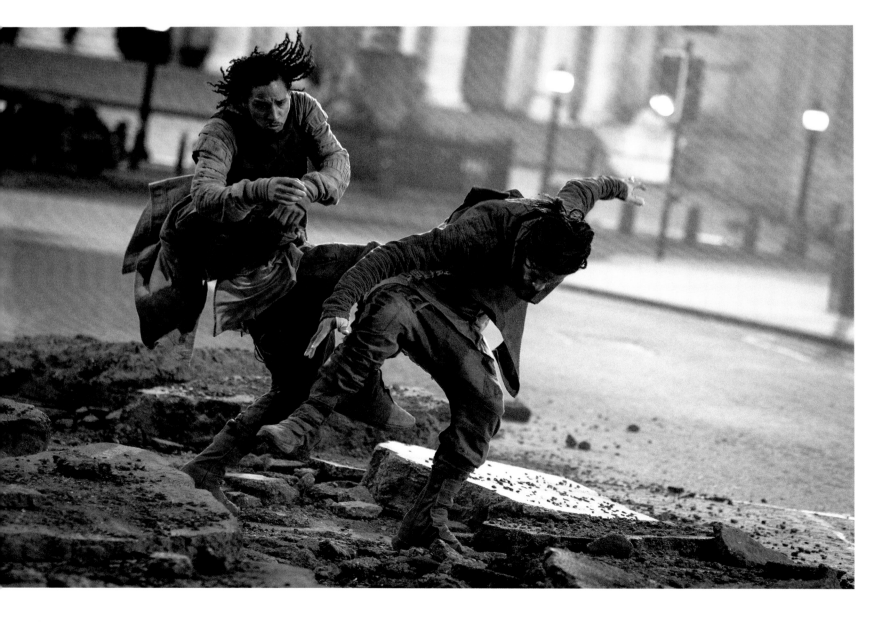

BELOW: Larry and Laurent on set performing one of the acrobatic fight moves.

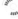

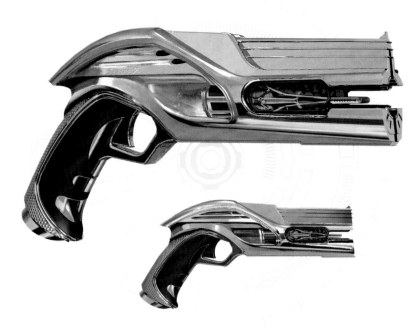

ABOVE: Concept art by Weta Digital of the Series 7 De-Atomizers.
RIGHT: Before (top) and after (bottom) the VFX team added in the devastating effects of the Twins' battle.
BELOW: Concept showing the MIB clean-up team and their technology (top). The fight scene mid-shooting (bottom).

"Nothing was choreographed," says Laurent. "The stunt guys were like, 'So how are you going to do something?' They were so worried about it but, at the same time, they believe in us so much. But you have to do the same thing, twice. I have to literally remember everything. But we try and we did it."

"Our freestyle is way better," explains Larry. "We didn't practice, but we did lock some moves A, B, C, to go back to do this move. They all are going to look great, but it is not going to be the same thing. But the A move is going to be the same. The B move is going to be the same."

Another concern for Eastwood was that, as the film's 'baddies,' the Twins needed to look formidable on screen.

"You want to be a little bit scared of them because they're the antagonists," he points out. "When they're two good-looking guys, you're not automatically scared, so we've got to make their unique moves part of what they are to appreciate them as our baddies. That was the hardest part for me, working with them to make them the main antagonist."

Making those moves less fluid, less polished, was one key to giving the twins the disturbing quality that ended up on screen.

"Wade, he is telling us to do something and we are doing it perfect," laughs Laurent. Eastwood, however, wanted less than their best to achieve the style he was aiming for. In the end, he asked the Twins to only give twenty-five percent of what they usually would. "'This is too easy!'" Laurent remembers telling him. "But he said, 'This is exactly what I need.'" It worked, too. "We did it with no special effect," Laurent adds, "and it looks really good."

AGENT H'S CAR
AND WEAPONS

It wouldn't be a *Men in Black* film without a plethora of extraordinary weapons and vehicles mixed into the action. *Men in Black International's* production design and construction departments outdid themselves, creating and then making hundreds of props. There were so many guns required, says prop master Ben Wilkinson, that his team started making scratch-built weaponry from whatever they had in the shop in between their other tasks so that they wouldn't get caught on the hop when asked to dress a set. "We always had

some tricks up our sleeves," he laughs, "and pretty much everything we made ended up in the film."

One of the earliest guns designed was H's handgun, a hero weapon for a hero character. Meanwhile, the first of the film's entries into the franchise's fantastical vehicle hall of fame is H's personal car – which turns out to be very personal indeed.

"H has a classic E-type Jag, which is beautiful for all the obvious reasons," says Chris Hemsworth, "but quite unique in the sense that every part of that car is also a weapon."

BELOW: Agent H's car near The Black Friar – MIB London's entrance – during filming on location in London.

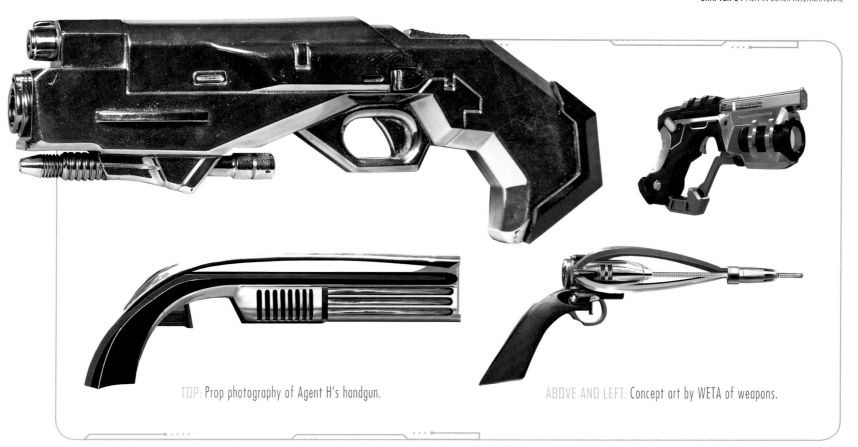

TOP: Prop photography of Agent H's handgun.

ABOVE AND LEFT: Concept art by WETA of weapons.

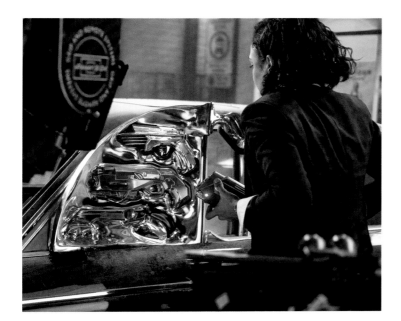

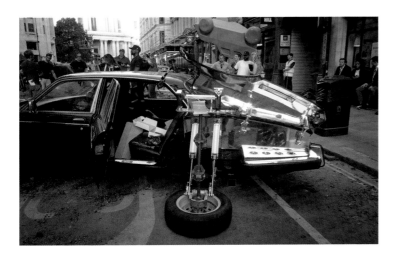

"It's very *Men in Black*, isn't it?" laughs production designer Charles Wood. "A totally maniacal gag where you have this beautiful old classic vehicle and then pump the whole thing up with all these crazy weapons! The Jag itself was very much the idea of planting that part of the film in the UK – the nostalgia of our classic auto industry and aligning that with the character."

Having come up with the idea that H's Jaguar was hiding a series of lethal secrets, the challenge was how to make the scene work in a practical sense. It wasn't just a case of making guns that could conceivably be hidden inside the car, either. The actors would need to physically remove them from their housings during the course of the scene, which meant the props department had to actually retro-fit a vehicle to perform exactly as written in the script.

"Basically, they got a Jag and cut it to pieces," says Ben Wilkinson, with a laugh. "They took a chainsaw to it to make it work."

"That was probably the biggest scenario for us, just to build all the guns but also to figure out how the guns came out of the car," says Pierre Bohanna, whose team first produced a series of roughly printed versions of the weaponry to help them figure out how they keyed into the vehicle before building the final props. "It's this idea that as they're battling the Twins, the weapons they're using are not powerful enough, so they have to go up to the next stage. Everything gets bigger and bigger, until you get right to the very end where you have this mad rocket launcher just as a final punch," he laughs. "It was great to come up with ideas of how we'd hide them in the car."

LEFT: Unit photography demonstrating how H's Jag transformed into a weapon.

AGENT C

"You've got so much paperwork coming your way."

REPORT: AGENT T

DESIGNATION: AGENT C

YEAR OF ACTIVATION: 2012

PLACE OF RECRUITMENT: LONDON

CURRENT FIELD OFFICE STATION: MIB LONDON

RECRUITER STATEMENT:

Agent C is what I would call an old school member of Men in Black. He's a hard worker and prides himself on doing things by the book. This makes him extremely reliable, but to my mind he lacks flexibility, which in its own way can be detrimental. Of course rules are necessary — vital, even, in our line of work — but a truly exceptional agent will also understand that to be effective, there is a gray area that we must learn to navigate. I have confidence that, in time, C will work this out for himself.

SIGNED, AGENT 'HIGH' T. MIB LONDON

"I've always been a huge fan of the franchise," says actor Rafe Spall, who plays the somewhat ambiguous figure of Agent C. "I remember when the first one came out, I was delighted by the mix of sci-fi and fun and irreverence. So when I got the email telling me that they were going to make another one and there was possibly a part for me in it, I was delighted, especially when I knew that F. Gary Gray was going to direct. I'm a fan of his work. In addition to that, Chris Hemsworth and Tessa Thompson were cast as the two

leads, two people that I'm a great admirer of. Really, I want to work with nice people, have some fun, and all of those boxes are ticked."

For Spall, working with his co-stars as well as F. Gary Gray was definitely the highlight of his experiences on *Men in Black International*. "Gary creates an amazing collaborative environment on set in the same way that Tessa and Chris do," the actor says. "We all seem to share the same taste in terms of what's good and what's not. He is extraordinarily versatile in the movies that he's made. To me, this seems to be the movie that he can employ all his different talents in one."

Though working with the rest of the cast was easy, Spall reports that there was an essential element of the *Men in Black* universe that he had a little bit of trouble with. "When I pulled out a neuralyzer, it gave me great respect for Tommy Lee Jones and Will Smith," he laughs. "That's a tricky prop. To get that thing to work — getting the glasses out, getting the neuralyzer out, opening it up in a slick way... It's not easy. It took some practice!"

BELOW: Rafe Spall working with an iconic prop on set.

MOROCCO

Mand H's quest takes them out of London to the hot, dusty streets of Marrakech, Morocco. The production filmed in the North African city and its environs for several weeks. Choosing the location was a painstaking task and had begun months before.

"We wanted to give the audience a very different experience with each place, to keep it international," says designer Charles Wood. "Gary was very insistent on finding palettes that would contrast beautifully: the dusty, more arid terracotta of Marrakech versus the limestone, regal world of London, versus New York and all the noise and density of a city like that."

Locations manager Jamie Lengyel says they looked at multiple countries from Turkey to India and Nepal. "We were trying to find something that would give us the right blend of locations – it's an action sequence, but it has comedic value as well – and that would work in the context of where we're coming from and where we're going. We shortlisted three different countries for each part of the sequence, and Charlie and I pitched it to Gary."

In the end, Marrakech won out not only for its stunning landscapes, but also for practical reasons. "Marrakech obviously gave us the medinas, the narrow streets, somewhere to get lost in, the elements of comedy, danger all mixed in," says Lengyel. "It also gave us an extra element in the sand dunes. Gary's big thing was to bring big cinema, and in all my scouting it was very much looking for where we could get scale. In action films it's very hard – you get very small moments to give a sense of place, because it's so fast-moving. So you're looking for shots and landscapes that say where you are, to open the film up. Morocco had that."

BELOW: Concept art of the range of locations that the agents would travel to in Morocco.

NASR & BASSAM

"SORRY H. A BEARD'S GOTTA EAT."

The *Men in Black* franchise continually finds a balance between outright science fiction and straight comedy. This is perfectly delineated by the character of Bassam the beard, probably the most unexpectedly-placed – and unapologetically funny – alien designs of *Men in Black International*.

"Bassam the beard was one of those things where you get the brief, and you just go, 'Brilliant!'" says Ben Wootten, who provided concept sketches of the character based on the script from his office at WETA Digital in New Zealand. "It almost designed itself, because it was so outrageous in its concept that once you'd got this stringy alien with his big hair and this beard wrapped around the guy's face in different positions, he just came to life very quickly."

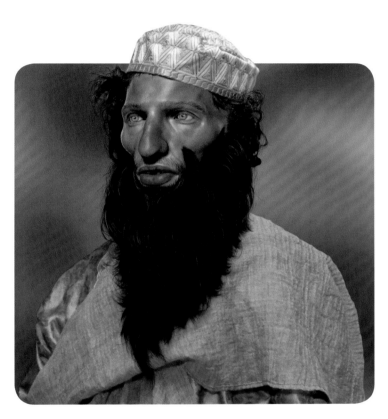

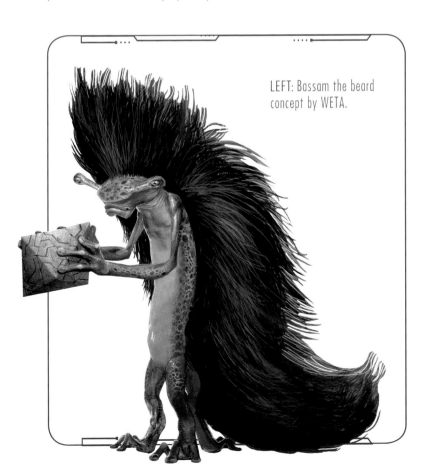

LEFT: Bassam the beard concept by WETA.

Wootten concentrated on working out just how Bassam would attach to his human friend, Nasr. "I played with how he could hang on the face in different positions. He could wrap around from ear to ear and have a big solid beard around the face or he could just hang physically off the chin with his three legs and end up with a really long beard." The artist also decided to give Bassam eyes on stalks. "There's the ability to have just the eyes sticking out so you've got no idea what you're looking at to start with," he says. "It was a lot of fun and such a crazy idea, it almost made it easy. He's kind of sneaky, and that comes through because he's sort of weasel shaped. It's just hilarious."

THIS SPREAD: Though Bassam the beard as seen on screen was entirely CG-generated, Robb Crafer of the prosthetics department actually produced a 3D printed model for on-set reference.

CHECKMATE
ANTIQUE SHOP AND CHESSBOARDS

Although set in Marrakech, the scenes inside the antique shop where H and M first encounter Pawny were filmed on a set at Leavesden prior to the production going on location.

"The first day I shot, I was in the antique shop where my character had been living his whole life," says Kumail Nanjiani, who played Pawny. "That set was gorgeous. Every single thing was so detailed – the spider webs, the dust. As soon as I walked in, I was like, this room is a work of art."

"The idea was that Pawny and his people live in the back room of this antique shop," explains designer Charles Wood. "The backstory is that they're allowed to live here incognito, but the payment for their shelter is that they produce weapons."

The original idea of a chessboard civilization had actually come from executive producer Walter Parkes. "It was one of those ideas with no context that he'd had a long time ago – could there be an alien civilization living on a chessboard?" says writer Matt Holloway. "He didn't know where to put it, it was

BELOW: A production designer's dream lies in the details of this set, as shown in these concepts.

BOTTOM: WETA concepts of Pawny and the other chess pieces.

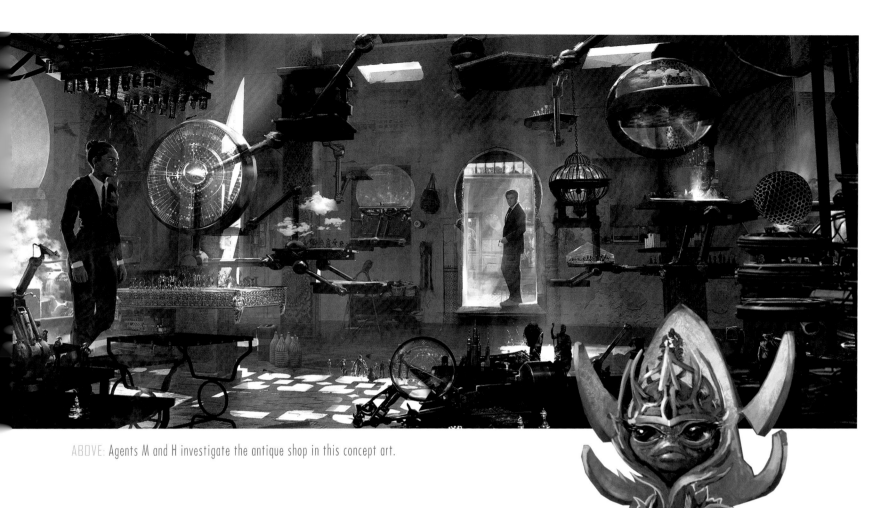

ABOVE: Agents M and H investigate the antique shop in this concept art.

just one of those ideas. We really liked it, so it was like, 'OK, what do we do with it?' We started talking and thinking about well, if you had a chessboard civilization, all of those pieces would fulfill the roles from pawns to bishops to the knights to the king to the queen, which is the most powerful piece on the board. So what if you had the queen's pawn character?"

Once the theory of the civilization itself had solidified, the difficulty became in how to produce a visual representation of the way it would work. This was not the first time *Men in Black* lore had created a microcosmic world ("The galaxy is on Orion's belt," anyone?) This time around, the task of making Pawny's world a cinematic reality fell to production designer Charles Wood and his team of concept artists.

"These illustrations were about trying to make little worlds that existed around Pawny," Wood says, of the concept art on these pages. "He existed in this kind of biosphere. It's based on these kind of cubist worlds. We tried to come up with these lovely little shapes that they could hop around so that he could jump up to the camera. So he and Queeny actually live on the chessboards and there are these atmospheres that exist around them that they exist within."

It would be the task of visual effects supervisor Jerome Chen and his team of digital artists to augment the chessboards for the final shots. For filming, however, the prop department built multi-leveled versions to provide the cast and crew with objects that were the correct size and shape to make lighting and reactions easier.

RIGHT: Concept of Queeny by WETA Digital.

PAWNY

"MY LADY, THE JACKASS NEEDS THE TORQUE WRENCH."

As if to prove that size isn't everything, if there's any challenger to Agent H's role as the main comic relief in *Men in Black International*, it comes in the diminutive package of Pawny. Though he turned out to be one of the funniest aspects of the film, writers Matt Holloway and Art Marcum didn't deliberately position him that way.

"His very existence is just kind of inherently absurd," Marcum laughs. "I think he was born to be funny. That was what made it fun and surprising for us writing it. It happened organically. Then you get an actor like Kumail who comes in and just adds a whole other dimension to it."

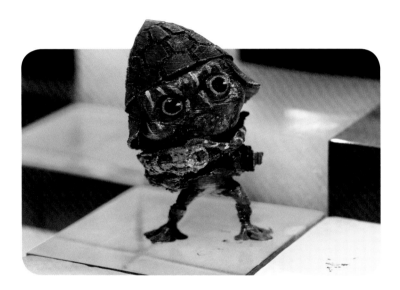

REPORT: AGENT H

NAME: PAWNY

DESCRIPTION: SMALL, ANNOYING SMART-ARSE WITH A KNACK FOR MAKING DEADLY TEENY-TINY WEAPONS

Frankly, I don't think we need to handle Pawny at all. I think we could just take him out into a desert far, far away from civilization and leave him there. Or shoot him out into the universe in a little rocket, maybe? Send him anywhere that isn't here, near me, is what I'm saying. He's too small to be useful. Although don't send him anywhere Agent M is, either. She's got enough on her plate without a mouse-sized stalker complicating things. All right, on second thoughts, leave him with me. I'll use him as a paperweight or something.

SIGNED, AGENT H, MIB LONDON

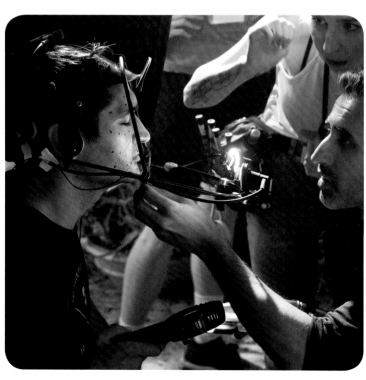

ABOVE: Although the 'real' Pawny was inserted by Jerome Chen's team in post production, prosthetics artist Robb Crafer produced a 'life size' scale model of Pawny that could be used for setting eyelines and lighting on set.

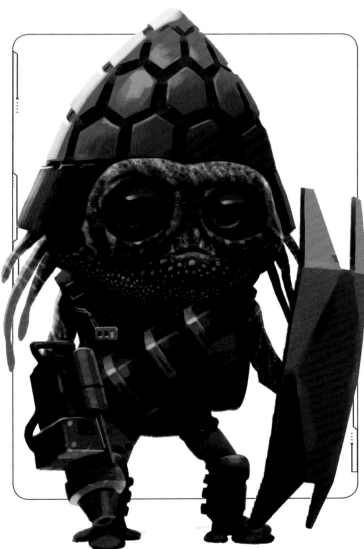

"First of all, I loved *Men in Black*," says actor and comedian Kumail Nanjiani, of why he was keen to take the role. "I'm a fan of those movies. But the fact that I get to play a CG character is very exciting. I've never done that whole thing with the dots on my face and the facial capture. Then they sent me the designs for Pawny and I got even more excited. I think the design is really cool."

Based on the script, the actor had a lot of ideas of how Pawny saw the world and what his world was. "Gary was very open and trusting," Nanjiani says. "He was like, 'Let's figure out a process that will allow us to find different aspects of this character.' They basically let me improvize a lot."

"You get a lot of opportunities with a character like that that you don't have with others," Marcum points out. "Pawny's this tiny, cute thing, so he can say a lot of blunt truths. Kumail would do some of the lines we wrote and he'd throw in some of his own and everyone was trying not to laugh out loud. He's just hysterical."

"What's interesting is, because it's also facial capture, you really have to use your face to communicate," adds Nanjiani, who used the opportunity to try something different in almost every take. "It's a little bit safer, because you can try something crazy and, if the director thinks it doesn't work, they can always change the facial animation later."

LEFT: Pawny's design was masterminded by character designer Michael Kutsche, who had previously produced concepts for *Maleficent*, *Alice Through the Looking Glass*, *Miss Peregrine's Home for Peculiar Children* and the Marvel universe, among others.

ALIEN MOTORBIKE CHASE

One of the biggest set pieces of *Men in Black International* is the spectacular alien hoverbike chase that takes place through the narrow streets of Marrakech. The brainchild of director F. Gary Gray and stunt coordinator Wade Eastwood, honed by writers Matt Holloway and Art Marcum, the idea for the chase really took hold after the first location scout. The team went to look at the section of the city known as the medina, a walled tangle of ancient, maze-like streets, and knew at once that they had to feature it in the film.

"It's using the geography of that location," Marcum explains. "We wanted something that you could only find in a *Men in Black* movie but also that could take advantage of it, so that was really the genesis of the bike."

Once the idea of the chase had taken hold, it was up to the writers to find a way to incorporate it smoothly into the film, because, as fantastic an idea as it was, they couldn't just dump an alien hoverbike into the action without it making sense. They also needed to make sure that both M and H had equal weight in those scenes.

"We didn't want to do an action sequence just for the sake of doing it there," says stunt coordinator Wade Eastwood. "It also needed to have that *Men in Black* comedy. We also wanted to make it a hero moment for Chris Hemsworth's character without it just being the more trained agent coming in to rescue Tessa's character as if she's a damsel in distress, which she most certainly isn't."

BELOW: Concept art of Agents H and M on their race through the streets of Marrakech.

OPPOSITE: The alien bike in varying stages of completion, from pre-paint to fully-mounted on the car rig.

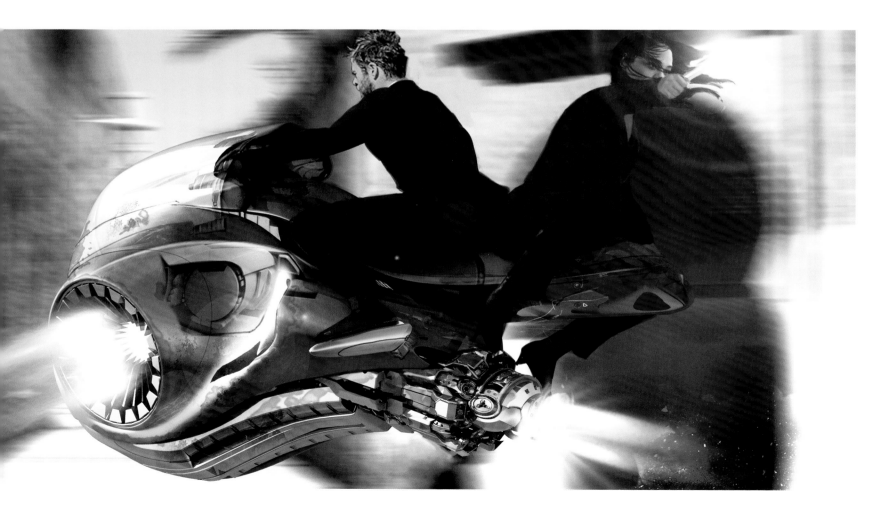

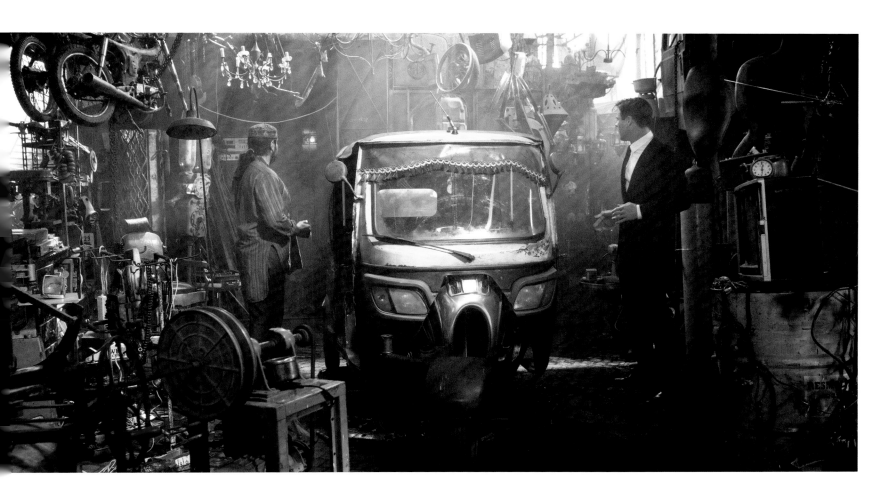

The writers came up with the idea of splitting the two agents up, which had the dual benefit of being able to use the location in different ways as the action followed each character. "It works on two levels," says Marcum. "Half is M going off on foot, being chased by the Twins through this creepy, deserted part of the medina. Then you've got H going off to find his friends Bassam and Nasr, who own a chop-shop, which turns into this high-octane chase."

"We establish that this is a friend of H's and they're a little shady," Holloway adds, "and you get a glimpse of this thing in the background, but you're not paying attention to it. So when H comes back to get the bike, you're hopefully not going 'Oh, I knew that was coming.'"

Building the 'hoverbike' was the task of Pierre Bohanna's prop department, specifically the vehicle team. It was a huge undertaking, not least because they needed to construct not just one but four full-sized bikes, each with a slightly different design and function for filming.

"One's a prop version, then there's an effects one that goes onto all different variants of rigs made by Paul Cobauld, the SFX supervisor, so that they can strap them on to vehicles," Bohanna explains. "Then one that gets flown on cables, and then there's a three-wheeled motorbike."

The three-wheeler was a heavily modified version of a real Can-Am trike, stripped down to what Bohanna calls "its bare bones" and then with the production's scratch-built body mounted on top. "We grafted on as much as we possibly could, probably the top two thirds," he says. "We provided the whole thing and visual effects animated any moving pieces."

The advantage of having a real bike was the possibility of being able to shoot Chris Hemsworth actually driving it around the streets of Marrakech. As a full-on action sequence, the scene would be shot second-unit by stunt coordinator Wade Eastwood while the main unit worked elsewhere. A former racing driver, Eastwood worked with F. Gary Gray to develop a specific ideas about what they wanted to accomplish with the scene, and how.

"I wanted to get as much practical done as possible, because Chris was very good at riding a motorbike," Eastwood explains. "A hoverbike doesn't exist, but I didn't want to just do everything on green screen. I came on board to bring a more practical element and to try to shoot things for real. When you've got the actor on something, driving on those streets – you just can't match it."

The stunt coordinator rehearsed with Hemsworth at various test tracks in the UK until they were both confident that he could drive safely at speed, even in the narrow streets of the medina and with a passenger riding pillion. "If we had to come to a point where we had to slow down, I'd change the camera move or something," says Eastwood. "But Chris was ready because we rehearsed a lot, and Tess was great on the back, because you want to make sure you've got a good passenger who's not moving around. So that was all real speeds and it was them doing it."

Then, with the bike built and ready to shoot, the production moved from Leavesden to Morocco and prepared to film the scene. Eastwood had shot in Marrakech before and was well aware of the difficulties he would face in committing the sequence to camera.

"The people are so warm and friendly and they'll do anything for you, and from that aspect it's amazing," says Eastwood. "But we were typically shooting around these surges of people who want to get somewhere down these narrow streets. To control it in a safe manner – because I can't let that motorbike or any rig move until it's 100 percent safely locked up – that's a big challenge."

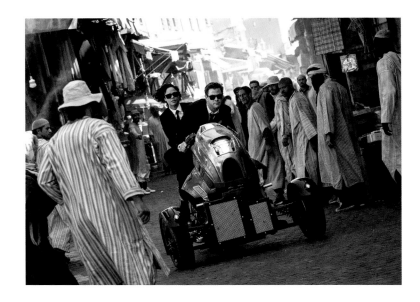

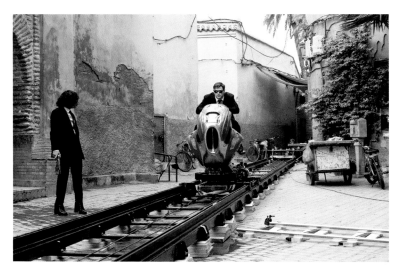

THIS SPREAD: Tessa Thompson and Chris Hemsworth proved very skilled at riding an alien motorbike (above). These concepts show the different forms that were considered (below and right).

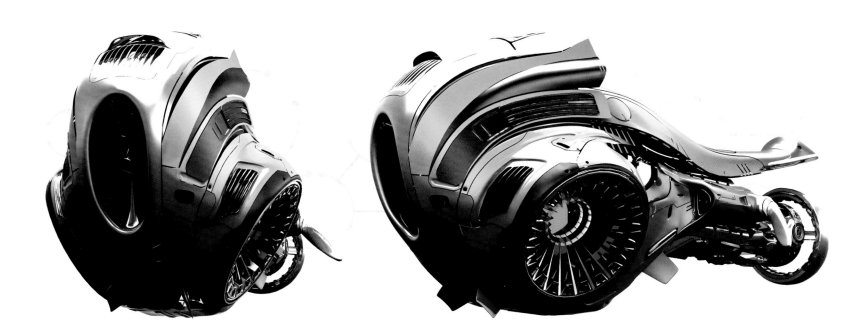

There was also an additional safety aspect in the shooting of the scene because, although the production was utilizing the actual medina streets, they couldn't have the bike ricocheting off real walls and street furniture. Instead, the set department built breakaway sections of set that could be put in place for those elements. In the event, though, the shoot went perfectly.

"The Can-Am worked really well. It put the bike at the correct height, as if it were hovering. It meant I could shoot medium to medium-wide shots and it actually looks like a proper hoverbike."

Visual effects supervisor Jerome Chen was also a vital part of filming, as he gathered what would be required to successfully blend all four versions of the bike into the final scenes. That involved creating a fifth, completely computer generated version of the bike, as well as intricate digital doubles of Chris Hemsworth and Tessa Thompson.

"The bike needed to do these incredible maneuvers that we couldn't do for real," Chen explains, of making the hoverbike an on-screen reality. "I used digital doubles and a CG bike to create shots where we couldn't make it work with the practical ones, and the full CG ones are intercut among the sequence to complete the illusion."

Chen's team also created additional CG elements such as the dust sent up by the pad of air on which the bike hovered, as well as replacing the static turbines built by the props department with moving, lit engines. The finished effect is a unique and distinctly *Men in Black*-style chase though the beautiful, ancient streets of Marrakech.

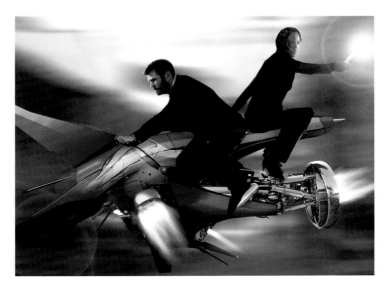

WEAPONS

PUZZLE BOX AND WEAPONIZED BLACK HOLE

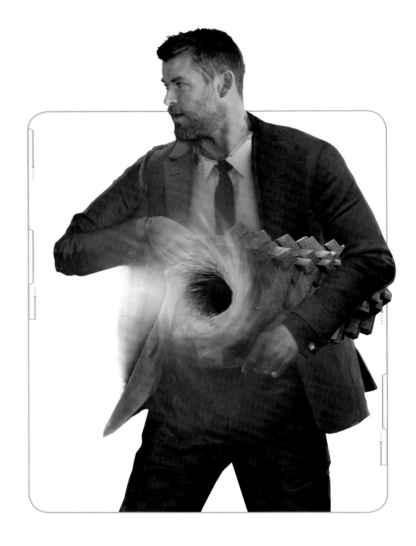

The look of the device at the center of M and H's chase across the world was one of the most difficult for the production to nail down. "I'd say that probably went through more passes than anything, we did so many versions of it," says prop master Ben Wilkinson. "That started off as an old pocket watch – you'd open it up and there was going to be a whirling black hole inside that. Then it changed into a more square puzzle box and then went through lots more designs before we came up with the one we used."

Part of the complication was that the weapon had to be small enough to conceal, but then expand into a believably formidable – and distinctly alien – device capable of unleashing the enormous destructive power of a black hole. "We did a few designs that were brass puzzle box things, quite ornate alien-artifact devices that opened up to show the black hole inside, and then we settled into a more tesseract-like object," says Ben Wootten of WETA Digital. "It started off as an eight-sided object and then broke out into a bigger, more complex shape as it went. We had a few designs for that and I remember Ben Wilkinson in props saying, 'Wow, that looks great, what about animating it?'"

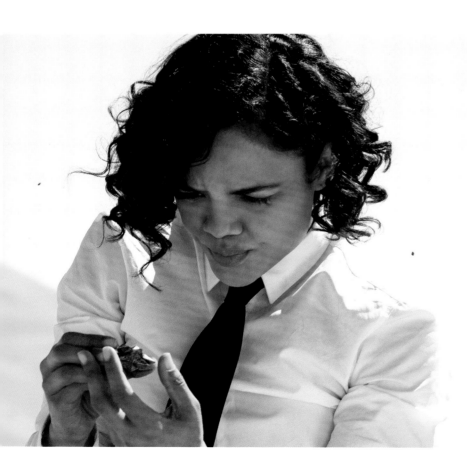

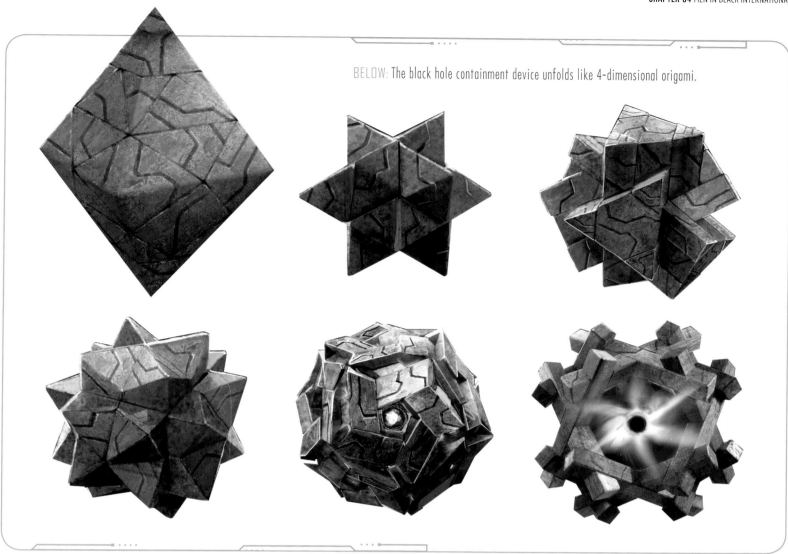

BELOW: The black hole containment device unfolds like 4-dimensional origami.

Animating the device would involve having two props, one small and one large, with the transition from one to another falling to Jerome Chen's visual effects team in post production. "We made the small version of it, and a small version that you could turn as if it was the start of the puzzle," says Wilkinson. "The full sized version, we had in our minds that would only be digital. We only ever made a proxy of that out of rubber, and then visual effects would take that over when you see the final version of it in the film." Then, with the final design still in flux, and with the additional idea that some elements of the black hole weapon could be moving constantly, not just when in use, the production decided to make the whole element a visual effect.

"Sometimes you don't necessarily know at the time you need to shoot exactly what that prop will look like," Chen explains. "Because it was such an important element, we decided it would be better to create a very basic shape for Tessa to hold and then later visual effects would replace it with a design that would have lots of moving parts. So we just made something very light and economical for her to work with. It doesn't look glamorous while we're filming it," he laughs. "It just looks like a black, spray-painted foam core toy – but it looks very, very exotic in the movie!"

THIS SPREAD: On location with the pre-CGI puzzle box and black hole device.

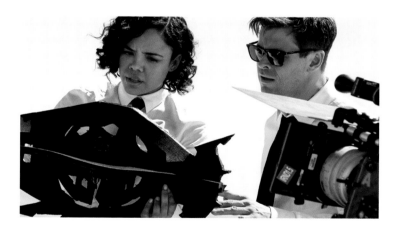

RIZA'S ISLAND

The rogue agents' quest takes them into the lair of arms dealer Riza, played by Rebecca Ferguson. It's an encounter that reveals a little more of H's past.

"Rebecca's incredible," says Hemsworth, of his co-star. "I only did a couple of scenes with her but the character needed to embody a huge amount of intensity, and also there needed to be a chemistry between H and her. So there needed to be a very attractive, powerful character there for us to fear. Rebecca has a great amount of improv ability and sense of humor, which fit the tone of the movie so well."

The setting for Riza's island stronghold provided another opportunity for the production to introduce a different international location into the film. After many discussions, Ischia, an island off the coast of Naples in Italy, was chosen as the basis for her home and workplace.

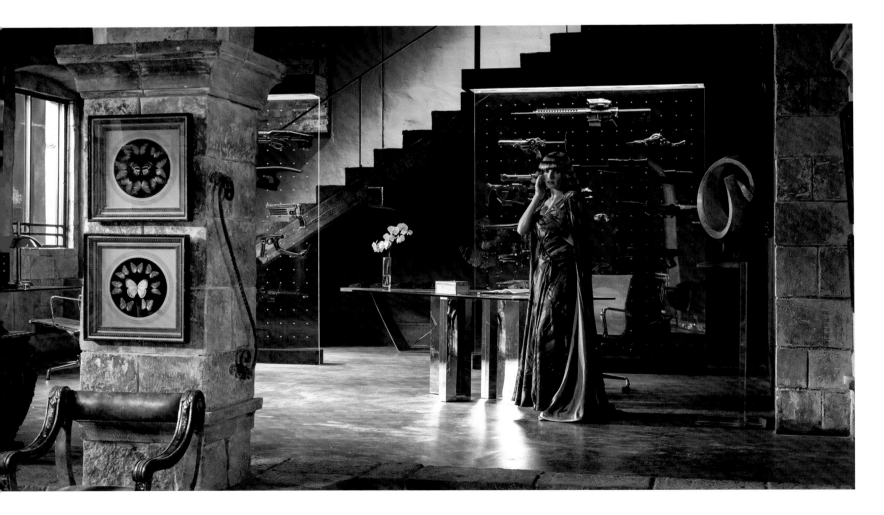

THIS PAGE: The interior scenes in Riza's menagerie were shot on location, not in Italy, but in the orangerie of an English stately home called Castle Ashby in Northampton. Green screens were installed to allow the VFX department to add in the Mediterranean vista in post-production.

 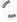

RIZA

DESCRIPTION: INTERGALACTIC ARMS DEALER WITH A PENCHANT FOR EXOTIC SPECIES... AND AGENT H.

MIB AGENT ASSESSMENT:

Don't let looks deceive you. Riza might seem as though butter wouldn't melt, but the truth is she's hard as nails and handy in a fight. Very handy, if you get my drift. If you want to get on her good side, your best bet is to rustle up an interesting pet or two that she might fancy adding to her menagerie. Come to think of it, if you ever need such a thing, give me a call and you can take Pawny. We'll spray-paint his armor pink and she'll never know she's seen him before. Do us all a favor, eh?.

SIGNED, AGENT H, MIB LONDON

LEFT: Early concept art of the beautiful yet formidable "agent of death" by WETA.

"Gary's big thing with all my scouting was 'I want to see that turquoise blue of the sea,'" explains locations manager Jamie Lengyel. "We'd been in these city worlds with New York and London, and it became apparent that Riza's world needed to be an island."

The landscape of the setting also informed costume designer Penny Rose's wardrobe choices for Riza, whose clothes are a vibrant contrast to M and H's stern black regulation suits. "Riza had to have had an affair with H, he has to kiss her. And it's Rebecca Ferguson, for heaven's sake, so she couldn't be revolting," says the designer. "So she's basically wearing a swimsuit and a sarong, and a cape. Because capes always work, don't they? Everyone loves a girl in a cape!"

To complement the beautiful coloring and lines of Riza's Mediterranean-inspired clothing, hair and make up artist Jeremy Woodhead created an equally stunning hairstyle.

"That was quite a complicated one," recalls Woodhead, of the character's wig. "There was no fitting, so I had to get a wig that would be adaptable. I bought the blondest one I could find and then bleached it further and re-dyed it to have those rings. It was a three-color process: orange, purple, and a kind of dark blue. The idea is that visual effects will take those on afterwards and whenever she gets slightly emotional or het up or angry, the rings come to life and oscillate."

ABOVE: Sketches of possible designs for Riza's make up by Jeremy Woodhead.

RIZA'S ALIEN PETS

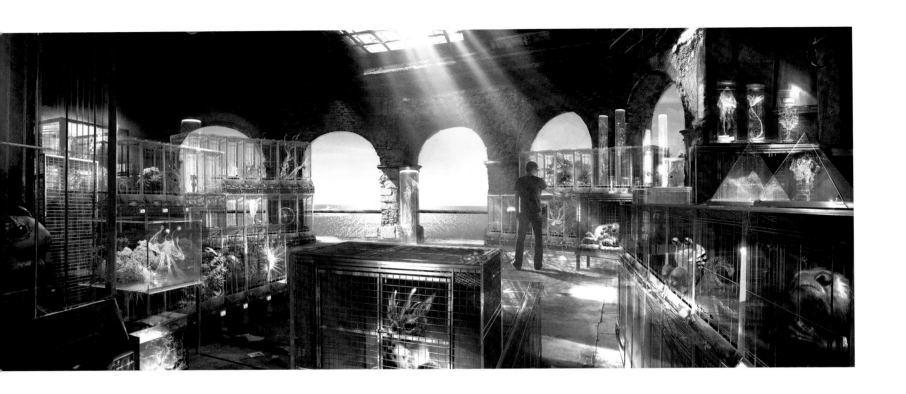

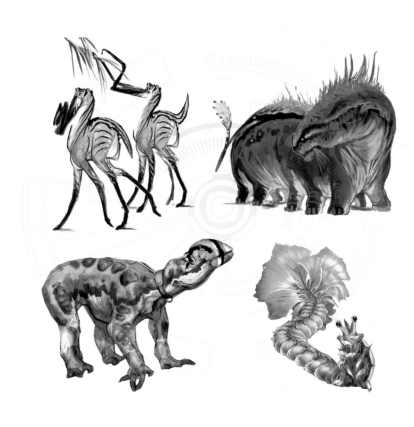

THIS PAGE: Riza was a collector of unique creatures from all over the universe, giving the concept artists a chance to create exotic lifeforms.

H and M's visit to Riza's lair gave the production a chance to really go for it when it came alien design. The island's menagerie could be colorful, wacky, and a complete departure from the other alien elements in the film. After all, Riza had collected them simply because they were cute and strange, so the cuter and stranger they looked, the better. For the design of these aliens, the production turned to WETA Digital, who had put together a team led by Ben Wootten to produce various concepts for the film.

"It was pretty open, that brief," says Wootten, of what the production was looking for in terms of Riza's exotic menagerie. "And quite different, too, because all of the other stuff we were doing was heavily alien character based."

As a result, Wootten and his team decided to take a very different approach to these designs, thinking about what environments on other worlds might have produced in terms of evolution of flora as well as fauna. "It was nice to dive in and think about the fact that there are animals on other planets as well," he says. "I really like that idea, that you've got these kind of plant/animals. You can imagine this whole ecosystem where the animals never evolved, but plants started moving around instead."

The result was a series of beautifully different and extremely cute "planimals" that can soften the heart of even the most murderous arms dealer…

"You always knew the way to my heart."

MIB HEADQUARTERS: ALIEN DATA

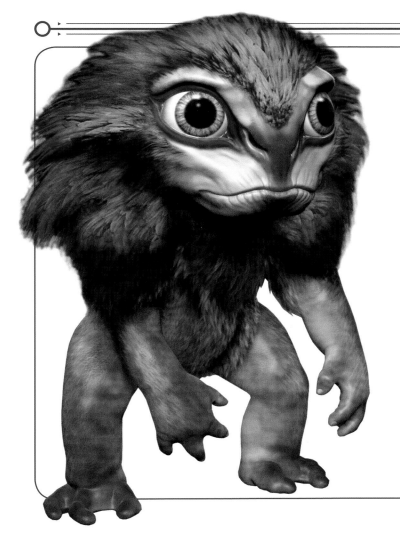

LUCA

The revelation that Riza's formidable bodyguard is actually the grown version of the cute creature that set a young Molly on the path that eventually led her to the Men in Black is a lovely emotional pay-off in the film. In terms of design, it meant finding a way to link the younger and older versions of the character without making it too obvious for the audience what was going on. It was a process that took time and changed a lot.

"That was another story arc that got switched on and off for a time," explains Wootten. "For a while, it was going to be a baby version of the big bad guy and then it wasn't, so then it just had to be a cute baby alien. We had a few hangers on from when the baby Tarantian was going to be a separate creature, so there was a bunch of alien babies that we did that made it through into Riza's pet collection."

LEFT: Who would expect this cuddly creature to grow up into a mighty foe?

EIFFEL TOWER
THE ORIGINAL ENTRY POINT TO EARTH

The action of *Men in Black International* begins and ends at Paris's iconic Eiffel Tower, a beautifully cyclical way to bring the story back to that all-important moment in H and High T's common past. In true *Men in Black* fashion, the extraordinary structure is given an additional level of wonder with the revelation of the famous landmark's true purpose. Much like Ellis Island, the original immigration entry point for travelers to the New World, the very top section of the Eiffel Tower connects Earth with the rest of the universe. "If you were coming from somewhere far, far away, you would come through a portal at the very top of the Eiffel Tower and be dispersed into the streets of Paris and beyond as an extraterrestrial," explains production designer Charles Wood.

"So this beautiful, pointed shape was manufactured by Gustave Eiffel as an arrival point for extraterrestrials, and it is now governed by the MIB."

Though the production did film establishing scenes at the base of the actual Eiffel Tower, the majority of the action was shot on a large recreated set built at Leavesden Studios. This allowed them to safely control the frenetic action scenes that take place as H and M confront the truth about that fateful night years before. It also meant that Charles Wood could subtly change certain aspects of the interior to more accurately provide what was required for the story. Even then, the designer was careful to make sure the style of his re-imagined version of the tower was a fitting extension of what is really there.

BELOW: Concept art of the Parisian portal: MIB containment vehicles outside the Eiffel Tower, Agent H parks up his alien bike, the portal gate, one imagining of the open portal.

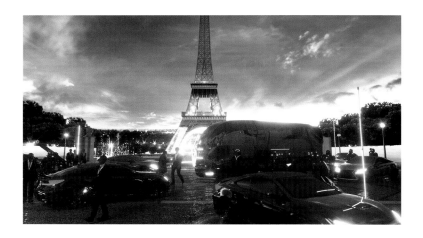

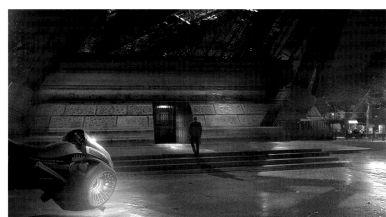

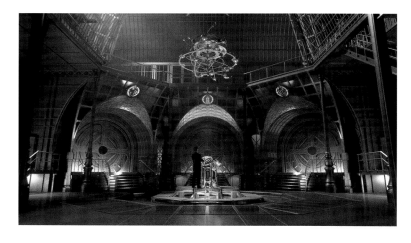

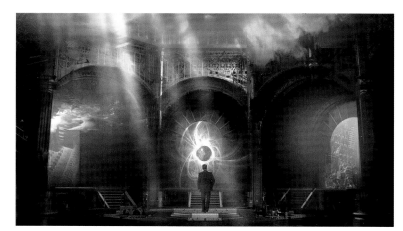

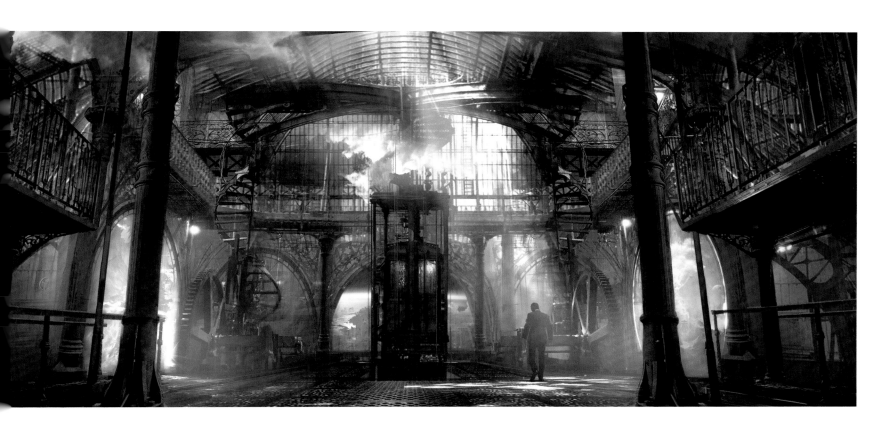

"The interior is actually based on the Gare d'Orsay, which is a period train station," he says. "The arches are all taken from that, as is all the metal work. We wanted to give this a sort of cathedral-like look, and for the glass ceilings we took inspiration from Alexandra Palace, so the same period again."

The colors and textures of these interiors were also designed to match the original, with the construction and set decorating departments adding detailed patinas to simulate the texture of the metal beams. To accommodate the actual portal room itself, Wood extrapolated the dimensions of the real Eiffel Tower in order to add another level. He produced detailed architectural schematics that would help both the construction team and then, later, the visual effects department. "We built quite a bit of it, but then there's these very extensive top ups that become a big virtual set."

Visual effects supervisor Jerome Chen and visual effects producer Deven LeTendre were both on set as these scenes were filmed, ensuring their team got what they needed to finish the scenes in post. This involved not only making sure they would be able to tie the city of Paris into the background, but also adding the portals and the glass ceilings. Besides these aspects, the VFX team also needed to set up for the epic battles that were fought within the tower itself. "I have to imagine what the finished image is going to look like in my head," Chen explains, of his role during filming. "I have to have a very good idea of what it's supposed to look like so that I can help everyone else act the part. It's a very fun, high-end level of play acting, which is what I love about what we do."

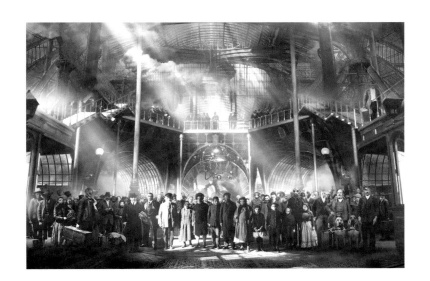

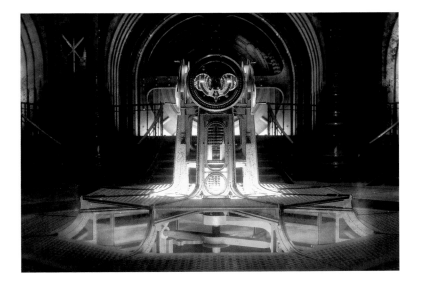

RIGHT: Can you spot any familiar faces among the portal's first visitors?

 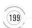

THE MANY ITERATIONS OF THE HIVE

Coming up with the look of the creature known as the Hive took the team months, and lasted well into post production on *Men in Black International*. One of the biggest problems in nailing down the design was finding an original approach for the look of the film's 'big bad.' As producer Walter Parkes points out, since the first *Men in Black*, the growth in the amount of screen monsters out there has been exponential. "It's not only that there are all these monster movies," he says. "The amount of science fiction that is taking place in the world of video games is extraordinary. It's very, very hard to find originality. What we try to do is to stake a slightly different claim than those other movies. *Men in Black* wants to be sort of witty, and it operates in the real world."

This idea that the action and style of the film is rooted in reality, says producer Laurie MacDonald, is often where the production turns for its inspiration. "We always go back to natural forms: sea creatures, insects," she says. "It amazes me, what they're still finding on our own planet that is more alien than anything we can imagine. So that's always part of the process."

Nature also provided a breakthrough for artist Ben Wootten as he began to conceptualize what the Hive might look like. "Early on I found these little sculptures out of pencil stubs. They're spiky on one side and flat into the pencil on the other and it's an incredibly weird looking thing." The sculptures were by the American artist Jennifer Maestre, who takes her inspiration from sea urchins and other strange underwater creatures. "I was imagining that the person was just pulling themselves inside out, and on the inside they were made of these spine-like things. That was my first pass on High T, which was kind of disturbing. Then we looked at this parasitic fungus/spore type of idea, which still played to that reveal – his skin peels away and the fungus grows out to reveal that this has been hiding inside him the whole time."

THIS SPREAD: The Hive had many different looks and limbs.

 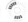

Even once the spore idea had taken hold, there were still many changes as the team worked towards the final Hive creature. For one thing, even though they could continue altering the look of the monster long after the scenes in which it appeared had been shot, there were certain factors that had to be decided on and locked into place before the those scenes went in front of the camera. "Once we have the set built, there are the constraints of the character within the set," Deven LeTendre points out. "How does he walk? How does he bend?"

"You have to make sure that the actual shot is composed correctly," Chen agrees. In the case of *Men in Black International*, the key to that consisted partly of a tennis ball on a stick, coated in green so that it could later be replaced by the finished Hive. It's a simple visual clue, but it allows the camera operator to compose the shot knowing exactly where and how tall the finished creature will be. "Then what's really important is the actors have to have an eyeline," Chen adds. "They have to be looking at the correct spot where you're going to put the creature. That's vital. If they're not looking in the right place, you won't believe it. Then we have basic action beats that we've already filmed and we understand, story-wise, what the creature needs to do."

BATTLE IN PARIS
WITH THE HIVE

The showdown between Agent H and the transformed High T that takes place at the top of the Eiffel Tower packs an emotional punch as well as being a high-octane action scene. "Moments before H walks into the portal room, he realizes he's been neuralyzed, and what he thinks happened years ago didn't happen at all," says writer Art Marcum. "So he doesn't know what actually happened three years ago, he doesn't really know who he is. That father/son dynamic was definitely the spine of the scene. We built everything around that."

It's a powerful way to start the final act of *Men in Black International*. "That was something that goes right back to our first draft," says Matt Holloway. "We thought it would be interesting to take a character who is so confident and exudes so much of that quintessential secret agent exterior and take it all away from him."

This emotional explosion, of course, is set against the backdrop of an immense fight to prevent Earth from falling victim to the machinations of the Hive. "We wrote it with a basic understanding of what the actual monster looks like and exactly what it can do," shares Holloway, who says that beats of the fight scene itself were worked out once the sets had been built. "We walked around the set with Gary, Walter, and Wade, and that was fun because we knew what story we were telling in there but we were deciding the beats and tying that into how the monster operates. 'Hey, what if we did this over here?' and 'There's a steam pipe over there, we could…' basically we walked around and founded that on the incredible set that Charlie had built."

Many aspects of the battle were accomplished with visual effects in post production, which meant that Jerome Chen and his team had a lot to set up to make sure they had the backdrop they needed. This involved working with director of photography Stuart Dryburgh and the special effects department to implement the interactive light elements that would later tie into the battle itself. When an explosion occurs or a laser gun fires, for example, it's not just the light of the explosion or the laser itself that needs to be seen on screen – it's the way the light, heat, and energy from those events affect what's around them. When those elements are virtual, as many of those effects as possible need to be in place on the day of shooting to make the finished shot realistic.

THIS SPREAD: Unit photography on set of the last battle between Agents H, M, and the Hive. The background view of (and from) the Eiffel Tower was added after filming.

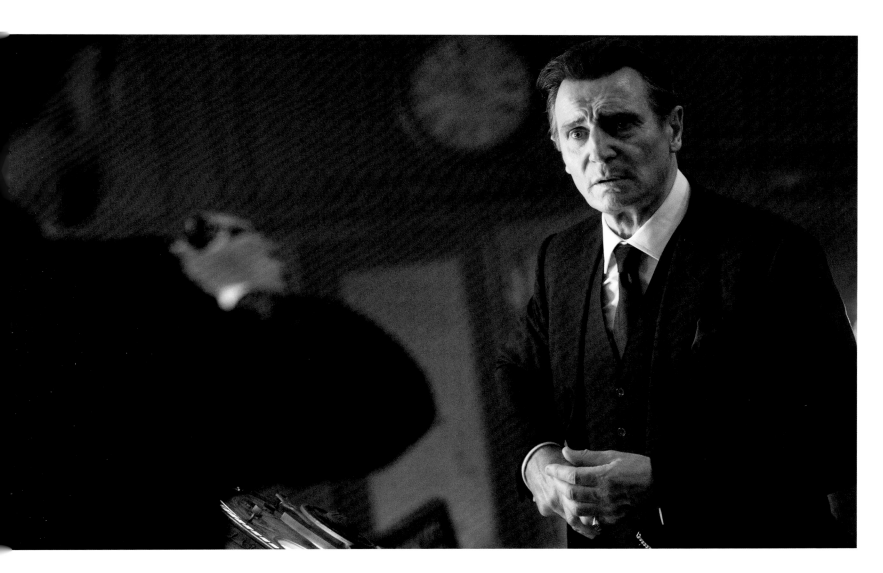

"It would be impractical to have a real explosion on the set: too dangerous, too difficult to accomplish for real," explains Chen. "So if I had to put the explosion in later, I would want Stuart to help me create a very bright light source, as if the explosion had caused light. In that same regard, you have the special effects department help by creating wind and smoke on the set, and then I add the rest of the illusion in – debris flying, a giant fireball, things like that. I have to work with all of the departments to help me create the pieces of the illusion that I will then finish in post production."

It's a signature move of the *Men in Black* franchise to turn a showdown into something emotionally deeper than might be expected from a sci-fi action film. H believes himself to be a hero, but when it comes down to it, will he actually prove himself to be one when it matters the most?

"We traverse a lot of landscape and a lot of different settings in this," says Chris Hemsworth, "but there's a huge amount of heart, too. I think it always comes back to the characters, their relationships within this world – what it means to work within MIB and what you have to give up and sacrifice in order to know the larger truth about what's in the universe. And it comes at a cost."

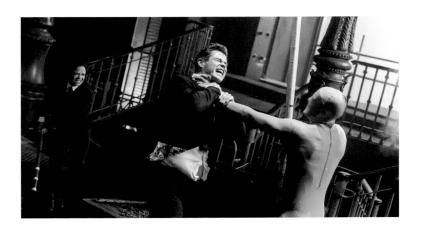

RIGHT: The Hive's full alien anatomy was added to the scene after filming.

BACK
IN BLACK

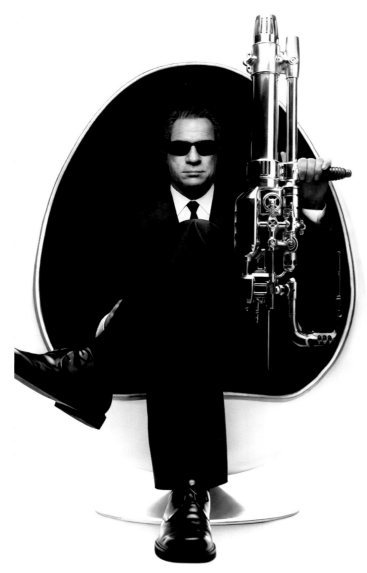
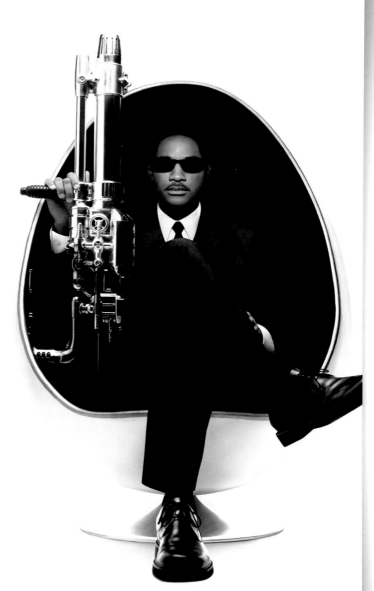

MR. JONES MR. SMITH

MIIB

COLUMBIA PICTURES PRESENTS AN AMBLIN ENTERTAINMENT PRODUCTION IN ASSOCIATION WITH MacDONALD/PARKES PRODUCTIONS A BARRY SONNENFELD FILM
STARRING TOMMY LEE JONES WILL SMITH "MEN IN BLACK 2" LARA FLYNN BOYLE JOHNNY KNOXVILLE ROSARIO DAWSON TONY SHALHOUB AND RIP TORN ALIEN MAKE-UP EFFECTS BY RICK BAKER
SPECIAL ANIMATION AND VISUAL EFFECTS BY INDUSTRIAL LIGHT & MAGIC COSTUME DESIGNER MARY E. VOGT MUSIC BY DANNY ELFMAN EDITED BY STEVEN WEISBERG RICHARD PEARSON PRODUCTION DESIGNER BO WELCH DIRECTOR OF PHOTOGRAPHY GREG GARDINER CO-PRODUCER GRAHAM PLACE
READ THE DELL WAY AND HarperCollins Books EXECUTIVE PRODUCERS STEVEN SPIELBERG BASED ON THE MALIBU COMIC BY LOWELL CUNNINGHAM STORY BY ROBERT GORDON SCREENPLAY BY ROBERT GORDON AND BARRY FANARO PRODUCED BY WALTER F. PARKES AND LAURIE MacDONALD
 MenInBlack.com DIRECTED BY BARRY SONNENFELD COLUMBIA PICTURES

 JULY 3

ACKNOWLEDGEMENTS

Lisa Fitzpatrick

Thank you to Walter Parkes, Laurie MacDonald, Barry Sonnenfeld, Bo Welch, Doug Harlocker, Ed Solomon, Rick Baker, Etan Cohen, Josh Brolin, Eric Brevig, Lowell Cunningham, Cheryl Carasik, Kasra Farahani, Mary Vogt, Carlos Huante, Mark Setrakian, Jurgen Heimann, Irene Webb, Lorne Peterson, Tony Urbano, Tim Blaney, and the many other *Men in Black* creators and contributors for your patience and your stories. As a co-author, it was a privilege to put together this *Men in Black* 1-3 retrospective.

Thanks as well to Parkes-MacDonald's Riyoko Tanaka and Will Schlich, Sony's Virginia King, Monica Guzman, Gil Embralino, Karen Boysen, and Provvidenza Catalano, Amblin's Marvin Levy, Michelle Fandetti, Lauren Elliot, and Kristin Stark, unit photographer Melinda Sue Gordon, and of course, the staff of Titan Books, especially my editors Charlotte Wilson and Eleanor Stores, and the amazing in-house design team, Natasha MacKenzie and Tim Scrivens for your Herculean efforts.

Sharon Gosling

A special thanks to all the *Men in Black International* production team, particularly F. Gary Gray, Walter Parkes, Laurie MacDonald, E. Bennett Walsh, Riyoko Tanaka, Michael Sharp, Art Marcum & Matt Holloway, Wade Eastwood, Stuart Dryburgh, Penny Rose, Charles Wood, Jeremy Woodhead, Paul Corbould, Jerome Chen, Deven LeTendre, John Bush, Ben Wilkinson, Pierre Bohanna, Jamie Lengyel, Ian Clarke, Alex Caldow, Paul Catling, Pete Thompson, Norman Walshe, Ivan Weightman, Katherine McCormack-Wherry, and Sara Aghdami. Thanks also to Ben Wootten, Cathrine Mitchell, and Talei Searell at WETA, Virginia King at Sony, and Natasha MacKenzie and Eleanor Stores at Titan Books.

A big thanks to Giles Keyte, *Men in Black International* Unit Stills Photographer.